LETTERS TO GWEN JOHN

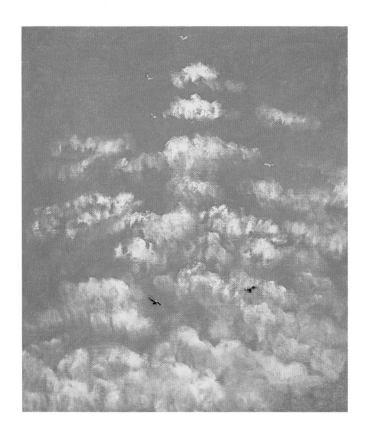

BY THE SAME AUTHOR

Self-Portrait

Letters to Gwen John

Celia Paul

JONATHAN CAPE
LONDON

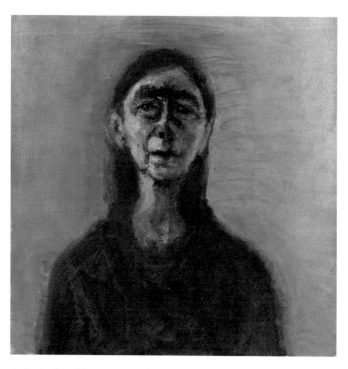

Celia Paul, *Self-Portrait, Early Spring*, 2020

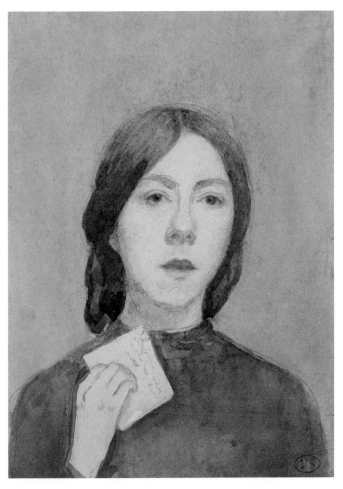

Gwen John, *Self-Portrait with a Letter*, 1907

1 3 5 7 9 10 8 6 4 2

Jonathan Cape, an imprint of Vintage,
20 Vauxhall Bridge Road,
London SW1V 2SA

Jonathan Cape is part of the Penguin Random House group
of companies whose addresses can be found at
global.penguinrandomhouse.com

Penguin
Random House
UK

Copyright © Celia Paul 2022

Celia Paul has asserted her right to be identified as the author of this
Work in accordance with the Copyright, Designs and Patents Act 1988

First published by Jonathan Cape in 2022

penguin.co.uk/vintage

A CIP catalogue record for this book is available from the British Library

ISBN 9781787333376

Typeset in 10.75/15.75pt Adobe Garamond Pro by Jouve (UK), Milton Keynes.
Printed and bound in China by C&C Offset Printing Ltd

The authorised representative in the EEA is Penguin Random House
Ireland, Morrison Chambers, 32 Nassau Street, Dublin D02 YH68

Penguin Random House is committed to a sustainable future
for our business, our readers and our planet. This book is made
from Forest Stewardship Council® certified paper.

For Frank

LETTERS TO GWEN JOHN

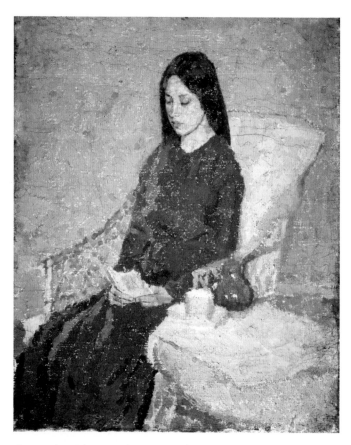

Gwen John, *The Convalescent*, c. 1923–4

On the shelf in my studio in Bloomsbury are four postcards of paintings that I love: *The Blue Rigi, Sunrise* by J.M.W. Turner; *Stonehenge*, a watercolour by John Constable; *Self-Portrait* by Rembrandt, dated 1658; and *The Convalescent* by Gwen John.

Just one look at this reproduction of Gwen John's painting and my breathing becomes easier. The whole composition is a symphony in grey. She must have mixed the colours on her palette first – Payne's Grey, Prussian Blue, Naples Yellow, Yellow Ochre, Brown Ochre, Rose Madder, Flake White – then all the other colours would be dipped in this combination so that every form is united in grey: the dark blue of the girl's dress, the thrush-egg blue of the cushion behind her back and the tablecloth, the rose pink of the cup and saucer echoing the delicate pink of her fingernails and lips, the teapot like a shiny chestnut. The wall behind her is flecked with mustard-coloured dots placed randomly and precisely, as marks in nature always are, like the speckles on an egg. The painting is as fragile and robust as an egg – the structure of the composition holds everything in place; this delicate painting will endure.

Gwen John instructs the model to loosen her hair and part it in the middle. She wants the model to resemble her. Before Gwen starts the painting, she positions herself in the wicker

chair and tells her model that she must sit in exactly the same pose. Gwen lowers her eyes and holds a small piece of paper in her hands. She is completely still, and her stillness pervades the space around her. The room becomes silent. The model now copies Gwen; she looks down at her hands, and she doesn't look up until she has heard that Gwen approves. Gwen is pleased with her. Gwen was in her forties and living alone in Meudon, on the outskirts of Paris, when she befriended Angéline Lhuisset. Angéline was often ill. Gwen wrote, 'it may not be always a misfortune to be ill. One may have thoughts then that one would never have had being well, good thoughts I mean . . .'

In a letter that Gwen wrote to her friend Ursula Tyrwhitt in 1910, she said, 'As to me, I cannot imagine why my vision will have some value in the world – and yet I know it will . . . I think it will count because I am patient and recueillie [*collected*] in some degree.'

I know this painting well. The original painting is small, measuring about the same as an A4 sheet of paper. I have often stood in front of it, trying to learn from Gwen's composure and presence of mind. It hangs in the Fitzwilliam Museum in Cambridge, where my mother lived and where my son and his wife and children still live.

I have been thinking of Gwen John's early years when her mother, Augusta, was still alive. Gwen was the second child, born on 22 June 1876. She had an older brother, Thornton, with whom she was affectionately close. I am trying to imagine

her as a baby. I think she had a stillness about her, and that she watched and noticed from early on. But then she could cry inconsolably – nothing could comfort her – until suddenly she was distracted by a little bird hopping on a branch outside the window, or she noticed her mother's earring twinkling in a shaft of sunlight coming into the room, and she would be stilled again. Her eyes were very blue. She gazed at her pretty mother's face as she looked down at her. The mother and daughter looked into each other's eyes. The daughter loved and was loved. She wanted nothing more.

And then her brother Augustus was born. Augusta must have had a deep attachment to him from the start. She called him Augustus to signify to the world their closeness.

Augusta, Augustus. And there would be Auguste, later on. Did that name – Augusta, the first of the three – suggest a sort of template of deep attachment? In my own life, the two men I have been most intensely involved with, Lucian Freud and my husband Steven Kupfer, in both cases their girlfriend before me was called Kate, the name of my younger sister, the sister I am closest to; I had suffered terrible jealousy at her birth and felt supplanted by her in my mother's affection, but then grew to love her particularly.

Jealousy heightens love; the special intensity with which we observe the object of our mother's (or lover's) devotion narrows down the beam of our focus. Who was it who said that love is the highest form of attention?

My husband's mother was called Käthe, and he has suggested to me that part of the heartbreak he suffered after his

girlfriend Kate left him – and she chose to leave him as his mother was dying – was that he'd lost two mothers. Lucian was named after his mother, Lucie, because she sensed a special bond with him at first sight. So often there is a tangled web of emotion surrounding a name – jealousy, possessiveness, entitlement – for the named person and for the person who named them.

Gwen's mother was a painter. She used to sign her paintings 'Gussie', the name that Augustus was also called by his family and friends. One painting she signed 'A. John' and it hangs in the Dalton Collection, in Charlotte, North Carolina, because the collector thought it was by Augustus. The walls of the sitting room in the family home were covered with Augusta's paintings: pastoral scenes of women and children on lonely roads. She decorated the nursery walls with images, for the children's amusement. She taught her children how to paint by filling in the outlines of a colouring book – this is a technique Gwen adapted in her own work much later on; Gwen always acknowledged her indebtedness to her mother.

Haverfordwest, where Gwen was born, is a seaside town in Pembrokeshire. Augusta would sketch on the beach. Gwen stood by her, captivated by the mystery and importance of painting. The sea was always connected in Gwen's mind with her mother. Later, in France, 'La Mère', or 'La Mer', filled her with longing.

Gwen said, 'When I was a child I used to cry all the time, and they told me "don't cry now, when you're grown up you'll

have something to cry about". So I was afraid of growing up and I never experienced any happiness in life.'

The atmosphere at home became very tense and charged with secrets. Augusta was ill and nobody would say what was the matter. She had often been poorly, suffering from rheumatism, but this illness was a new development. She spent days and nights shut in her bedroom, and the children were instructed not to go near her or to make any noise.

Augusta died when Gwen was eight years old. The official record states that the cause of death was 'rheumatic fever and gout', but Gwen suspected that wasn't the real reason. The secrecy surrounding her mother's death continued to haunt her.

The cause of her death remains unclear. I wonder if it was cancer. I know that, in Victorian times, cancer was considered a shameful disease. Even in 1983, when my father died from cancer, my mother couldn't admit to herself – or to anybody – that it was cancer that had killed him.

When Gwen was first told the news, she, together with Augustus, raced around the house and up and down the stairs shouting, 'Mama is dead! Mama is dead!' The children felt released from the confines of the terrible strain of waiting. They were almost exhilarated. But Gwen had lost her first and purest love. She would never fully recover from the loss.

Her father was a churchgoing man, though not fervent in his belief. He played the organ in church on Sundays. He was a solicitor by profession. After the death of his wife he needed a change and the family moved to Tenby, another seaside town

in Pembrokeshire. The new house was tall and narrow. The rooms were crowded with heavy furniture, and the curtains blocked out the natural light to protect the interior from sun damage.

Gwen spent all the time she could out of doors. She sketched on the beach, as her mother had done. She drew the children playing there. One little blond boy, whom she thought looked like an angel, she invited back to the attic room she shared with her brother, so that she could paint him. He arrived with his mother. Gwen's father saw them arrive and was very angry. He felt that his position as a grieving widower was being compromised, and he told Gwen that he didn't want strangers coming to his house. Gwen responded vehemently. She told him that he was ruining her life with his narrow-mindedness. Her younger sister Winifred backed her up, but her brother defended their father against her. Later Augustus reminisced about this aspect of Gwen's character and commented on her 'implacable nature when roused'.

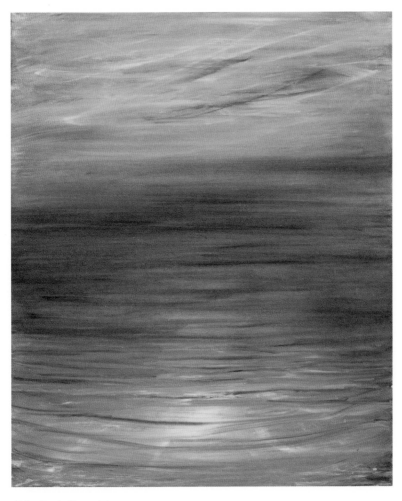

Celia Paul, *Santa Monica*, 2019

Santa Monica, California, 14 February 2019

Dearest Gwen,

I know this letter to you is an artifice. I know you are dead and that I'm alive and that no usual communication is possible between us but, as my mother used to say, 'Time is a strange substance'; and who knows really, with our time-bound comprehension of the world, whether there might not be some channel by which we can speak to each other, if we only knew how: like tuning a radio so that the crackling sound of the airwaves is slipstreamed into words. Maybe the sound of surf, or rushing water, is actually the echo of voices that have been similarly distorted through time. I don't suppose this is true, and you don't, either. But I do feel mysteriously connected to you.

We are both painters. We can connect to each other through images, in our own unvoiced language. But words are a more direct form of communication. So I will try and reach you with words. Through talking to you I may come alive and begin to speak, like the statue in *Pygmalion*. I have painted myself in silent seated poses, still as a statue, and so have you. Perhaps, through you, I can begin to trace the reason for my transformation into painted stone.

You wrote, in a letter to your dear friend Ursula Tyrwhitt, whom you met when you were both art students at The Slade,

and who remained close to you throughout your life: 'No doubt all these words are not chosen well. It is difficult to express oneself in words for painters, isn't it?' Earlier, in March 1902, during The Slade's spring holiday you wrote to Michel Salaman: 'To me the writing of a letter is a very important event! I try to say what I mean exactly, it is the only chance I have – for in talking shyness and timidity distort the very meaning of my words in people's ears.' Michel Salaman was another Slade student, and you were in love with him.

I would like to try to say what I mean exactly, by writing this letter to you, even though, as a painter, words don't come easily to me.

It has been a time of upheaval for me and I have been trying to gather my thoughts. So many things have ended, or are ending. New beginnings, too. You would be surprised by just how much I think of you. I wish we could have spent time together.

I have been thinking a lot about the past, about our past, and though I've often thought about how much we share in our attitudes to life and to our lived experiences, it has never struck me so forcibly as now, when I am nearly sixty years old, quite how much our lives have been stamped with a similar pattern.

We both came to study at The Slade School of Fine Art from our homes in the West Country; we both had passionate relationships with much older and more famous male artists, whom we also modelled for; we were driven to find our true creativity by leading interior, solitary lives; we both became

interested in abstraction (and the idea of God) in later life. The sea has always been important to us: you died trying to reach the sea coast at Dieppe, 'feeling the old compulsion' upon you to glimpse the sea before you died.

We both work best from women. Your mother died when you were only eight, whereas mine died when I was fifty-five, yet mothers are of central significance to both of us. We are both close to our sisters – one in particular: you to Winifred, whom you often painted; I to Kate, who is my most regular sitter.

There are differences too, of course. You never had a child, I have a son. I would like to speak to you about the challenges I have faced by being a mother and an artist.

One of the main reasons I want to speak to you now is because I've become increasingly aware of how both of us are regarded, in relation to men. You are always associated, in the public's eyes, with your brother Augustus and with your lover, Auguste Rodin. I am always seen in light of my involvement with Lucian Freud. We are neither of us considered as artists standing alone. I hate the term 'in her own right' – as in 'artist in her own right' – because it suggests that we are still bound to our overshadowed lives, like freed slaves. I hate the word 'muse', too, for the same limiting reason. We are both referred to as muses, and you have repeatedly been described as 'a painter in her own right', as I have. Why are some women artists seen freely for what they are uniquely? What is it about us that keeps us tethered? Both of our talents are entirely separate from the men we have been attached

to – we are neither of us derivative in any way. Do you think that, without fully understanding why, we are both of us culpable?

You never travelled to America, from where I am writing to you now. I'm in my hotel room, lying on my bed, from which I can just see a glimpse of the ocean. I pace the room occasionally, and sit on one or other of the two low chairs. There is a notice on the door with instructions about what to do if there's an earthquake. Someone is dragging a heavy rattling object through the corridor outside the door: possibly a trolley loaded with crockery. Your face comes into my mind and I'm comforted, somehow.

I know how you and I both suffer terribly from homesickness, so this feeling may have been what prompted me to communicate with you. You always said that one doesn't get to heaven in twos and threes, one can only get to heaven alone. But doesn't being away from home intensify this loneliness so that it's almost unbearable? Not that either of us has ever properly had a 'home' in any consoling sense: the homes we've lived in as children never felt like 'home'. When did you become aware of this feeling of rootlessness? For me, this sensation seems to be bound up with my identity. And with stillness, of course. I have never been able to understand why people are so restless.

It isn't restlessness that brings me here, or even curiosity. I am impelled to come for the sake of my paintings. I am having an exhibition here, in California, organised by the same man

who has helped me so much with my career. Here is one of the differences between us: you would never have used the word 'career'. Painting, for you, was always a vocation. It is for me as well, but I am more ambitious than you, more organised and driven. These qualities in me have been the aspects of my nature that may have surprised this American man who has helped me so much. He used to refer to me as 'a very patient woman' but I am sure he was thinking of you, really. This is the third exhibition in America that he has dreamt up for me. The first time was just over three years ago, in New York. Prior to this, I had never been to America.

New York had frightened me. Before I went, people assured me that it would seem very familiar because I would have seen it in so many films. But actually it seemed the most alien place I had ever encountered. I was only there for four days. I arrived in a heatwave; the weather broke on my last day: in a torrential downpour, accompanied by apocalyptic thunder and lightning. New York seemed primeval and everything uncertain, as if the skyscrapers and towering buildings were built on sand, not rock, and the whole fabrication could just collapse and there would be left only the howling emptiness of a barren, uncultivated land. I had hardly dared go out of my hotel room, and I lived on room service. I had ventured out to the Frick Collection and found consolation in Rembrandt's great masterpiece: his *Self-Portrait* dressed in gold, the postcard of which I keep on the shelf in my studio in London. I looked into his shrewd, kind, knowing eyes and felt more grounded suddenly. It made me aware of the urgent importance of the language of

painting – this subterranean language that speaks most powerfully to lost souls.

The second time I went to America was to Yale. It had been snowing when I arrived. My experience of being abroad was partly soothed by the subduing presence of snow. But it was really the fact that the gallery, the Yale Center for British Art, owns such a great body of work by you. Your paintings appeared to me like essential fragments of a life blown over the ocean like rose-petals in a storm: delicate, broken, unfinished, yet intact and suggestive of a secret perfumed world, a guarded haloed world, a sheltered rose-garden. You weren't interested in the efforts of John Quinn, the enlightened and influential American patron of artists and writers, to make presentations of your work in America. You guarded yourself against any intrusion. And, for this reason, you were able to make these silent evocations of your spirit, of your soul. It had seemed a miracle to me to see them here because they looked so fragile. But they have the tenacity of seeds that flourish wherever the wind blows them.

I have been invited to talk here in Los Angeles about the group of seven paintings of mine on show in the Huntington Museum, which, among many treasures, also houses several paintings by John Constable. The director asked me to speak about how I feel that my paintings of water and sea connect to Constable's work. I said that although Constable and I often rely on nature as our subject, my paintings from water differ to some extent from his, because I only started to paint water as my mother was dying, and continue to do so after her death.

My water paintings are about grief. I said that I hope one day to stop painting water.

It's my second night here and I can't sleep. I have lost my bearings and I'm not sure of the time. I feel almost as if I am in some land that I myself have conjured up, a half-memory from childhood. When I arrived at the airport my first sight was of palm trees and, as it was the evening of what must have been a hot day, there was a deep-crimson sunset. It reminded me of India, where I was born. I left India when I was five years old, but I retain a vivid impression of the quality of the light, the palm trees, the wide-open spaces. Images of my father standing straight in his long white missionary robe, a thin leather belt tied round his waist; my mother beside him, with her radiant smile. She is wearing a wide-skirted dress made of a stiff cotton material, patterned with blousy red roses. I try to see myself as a child and, in my thoughts, I deliberately place my childish hand into my father's strong one: this is an image I often evoke to myself to give me courage.

I am adrift with loneliness in this strange bed. Half my thoughts are in England. I was very frightened about leaving my studio. This is further away even than India, the furthest I have been from home. The plane flight disoriented me. We had travelled back from India by ship, so I could now trace my slow journey from Bombay to Liverpool, the seas we had travelled across, the countries we had stopped at; but, by air, the flight path is more mysterious to navigate in my mind and I am uncertain by what route I have landed in California.

Let me tell you what it is like here. The hotel that I'm

staying in is very beautiful. It is right on the beach in Santa Monica. If you look at it from the beach, it has a Moorish aspect: the windows are arched and scrolled and remind me of pictures I have seen of the Alhambra in Granada. It is big and square and made out of solid stone, which, though grey, has a sort of blush, as if it is constantly reflecting a sunset over the ocean onto which it is facing.

On the first morning I decided to walk on the beach, crossing the track where an army of joggers was pounding along continually, to the water's edge. The light, though overclouded, possessed an opalescent intensity; it was like seeing a blazing fire through gauze. The air was milky and very still. I watched the funny little birds that bounced along the shoreline. I had seen hummingbirds in the bushes outside my hotel window – I had watched them from my bed as I drank my first cup of tea. I noted that not one single bird or tree or flower was the same as in England.

I stood at the ocean's edge and watched the lapping waves. Then, as the waves continued to break gently onto the shore at my feet, I thought about Charlotte Brontë's book, *Villette*. I know you must have read it too. There is an undertow of sadness throughout, like a low murmur that gradually gets louder and more intense until it threatens to drown out the narrative and break up the rhythm of the plot. On the last page, Lucy Snowe is waiting in her bedroom above the schoolroom in Brussels for her beloved Monsieur Paul Emanuel (her 'Mon Maître', as you always called Rodin), who is travelling home to her from America. A storm is raging outside her window. She

is restless and paces up and down; she is waiting, perhaps forever waiting, since the ocean across which he is travelling towards her must be impossibly treacherous. The lightning strikes and the storm rages on, and Lucy is still waiting. There's a foreshadowing of Lucy's fate near the beginning of the book, in the story that the old lady (whose paid companion Lucy is) tells her: how she had lost her beloved fiancé, Frank, in a riding accident the day before they were due to be married.

I returned to my room. There was a family packed into the room next to mine. Their baby yelled and screamed incessantly. I had never heard such screaming. When there was the sound of the bedroom door opening, I went out and saw a woman with the child in a buggy, pushing it up and down. I asked her if the child was ill. She replied, with a small sideways shake of her head, very unperturbed, 'Oh, he's just a little cranky.'

I had lunch in the restaurant that looked over the beach towards the ocean. I was lucky to get a table by the window. I ordered a cheese-and-spinach omelette, which, when the waiter brought it to me, looked rather dry. I asked for some ketchup. When the waiter returned with a pat of butter, I asked, 'Is this the ketchup?' He made a comic gesture, spread out his hands and rolled his eyes.

After lunch I went back to my bedroom. I hoped I might sleep.

My bedroom window has only an oblique view onto the ocean beyond the hotel car park, but I am aware of it as a constant presence. It has a mirage-like quality, quivering, an

intimation of light across the expanse of sand. It suggests to me the vastness of nature, of the universe. On this first afternoon I watched, from my bed, the tiny figures on the beach, black shapes like cloves with vestigial arms and legs, silhouetted against the shining strip of water. One figure walked more slowly, pacing backwards and forwards on the shoreline, trailing a black billowing cloak. It reminded me of the figure of Death in a film called *The Seventh Seal* by a film-maker that I think you would like, Ingmar Bergman.

As the evening light intensified into a final flaring, I decided to venture out again. I hadn't been able to sleep. The child was still screaming in the next room. Outside there was a clarity to the light that was quite different from anything I had experienced in England, where there is always a blurred halo around every form. Here, it was as if some lens had been wiped clean and every outline was distinct. I felt closer to the outer air and the stars. Sounds travelled more keenly too. Three boys were calling to each other and their voices were without echo. I walked along the water's edge. The waves on this ocean followed each other in straight uninterrupted lines, no unruly over-spilling before the whole straight, unbroken wave came cleanly down onto the shore, which stretched in both directions as far as the eye could see. The foam trimmed the water's edge and clung neatly to it, never flooding too far into the sand. There was a clear demarcation between land and water.

Now, when I look out of the window, I see that the weather has changed. A thin rain is falling steadily. I have arranged for a car to collect me from my hotel and drive me to the Getty

Villa, which is situated further along the coastline. The driver of the car is an elderly man who alarms me by fiddling constantly with switches and knobs on the dashboard. I don't understand what he is searching for. I realise, with dismay, that he is trying to locate the windscreen wipers. The glass is becoming opaque with rain. Eventually he manages to turn the correct switch and the view opens up to reveal a heaving ocean, to the left of the highway, lit by a brooding sky. The museum stands on a hill surrounded by towering pine trees. I get out of the car. I arranged for the driver to wait for me. I breathe in the air, which is saturated with pine and herbs from the immaculate herb gardens. The fragrant rows of thyme and sage and marjoram are punctuated with pools filled with ornamental fish.

Inside the Getty Villa are ancient statues and paintings from Greece and Rome. They seem like captive spirits waiting to be freed from their cages of stone and paint. I cry in front of a battered stone carving of the face of a woman, titled *Elderly Woman*, still beautiful in her endurance: she has a peaceful air as though she is saying that 'all will be well', despite the ravages of time. She is probably only in her mid-fifties, younger than me.

I am terrified of ageing. You only lived to be sixty-three. I dread real old age. I am fifty-nine. I think of my mother and all the pain she suffered towards the end, and then the dementia that gradually carried her off into an unreachable place until her death, aged eighty-seven.

I think of the unfinished sculpture Rodin did of you. It

must have been a very difficult pose to keep, with one leg raised onto a plinth, your neck stretched out and your lowered head tilted at an angle. You look as if you are consciously being patient, like an animal lowering its humble head so that its master can put the harness over it. You were in your late twenties then.

I return to the car, and the driver takes me down the hill, away from the museum, along a winding road bordered by immense trees, to a restaurant built on a pier that stretches out into the ocean. I stand by the railings looking out across the water; the waves are crashing against the stilts of the terrace. I could reach down and touch the water with my hand. I need to stand here and look at the steady breathing of the waves, without even thinking, so that the disturbance in my heart can subside.

I am back in my hotel room now. I have just had my first cup of tea. Again I didn't sleep. It is my last day in America, and my flight to London leaves this afternoon. I will need to pack and prepare, so I will have to finish this letter now, dearest. I will write to you again when I'm home.

With a handshake (as Vincent van Gogh used to say, when signing off a letter to his beloved brother, Theo),

Celia

Written from an aeroplane, 14–15 February 2019

Dear Gwen,

I couldn't wait until my return to London to write to you again. I am excited that I have begun to communicate with you and don't want there to be a pause just now. I am sitting by a window in the aeroplane and we have been flying over Canada for what seems like an impossibly long time. I only know it's Canada because I asked the kind American lady sitting next to me. She told me that she regularly flies between Los Angeles and London. The reassurance of her presence is a direct contrast to the strange, unpeopled landscape spread out beneath me – colourless amoeba-like forms interlocking and separating, like no landscape I have ever seen. I wonder what you would make of it? This taste of adventure, this experience of being away from home for such a short while, in a different time zone, has made me think about time and memory. The plane will soon be heading east – it suddenly feels as if we will begin hurtling backwards in time towards the past. I start to think about my own past, my childhood, and how it compares with yours.

My childhood had similarities to yours. My earliest memories are of brightness and freedom. I was in love with my mother, as you were with yours. My father was always a remote

presence to me and I sensed that he found children, little girls especially, irritating. I loved nature passionately. In India we had a rich, lush garden and I scrutinised every bush and flower and shrub as if my life depended upon the intensity of my observation. When we returned to England, when I was five years old, to live first of all in a Victorian terraced house, very similar to your two childhood homes in Haverfordwest and Tenby, I felt that my world was closing in on itself, and that everything natural and free had been taken away from me.

In India, our garden was intensely full of life. Our house sat in the garden like a ship in a surging ocean. The shadows under the trees were blackish-purple, the unshaded grass burned my feet as I walked on it. The open areas between the bushes and trees were dazzling and hurt my eyes. I preferred to be in the shade. The scratching of insects in the dry leaves, the birds screeching and cawing, sinister rustling in the undergrowth. Could it be a snake? A feeling of danger everywhere. Beauty, too. The changing rose that began the day pure white slowly became first a delicate opalescent pink by mid-morning, then carmine by noon, deepening and darkening until by the last light it glowed a crimson ember. Its scent was like guava. The moonflowers were its opposite. They glimmered with a spectral, cool light. Their flowers were trumpet-shaped and the stems and tendrils were fine as thread. The plant had been trained to creep up the wall by the kitchen door.

I used to sit quietly by myself on the stone veranda in the shade of a water tank and watch the garden and listen to the sounds it made.

One of my earliest memories is of my mother walking in front of me. She moved away from the house into the dark shade. I followed her. The ground sloped into a dank hollow. Huge trees towered above it. I was afraid of everything. The undergrowth teemed with biting insects and there were tree-snakes hiding in the overhanging branches of the jackfruit trees. My mother was wearing a loose dress patterned with flowers. Her body was big because she was expecting another child. I would no longer be the baby of the family. She had a preoccupied, irritable air. She was feeling tired and uncomfortably hot. She was making her way up from the hollow and moving slowly into the denser foliage of the wood. I was struggling to follow her. She didn't wait for me and she didn't turn round to look at me.

When we arrived in England, we stayed in a house in Southsea owned by an elderly lady who rented her house out to missionaries on leave. The contrast with what we had left behind was stark. The house formed part of a Victorian terrace in a quiet tree-lined avenue. There was a small walled garden at the back of the house, which adjoined a nearly identical garden belonging to the house behind ours. If you looked out of any window, there would be another window looking back at you. The rooms were crammed with heavy furniture. The windows had a double layer of net over them and heavy brocade curtains hung on either side. A fusty smell permeated all the rooms, which were very dark.

This was the first time my mother had had to do any cooking or housework and she found the challenge too much for

her. The stove and utensils became black and greasy, and the dust piled up in corners and under the furniture. She was permanently exhausted and suffered from headaches. Some evenings after supper she would say that she needed to be alone. Of course this just made us clamour for her even more, until she announced that she was going to do the washing up and that we could help her. She knew this would work to get rid of us, and we rushed out of the kitchen into the sitting room across the corridor.

One evening I glimpsed my mother through the half-open door of the kitchen. She wasn't doing the washing up at all! She was sitting in a chair next to the grease-smeared oven, smoking a cigarette. She drew on the cigarette, dreamily narrowing her eyes, and then, with her full lips parted, she gently breathed out the smoke. I felt unbearably disturbed by the sight. I felt as betrayed as if she were my lover and I had caught her out, kissing a man. I made a terrible scene and became hysterical. From then on she became very secretive about her occasional cigarettes, and her secrecy only increased my jealousy. I would suspiciously smell her breath when she kissed me goodnight. If I detected the smell of smoke on her lips, I cried uncontrollably and nothing could calm me unless she vowed never to smoke again. She did vow, but only to placate me. I sensed that she wasn't serious and I was troubled by my lack of power over her.

When I was eleven we moved to Lee Abbey on the North Devon coast – a religious community where my father was the warden. It was there that I became an artist. I was inspired by

the beauty of the surroundings and by the sea, just as you had been. We ate our meals with the community. I was sent to an all-girls boarding school. I had no privacy, either at home or at school. Art became my way of guarding and controlling my inner life against all intrusion. My early paintings from nature are what got me into The Slade.

My neighbour, in the seat next to me, has been trying to catch my attention. The staff are soon going to bring us our supper and I should unfold the little table fixed to the seat in front of me, in preparation. We smile at each other, my neighbour and I, but we don't enter into conversation. She attaches some headphones to her ears and starts to watch a film on the screen in front of her. After supper, the passengers prepare for sleep by placing the provided blindfolds over their eyes. There is silence. I look out of the window and witness the immensity of space, unknown territories and darkness. I will shut my eyes. When the daylight returns I'll be nearly home. I will write to you again soon.

 With a handshake,
 Celia

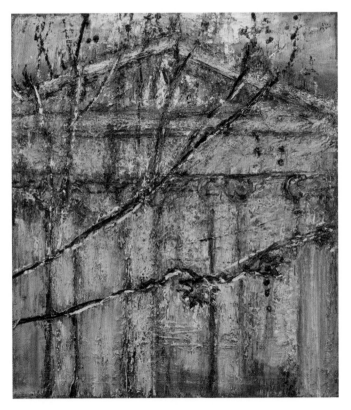

Celia Paul, *British Museum and Plane Tree Branches*, 2020

Celia Paul, *St George's Bloomsbury, Bright Spring*, 2020

Great Russell Street, 21 February 2019

Dear Gwen,

I am home again now, in my studio, which is also my flat where I live, in central London. I have uploaded photographs of Santa Monica onto my computer: the ocean, the silhouette of my hotel, palm trees, mountains, all lit up like fever dreams. They appear on the screen like visions from another world.

If I turn my head to the left, away from the computer, and look out of my kitchen window, I see wet roofs and a slate-grey sky and, in the near distance, the spire of St George's, Bloomsbury.

This part of London is a place you know well. You ran away from it.

Bloomsbury has a specific mood. I don't think it can have changed much since you were last here. There is a painting by the Danish painter Vilhelm Hammershøi of the British Museum, dated 1906, soon after you had left London for Paris. If I look out of my studio window, to the right, I can see the plane tree, gnarled and massive now, depicted by Hammershøi as a frail sapling guarded by a wooden fence.

Hammershøi's British Museum is seen from a westerly position and differs from my paintings in that I always paint the

full-face pediment, because that is the direct view I have of it from my window. Everything in Hammershøi's painting is grey, everything luminous – the water-reflecting clouds, the grandeur and melancholy. Looking out of my window now, on this grey rainy day, the light is the same. The solidly squared buildings, which look as though they were made of a rock more enduring than granite, the black railings pointed like Egyptian spears: all would be familiar to you.

There is an eerie feeling to the paintings by Hammershøi of these streets and houses in Bloomsbury, almost as if he has come back from the dead to record the site of some secret dark crime. He painted every brick, every branch, with forensic precision. The streets are deserted. Only the dead live here.

I think about the suggestion of a smile hovering on the faces of the Egyptian statues in the British Museum, more mysterious than the smile of the Mona Lisa. You studied the Greek sculptures: did you also look at these? I prefer Egyptian sculpture to Greek because it is more interior, apparently carved by the silence of the surrounding desert; Greek sculpture seems more of a performance for a human audience. You must have visited the British Museum often. If, on leaving, you had looked up, you would have seen my window towards the top of the building directly facing you. It was a hotel then – the Thackeray Hotel – where your lover, Rodin, stayed once when he wanted to make studies of the Elgin Marbles in the British Museum. I don't think you visited him here. Perhaps you will visit me.

Someone has just rung the doorbell. I had a sudden other-worldly sensation that I conjured you up by my words!

Until soon!

With a handshake,

Celia

In 1894 Augustus John left the family home in Tenby to go to The Slade. Gwen remained, with her father and sister. She went for long cycle rides, gathering flowers from the beautiful hedgerows, which she took home to draw in her attic bedroom. She spent long days on the beach, drawing and painting the water and the sand and the people strolling along the shore. She made studies of shells and rocks and seabirds. She wanted to build up a portfolio so that she could join Augustus at The Slade. A year later she was accepted.

The first part of the course involved drawing from the 'Antique': plaster casts of heads and figures in Classical poses. When Gwen completed these studies, she had to work from life. She never had any problem with drawing. It all came naturally to her.

Gwen's early drawings are intuitive and free whilst at the same time being very precise. They remind me of drawings by David Hockney, who shares her ability to capture a likeness and the dimensions of the form in a minimal but wholly realised way. Her brother was limited in comparison: his drawings were brilliant, but tight with self-consciousness and preconceived thought. He needed to present his drawing to an audience in order to get a reaction.

Gwen's pencil drawing of her sister (who had briefly joined Gwen and Augustus in London), titled *Portrait of Winifred John*, is masterly in the economy and sureness of the marks, made to capture a living likeness: the sweep of her hair over her brow, the raised composure of her eyebrows, the dreamy, self-contained look in her eyes and three pencil lines for her lips suggest all we need to know about her quiet strength.

Winifred was a violinist. She had arrived in London with her friend Grace Westray to study music. Gwen did a painting titled *Young Woman with a Violin*. She used Grace as her model. The painting is accomplished in its technique. There is nothing in it that is naïve, primitive or searching. The coat and hat hang from the door to the right of the composition, and we can tell from the fall of the cloth the exact weight and texture of the material. The girl's fingers on the strings of the violin and the hand holding the bow are represented with ease. The tilt of her head as it rests on the instrument is as precisely observed as the way the light jewels the fretwork of the wicker basket to her right and the lines of the wainscoting on the wall behind her. Everything is given the same scrutiny – there is no part of the composition that is heightened, to draw the viewer's attention away from any insufficiency in the structure of the dimensions or handling of the space. I wonder how Gwen acquired such facility? Was it the early teaching from her mother? Did she worry that she didn't need to struggle? Was that one of the reasons why she left England for France – so that she would be out of her depth?

She was always prepared for a challenge. In the spring of

1899, while on holiday with Augustus in Swanage, during her time at The Slade, she described to Michel Salaman an experience she'd had while swimming:

> I bathe in a natural bath, three miles away, the rocks are treacherous there, and the sea unfathomable. My bath is so deep I cannot dive to the bottom, and I can swim in it – but there is no delicious danger about it, so yesterday I sat on the edge of the rock to see what would happen – and a great wave came and rolled me over and over – which was humiliating and *very* painful, and then it washed me out to sea – and that was terrifying – but I was washed up again.

Gwen was very confident. She was commended for her ability in both drawing and painting. She was never referred to as a genius, though her brother was soon regarded as such. She was one of a number of talented female students who appeared to have been treated with no outright prejudice by their male tutors. There is a particular 'Englishness' in the way these tutors related to the women they taught, however. They were gallant, so that everyone said what nice men they were, but there was always an edge of patronage. Gwen's teacher in drawing was Henry Tonks. On one occasion he reprimanded a young woman student, 'Your paper is crooked, your pencil is blunt, your donkey wobbles, you are sitting in your own light, your drawing is atrocious. And now you are crying and you haven't got a handkerchief.'

Gwen had various lodgings when she was studying at The Slade but, more often than not, she shared accommodation with her brother and several mutual friends. She had a lot of close friends, mainly women: Mary Constance Lloyd, Chloë and Grilda Boughton-Leigh, Edna Waugh, Gwen Salmond, Ida Nettleship, Ursula Tyrwhitt. Augustus commented that the women at The Slade 'abounded in talented and highly ornamental girl students; the men cut a shabbier figure and seemed far less gifted'.

One of the places Gwen shared with Augustus was in Fitzroy Street. She painted *Portrait Group* here. It is reminiscent of a painting by Michael Andrews, dated 1962 and titled *The Colony Room*, in which the painter has portrayed an artistic clique, his friends who used to gather together in the Soho drinking club of that name: Francis Bacon, Lucian Freud, Bruce Bernard. Michael Andrews had been a student at The Slade in the early 1950s; he had been taught by William Coldstream and Lucian Freud. Gwen's painting depicts a similar group of bohemian artists: her friends from The Slade in the late 1890s. Augustus stands to the right of the dark fireplace, his straw hat shading his face and one hand held up to his throat, self-consciously adjusting his tie. Gwen Salmond is on the left of the composition. She looks like the Angel Gabriel in an annunciation. She is almost flying into the room and seems to be bearing glad tidings to the group of people huddled on the right-hand side of the painting. Next to Augustus are Winifred in a seated position and Michel Salaman, with whom Gwen had been briefly in love. She portrays herself walking freely

outside the window with her new beau, Ambrose McEvoy. The curtain blows out into the room, suggesting a summer breeze: she wanted light and air. She didn't want to be cooped up inside with her brother and his coterie of gossipy arty friends.

Portrait Group is painted in watercolour and gouache. Gwen has not yet developed the technique that she learned from Rodin of using flat washes of watercolour laid over free pencil lines. This painting is tightly illustrative and entertaining – the nearest she ever came to doing anything that resembled her brother's narrative style. He was a brilliant draughtsman but his figures always strike a pose, acting out an emotion rather than suggesting it through psychologically acute observation. Gwen shared this preference for clear observation, over story-telling, with her drawing tutor Henry Tonks, who defended his own method of working against the Post-Impressionists: the French painters Manet, Van Gogh and Gauguin, as championed by Roger Fry in Britain:

> Why I hate Post Impressionism or any form of subjectivity is because they, its followers, do not see that it is only possible to explain the spirit . . . by the things of the world, so that the painting of an old mackintosh (I don't pretend to explain how) very carefully and realistically wrought, may be much more spiritual than an abstract landscape. There is no short cut to poetry . . .

The importance given to painting strictly from observation, and not from the imagination, formed the basis of the

doctrine that was the guiding principle for the painters known as the Euston Road School, founded in 1937 by William Coldstream, Victor Pasmore and Claude Rogers. Coldstream had recently retired as Slade Professor when I arrived at The Slade in 1976, but his successor, Lawrence Gowing, was steeped in the Euston Road discipline, which also influenced the other tutors, Euan Uglow and Patrick George; all shared the maxim that one must always work directly from life. These were the painters who taught me at The Slade.

William Coldstream continued to spend a lot of his time at The Slade after his retirement. He exclaimed to me once that he needed to rid himself of 'this Expressionist filth'. The moral purity of this doctrine inspired in me a sort of dread. I preferred what Gaugin said: 'Do not copy nature . . . bring your art forth by dreaming in front of her'. I wanted to use the seen world as my springboard for invention. I didn't want to be tied to the apron strings of 'the real' by pedantically copying what was in front of me. Coldstream is a great painter and although he followed this existential rule, it only served to make his paintings more poignant: his figures breathe with nervous inner lives despite, or because of, the constraints of the tiny red crosses that he used to measure the proportions of the forms.

I hated it at The Slade. I hated the catacomb-like corridors and the dark studios. No daylight penetrated. The Slade is part of University College and is dwarfed by institutional buildings on all sides. The studio rooms backed on to taller buildings that cut out the light. Electric light bulbs in cracked shades

hung from the immensely high ceilings, and strips of lighting buzzed with a perpetual whining sound – but they did nothing to dispel the gloom.

I was taught life drawing by Patrick George in the F studios (F stood for Figurative – as opposed to Abstract). During the first year at The Slade the students studied Figurative art in the first term, Abstract art in the second and Conceptual art in the third. You then had to choose which area to focus on for the remainder of your studies. I chose Figurative art. I wanted to learn a discipline, so that I could decide how I could break the rules to suit my own vision.

The first life model I drew from was called Sandra. Patrick George introduced her to us and told her that he thought she was very beautiful. There was nothing lascivious in his praise; he wanted to reassure her and put her at her ease, because he was an English gentleman. Sandra was sitting on a hard chair in the middle of the room. George pointed out to us that Sandra had a mole on her cheek and that we should use that as the point by which we measured all her proportions. We should draw a little cross where her mole was, on the paper pinned to drawing boards supported on easels in front of us; and we should hold out our pencils at arm's length while scrutinising the distance between her face and the top of her arms, nipples, stomach, thighs and feet, and should make corresponding crosses on the paper. Then we should join up the crosses. If we had measured it all correctly, we should end up with an accurate representation of the model, with all the proportions exactly as they should be.

I was puzzled. What was Sandra to me – or me to Sandra – that I should work from her? My drawings were very bad. I realised that I needed to work from someone I loved. I started to draw my mother and I knew instantly that this was what I wanted. I continued to draw the life model at The Slade, but my drawings were always inhibited by the artificiality of the relationship.

When Lucian Freud arrived at the Slade as a visiting tutor, I felt a connection to him from the start. He worked from people he knew well: his daughters, his lovers and, most significantly for me, he worked from his mother. He didn't rely on the services of a life model, even though he, too, worked strictly from direct observation. It was freeing to be with him for this reason. I could put life classes at The Slade behind me.

I think Gwen experienced a similar sense of liberation when she settled permanently in France and met Auguste Rodin.

Augustus worried about her when she was living far from him; he thought she neglected herself and needed to be taken care of; but when he tried to persuade her to return to live near him in London, she responded vehemently, 'If to "return to life" is to live as I did in London, merci Monsieur! There are people like plants who cannot flourish in the cold, and I want to flourish.'

Celia Paul, *Kate Pregnant*, 1995

Great Russell Street, 22 February 2019

Dear Gwen

I was looking at a book of paintings by you just now. I turned to the catalogue at the back. The first reference is to an oil painting of your sister Winifred, titled *Portrait of Winifred* and 'probably painted in 1895'. The text goes on to say that Winifred became a violin teacher in California, where she married a violin pupil of hers named Victor L. Shute.

I think about how much you must have yearned for her – for Winifred. I don't know how I could live if my sister Kate emigrated so far away from me.

I think of my recent trip to California. Winifred must have been very courageous to travel so far from home. She must have felt very alone. She must have missed you and worried about you.

Soon after my return from Los Angeles, I prepared my canvases for two new seascapes. I hadn't made studies of the sea while I was there, but the light – the particular visionary light – haunted my imagination.

I made a ground of Payne's Grey, Vandyck Brown and Naples Yellow by squeezing these colours onto my canvases. I then tipped on Sansodor, an odourless paint-thinner, which I'd begun to use as a replacement for turps.

Until a few years ago, when I opened the door to my flat the smell of turps, on entering, used to be overpowering. Everyone commented on it. I loved the smell. All my clothes and my hair were saturated with its pungency. I wore the scent with pride, like a saint revelling in her hair shirt. If I lit candles in my front room in the evening, their flames would shoot up towards the ceiling, fuelled by the gaseous fumes. But gradually I found it harder to tolerate and it became difficult to breathe. I had constant sinus pain and headaches. I had to give it up.

I think I used more turps than you did. I poured quantities of it over my paintings if I felt they were becoming too tight or illustrative. Often a new image would rise up miraculously from the resultant drips and disordered paint marks. Something that I could never have foreseen, if I had been controlling the depiction of an image.

But you always had your own delicate disorder: a dress thrown over the arm of a chair, a brown shawl slipping from your shoulders. You had an instinct for ordered haphazardness. In your garden you would have let the weeds grow naturally among the flowers, though you would have tended your garden to make sure the weeds didn't choke the other plants. You would have grown lavender and alyssum in the borders. And violets, your favourite flowers.

My garden, if I had one, would be less well tended than yours, though I would be more adventurous, both in the plants I chose to grow and in the design. I would import exotic flowers from India to remind myself of my childhood, and I would

introduce various water features: pools and streams. But I wouldn't worry if everything gradually became overgrown.

In preparing my canvases, I shift the paint, drenched in Sansodor, around the canvases, using whatever ragged scraps of material come first to hand, so that the whole surface is equally covered in luminous grey-brown. Every item that strays into my studio, every bath towel, eventually becomes a paint rag.

I need to leave the canvases to dry now.

The first marks I make on the canvas suggest movement: the horizontal lines of the waves, the upward lift of the sky, the red and gold clouds breezing towards the top right-hand corner and beyond. The sunset of the evening of my arrival in Los Angeles is in my mind, but I am not working from memory. I am a slave to the demands the painting is already making on me. The sound of the waves is in my mind, too. My paint marks weave in this movement so that, when I step back from the canvas, I can see that the water is beginning to have a life of its own, quivering and shifting, the longer I look at it.

The painting comes about very easily and freely. I am still energised by the newness of my recent experience in America and some of this wonder makes its way into the painting, which I title simply *Santa Monica*.

As soon as I have finished it, I start on the second canvas. The over-clouded gauzy light of my third day in California is what I want to convey now. The sky broods, hiding a blazing sun, which remains concealed. The painting builds up like a covered pot of milk on a stove, boiling over when the waves

break onto the shore in a luminous, frothing band of bright white light. I title this one *Breaking, Santa Monica*.

I would love to know your opinion of my sea paintings, because I know how much the sea meant to you. Pembrokeshire and Brittany were the coasts that you spent most time on. Your memories of the sea were filled with a bracing wind, the horizon meandering as if warped by the waves and the wind. There were no straight lines, as there are between the sea and the shore in California. You would have to understand that, when you looked at my paintings.

I am suddenly tired, dearest. I will write again soon.

With a handshake,

Celia

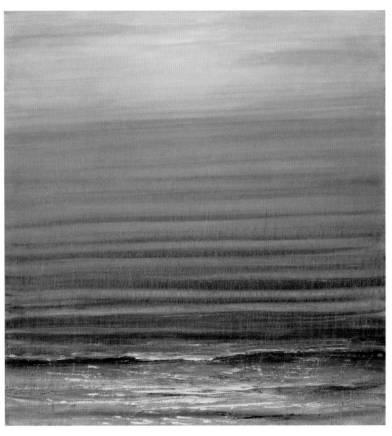

Celia Paul, *Breaking, Santa Monica*, 2019

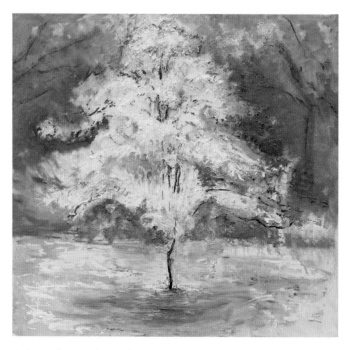

Celia Paul, *Hawthorn Blossom Tree*, 2019

Great Russell Street, 30 April 2019

Dear Gwen,

It is the most beautiful spring here, in London, and I have never seen the trees so laden with blossom. I go for walks on Hampstead Heath. I am searching for a hawthorn tree to make studies of, for a painting.

The blossoming white hawthorn stands in the clearing of a densely wooded part of the Heath. It is a dancer mid-curtsey. It was what I have been looking for. It stands in its own flood-lit area and the other trees watch over it from a distance.

In my studio in London I re-create it in paint. I want it to be about beauty and joy and anticipation. I render it delicate, but lavish, bridal. I am thinking of the Thomas Hardy poem 'Timing Her', which has the opening words 'Lalage's coming'. The building up of excitement and then 'Yes, she is here now.' The last lines 'Nothing to fear now / Here's Lalage'.

The poet T.S. Eliot, whose poems would be important to you, I know, was right in describing April as the cruellest month, 'stirring / Dull roots with spring rain'. I have been feeling torn apart by two conflicting emotions – as Eliot puts it, 'Memory and desire'.

I have been thinking about the past. About the times when my son stayed with me during the holidays, and on exeats

when he was at secondary school. Twenty years ago now, but still vividly alive in my memory. I made no concessions to domestic comfort. We guzzled down impromptu meals from plates that were propped precariously on any available surface. He would lie on the bed in my front room while I lay on my chaise longue. We didn't speak much, though sometimes he opened up and told me about his feelings and his friendships. More often we wouldn't speak, and he would find some music on his computer to play to me.

I had written in black ink 'NO ENTRY' on my studio door. The ink had dripped in a straight line down from the vertical back of the letter E. I hadn't written this notice for him – he knew too well that rule – but for my own peace of mind.

When my son was in his later teens, he was very angry with me. If he stayed in my flat during his school holidays, he wouldn't speak and he hid behind his long hair, the fringe hanging over his eyes. He made it clear that he needed absolute privacy, so I fixed a hook onto the inside of his bedroom door so that he could fasten himself in, without fear of my intrusion. I would leave his meals outside his room to collect when he was hungry.

I had arranged for him to go to boarding school, which he hated. He was very unhappy. He had been living with my mother since babyhood, but she felt she could no longer cope.

I grieved for the child who had hugged me and had told me that he loved me.

Even though the main reason he couldn't live with me was because I needed to be alone to work, I was still unable to,

because I was paralysed by guilt and anxiety about him. My painting became turgid and overstrained and blocked.

There is a film by a Russian film-maker that you would love, Gwen: his name is Tarkovsky. The film is titled *Mirror*.

It opens with close-up shots of a young man with his speech therapist, a woman. The young man suffers from a debilitating stammer, which the therapist is helping to cure. She is very persistent. It is painful to watch, and it pains me to think of this scene. The young man keeps shaking his long fringe from his eyes at each failed attempt to speak. He is tormented by self-consciousness. After every shake of his head he gives the woman a shy look – a look of resolve – and then he looks away. She is very self-satisfied. She puts her finger on his forehead and draws him to her by an invisible thread. He nearly loses his balance as he leans towards her. She then puts her hand on the back of his head. She commands him to stretch out his fingers and to channel all his tension into his hands. There is a long silence and then she shouts at him, urging him to speak. They are physically close to each other, their heads almost touching. He watches her relentless lips mouthing instruc-tions. At last he manages to utter consecutive words – he almost roars them. The overwhelming power of this emer-gence into sense is followed by a divinely ordered passage of music by Bach.

In the next scene, all is quiet. The camera comes to rest on a woman sitting on a fence outside her isolated house, sur-rounded by pine trees and undergrowth, the leaves of which are stirred by a soundless breeze. She is smoking a cigarette.

Her two little sons are playing silently inside the house. They are her only companions.

One of the sons will grow up to be the young man who couldn't speak. Until his tongue is set free.

My son found that he had a gift for languages. After leaving school, and before going to university, he travelled to Russia alone. I went with him to the airport. When I saw the Moscow plane flying over me in the airport car park, it felt like some angel of death had spirited him away. I wouldn't see him again for nearly a year.

Before leaving, he had compiled some of his favourite music, which he'd recorded onto a cassette tape for me as a parting gift. When, later in my flat, I listened to the songs, so full of feeling, so full of love, my heart ached for him.

It is still aching for him, even though he is now happily married with two children. He is openly affectionate to me and we are close, though he never hugs me.

He is an artist, too, and a writer.

Yesterday I went to the National Gallery. I wanted to see the Mantegna *Madonna and Child*, but it was impossible to see it properly because a crowd of people were standing in front of it, listening obediently to their guide.

I went into the room where the painting of St Catherine by Raphael caught my attention. The drapery flows around her body and accentuates its lavish curves, while her sensual face looks heavenwards. I stood for a long time in front of it.

I then studied the nativity scene by Piero della Francesca on

the opposite wall. I thought about the atmosphere of desolation, the loneliness and vulnerability of the Christ Child lying on the ground on the unfolded skirt of his mother's cloak, and separate from her, prey to the carrion magpie on the roof of the stable (one for sorrow) and to all the dangers and conflicts of the world. The burnt shrubs on the stony ground add to the bleakness.

I looked at the tiny *Virgin and Child in an Interior* by a follower of Robert Campin, which I have always loved. I have done my own versions of this painting. For me, it signifies the perfect unity of a mother and child before the pain of separation. A little fire is glowing in the grate and all is warmth and love and tenderness. Even their lips are touching.

It is a complete contrast to *Christ Crucified* by Antonello da Messina in the next room. Mary and St John are seated on the ground to the left and right of the base of an impossibly tall cross, and separated by it from their beloved Christ, who is pinned agonisingly to the high summit: he is unreachable. He will remain unreachable.

When you were in your last years of life, around the same age as I am now, you had many infatuations: Jeanne Robert Foster, Canon Piermé and an unnamed man with whom you were in love, and whom you wrote about in your notebook. I'd like to talk to you about them some time. It's impossible to believe, isn't it, that if one is over-mastered by the most powerful emotions, the object of our desire doesn't reciprocate our feelings? You showered your idol, Véra Oumançoff with the precious gifts of your drawings and watercolours, even though you

beseeched her most plaintively to listen to you, to spend more time with you. You stood outside in the street, looking up at her window, where you knew she could see you waiting. And then you hid around the corner until she came outside. You ran up to her, calling and crying out, 'Why have you not written to me, or communicated with me?' Your passion made you reckless.

When you were still a young woman you had disciplined yourself. You castigated yourself for being so shameless and wanton.

Is this why you signed your letters to Rodin 'Mary'? So that the wafts of incense floating in front of your holy face could act as a smokescreen to hide your shocking desire? He called you 'Marie' and told you that you reminded him of his beloved sister who had died when she was in her twenties, about the same age as you: a quiet, gentle girl called Marie. He called you 'Ma petite soeur'.

You went back to your attic room in Paris. You seated yourself in front of the mirror, which you had placed so that it faced outwards across the bed that had been pushed against the wall by the window frame. You were dressed in a pale-blue shirt and moth-grey skirt. You folded your hands in your lap and tilted your head. You painted yourself in this position. You gave yourself a discreet halo, just discernible against the bright light coming through the window behind your head.

When you had finished this painting, you started another. You opened the window onto the still blue morning. The interior was lit with gold. A book was open on the table

underneath the window. Its pages unfolded like the wings of a dove. The delicate fretwork of your wicker chair glimmered with light. Your abandoned dress had been flung over the arm of the chair. You were glad to be alone. You had no needs. Everything you ever wanted was contained within this quiet space.

I had a visitor the other day. I showed him my paintings. He photographed me in front of them. I watched him. I saw him framed in the long mirror of my studio. It suddenly seemed strange to me to see him here, in this very private space. I never let anyone into my studio unless they are sitting for me, in my normal routine. His beautiful mirror-image had a super-natural quality. Lucian had bought me the mirror from an antique shop in Notting Hill. The glass is set into a door identified as such by the keyhole still visible, the wood around it carved with fleurs-de-lys.

I showed him the painting of my sister Lucy. She had sat in the dark corner of my studio and the blinds had been drawn up, so that she could see the sky and the uppermost branches of the plane tree outside in Great Russell Street. She had watched the clouds above the pediment of the British Museum. Her head was at an angle towards the window, so that her right eye was lit up like a dazzling area of water reflecting a sudden shaft of sunlight from behind a cloud.

I showed him the second of my Californian seascapes, the one I titled *Breaking, Santa Monica*. He said that it made him think of Agnes Martin's paintings. If you had lived to see her

work, you would understand how flattered I was by this; you would have felt a deep affinity with her art: the stillness and the quiet mystery.

I showed him the frothing white blossom on my hawthorn tree, the white and cream paint marks standing out in sculpted whorls from the thinner washes of green and blue-grey.

When it was time for him to leave, to make his journey home, I accompanied him down the stairs. As we came out of the front door and onto the street, a taxi was just approaching. I hailed it and he kissed me hurriedly on the cheek and then climbed inside. He didn't turn round to wave to me. I watched the taxi drive away in a westerly direction.

I went back to my space, which seemed empty now, in a way it hadn't done before. The emptiness had always seemed full of promise and possibilities. Now it seemed echoing with loneliness.

I lay down on my chaise longue and turned my face to the wall.

You wrote in your notebook on 30 August 1922:

Turn gently towards your work.

Instead of this sudden discouragement and sadness take up in your mind a leaf, a flower, a simple little form and find its form, take it into your possession as it were . . .

Every day may add to your possessions – every flower and leaf and other things may be taken possession of as it were.

Today I think I saw you, didn't I? We passed each other near the fountain in Russell Square. You had seen me first. When I looked up and caught your gaze, your eyes were very blue. They filled with tears when I smiled at you in recognition.

I am never quite sure when you are going to appear to me. People say that if you long to see someone, you mistake them for the most unlikely people, with no obvious resemblance to the beloved face. But on this occasion I was almost sure it was you.

I feel comforted for having seen you today.

You wrote to Jeanne Robert Foster on 20 February 1924, 'I was distressed that morning at saying goodbye to you in the taxi and I missed you very much for a long time. But when you made no sign for such a long time I stopped thinking about you.'

I watched you walking out of the gates and into Southampton Row. You didn't look back. You carried yourself very upright, in your close-fitting dark jacket and long dark skirt.

I stood by the fountain. Three children were playing in the water, lifting up their faces to the jets of water and screaming with pleasure.

I watched them for a long while, and then I turned in the opposite direction to the one you had left by.

The light is fading now and I need to get back to my painting.

With a handshake,

Celia

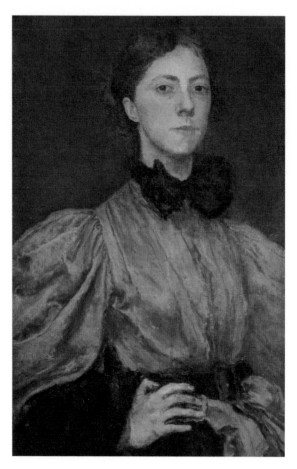

Gwen John, *Self-Portrait*, 1900

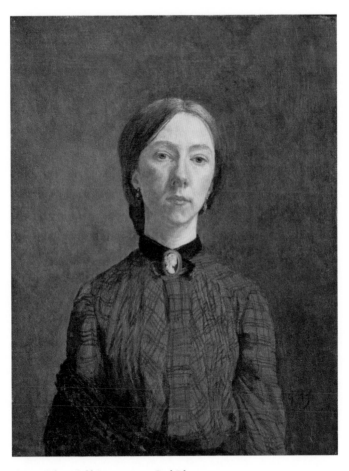

Gwen John, *Self-Portrait in a Red Blouse*, 1902

It makes me sad to read the letter Gwen John wrote to Auguste Rodin on 28 March 1912: 'Mon Maître, You asked me to remind you from time to time that the arms of my statue are unfinished. I'm much better now, my Master, and I can work for you if you like.'

Not long before he met her, Rodin had been commissioned to make a sculptural tribute to James McNeill Whistler. He decided to use Gwen as the model for 'a Venus climbing the mountain of fame'. In this unfinished sculpture Gwen looks as though she is bearing an invisible weight on her shoulders. She is bowed down under it. However much her master might beat her, poor beast of burden, she will never reach the summit of the mountain of fame. She will be bound, like Sisyphus, to her load, which will always roll back down to where she started. She is without words to convey that the peak is not her aim, and that she doesn't need any pity. She is delighted to submit to her fate and would fiercely reject any help to relieve her of any fraction of the weight she is carrying.

She had left one famous artist – her brother – to find herself with another. Auguste Rodin felt like family to her. He had the same name as her brother. She felt safe with

him. He had employed her as his model and they soon became lovers.

In her search for modelling jobs Gwen had had strange encounters with male artists. A landscape painter she came across caressed her breasts. He said that he wanted to see if she was 'bien développée' ('well-developed'). She couldn't understand why, as a painter of landscapes, he needed to know that. He had underestimated her strength. She easily brushed him away.

She escaped many perilous situations. She slept outside in the Jardin du Luxembourg and woke to find a circle of concerned onlookers gathered around her. She described to her friends the lonely men who approached her in the streets as 'les mauvais sujets' (bad characters). She didn't let her fear inhibit her. She had deliberately cut herself adrift from her home and family because she sensed that to make great art, she needed to be solitary. Rodin symbolised home and family; he also left her alone to be herself.

There is a *Self-Portrait* by Gwen John in the National Portrait Gallery. She painted it before she had met Rodin. It is full of assurance. She is at ease with her own body and with her place in the world. Her gaze is directed unabashedly at the viewer. Her hand is placed, almost swaggeringly, on her hip, and her fingers are nearly touching the masculine buckle of her belt. A florid bow, shamelessly flamboyant, is tied around her throat.

If she had continued to paint in this way – if she had carried on living within the benevolent shadow of her brother, who

always encouraged her and included her – Gwen would have been easily successful. She would naturally have been accepted by the New English Art Club, the recently established arts society of which Augustus was a member; she would have been patted on the back, and she would have won prizes. The establishment would have understood her art and felt safe with it. Her brother would have been very pleased for her and proud of his spirited sister. He was concerned for her. He remembered how, as a child, the loss of their mother had left her speechless with grief, and that Gwen had been driven inwards by her emotion and had withheld herself from him. He needed her and loved her. This new Gwen – the Slade Gwen, with her vigorous nature – was a relief to him.

The *Self-Portrait* that she painted shortly after this one is very different. She has made her choice: she is going to side with loss and solitude, like the saints. She is going to be a great artist even if it means complete deprivation. Her gaze is directed at the viewer, but she is self-enclosed and remote. She would not answer if I spoke to her. Around her throat, instead of a flamboyant bow, she has tied a thin black choker with a stone-coloured profile of a woman at its centre. The woman must be her mother. She is keeping her mother close. She will be Gwen's companion in the spirit world. Gwen has chosen her mother, and death, over anything that her brother could offer her in his world.

There is a photograph of Gwen taken at this time, and her resolve to live a hermetic life is vividly conveyed by the image. Augustus is standing with his new wife and baby. He

is a proud paterfamilias, and Ida – Ida Nettleship, Gwen's friend from The Slade – the devoted, adoring wife. The baby, named David, completes the family unit. Gwen is standing slightly apart. She is holding herself very straight, as if turned to stone or carved out of wood. She is like the figurehead of a ship, prepared to endure all that the open sea can throw at her. But she is not prepared to enter into any imprisoning family circle. She has chosen solitude. And freedom. Her gaze is directed at some invisible point beyond the horizon.

Soon after this photograph was taken, Augustus had fallen in love with a friend of Gwen's whom she had met at an evening art class at Westminster School of Art: Dorelia McNeill. Dorelia was living in a basement flat, a few doors down from where Augustus, Ida and the baby lived, in Fitzroy Street. Gwen was instantly attracted to Dorelia and introduced her to Augustus. Gwen predicted that he would love her, as she herself did. Dorelia was an unsettling presence in the household and threatened to break apart Ida's relationship with Augustus. Gwen decided to walk to Rome with Dorelia. It was an exciting project: she would have Dorelia to herself, while removing her from the domestic tensions in the John household. They planned to travel by ferry to France and then they would make the rest of the journey, as much as was possible, on foot.

Gwen wrote vivid letters to Ursula Tyrwhitt throughout their travels. When they reached Toulouse, Gwen sent her impressions of the place, in a letter written in late 1903:

We hire our room from a tiny little old woman dressed in black with a black handkerchief over her head, she is very, very wicked . . . There is something very strange about her face, I cannot look at her much, she frightens me so . . . The night before last I had a frightful dream of a ghost and I woke up terrified, there was such a strange feeling in the room. I looked at once at the door and it was wide open . . . I was surprised because I shut it carefully and you cannot open it without a kind of latch or else making a frightfully loud noise.

I get a real sense, from Gwen's description, of a nervous but excited conspiracy: I picture her and Dorelia whispering to each other in the dark bedroom:

I said to Dorelia 'Look at the door', she said she had seen a figure like the little old woman's standing by the door a few minutes before – she was frightened too because there was such a horrid sensation in the air – neither of us could think of the little old woman without nearly dying of fright, and of course we heard some strange noises and a dog in the house barked suddenly . . . I don't know how I shall look the old woman in the face again.

I love the evocative sense of the lonely sounds of the night, the uncanny creakings and stirrings. I imagine Gwen and

Dorelia shivering with fright under their sheets until, startled by the sudden eerie bark of the dog, they jump up to peer out of the window into the darkness, their arms around each other, giggling despite their agitation. There was pleasure mixed with the fear, but Gwen must have needed some steadying consolation because she ended her letter by adding: 'Dearest Ursula, I wish you were here . . .'

The thought of Ursula's presence comforted her, always. Whenever she was anxious, as now, in this strange house presided over by the sinister landlady, and throughout the subsequent years, Gwen would turn to Ursula for reassurance.

In Toulouse, presumably in the room belonging to the little old woman, Gwen John painted a series of masterpieces.

In *Dorelia by Lamplight, at Toulouse* everything is still, everything is luminous. Dorelia looks down at the open book on the table in front of her, the pages resting on another book, closed so that we can see the title *La Russie*. Two violets lie on their heart-shaped leaf beside the open book. The colour of violets permeates the whole composition like a perfume and tints Dorelia's lowered eyelids with a transparent violet wash. The shadow cast behind her is made up of Prussian Blue softened and hazed by violet-scented smoke. The tall window to the right of her head seals in the interior in quietness against the night air. Her black hair is parted in the middle. But she is not entirely demure. Her pink lips are sensual and glisten like a rose beaded with dew.

The second canvas, painted shortly after the first, also at

night in Toulouse, shows Dorelia, standing now. She is holding a closed book in one hand and the other hand is resting on a chair to support herself. The book *La Russie* is on the table, in the same place as in the first painting. It's as if, in this painting, Gwen has caught Dorelia as she stands up, preparing to take a book to bed as it is late and she is tired, but that she momentarily pauses, entranced by the particular stillness of this summer night, reluctant to leave it. She is at peace. Her eyes are lowered and her expression is clairvoyant, as if she senses that these days alone with Gwen might be the last days of true freedom before she is reclaimed by the man, Gwen's brother, who needs her and yearns for her. She looks strong but resigned.

In *Dorelia in a Black Dress* she is giving herself up entirely to Gwen, who has stolen her from Augustus. Now she is completely Gwen's own – Dorelia will obey her, whatever Gwen commands. Dorelia's hands are wrapped around her waist as if in an embrace. She is desirable and she knows it, but she needs no male lover to give her affirmation. Gwen desires her and admires her, and understands her in a more intimate way than her brother ever could. The space around her is sheltered and private, inhabited secretly by the two women. A pink piece of material – a loosened hair-ribbon – has fallen haphazardly onto Dorelia's shoulder. This is the only point of colour. The rest of the composition is made up of black and grey and smoky brown.

Gwen wrote another letter to Ursula from Toulouse in 1904:

I do nothing but paint – but you know how slowly that gets on – a week is nothing, one thinks one can do so much in a week – if one can do a square inch that pleases one – one ought to be happy – for after all to do in a *year* something beautiful – 'a joy for ever' – would be splendid!

She was working slowly, but there was a measured happiness in her words. She knew she was making great art.

It was an enchanted time, which couldn't last. They both knew that they didn't have the stamina or the impetus to go as far as Rome. They decided to turn back and spend time in Paris. They found rooms in the Hotel Mont Blanc in the boulevard Edgar Quinet. It was at this point that Gwen realised that she didn't want to return to England. She wanted to live separately from her brother from now on.

Later, Dorelia remembered Gwen from that time: 'She was extremely queer and hard . . . always attracted to the wrong people, for their beauty alone.' Apparently Gwen had fallen in love with a beautiful married woman in Toulouse, who had deserted her husband to follow Gwen to Paris; but Gwen was immersed in her painting by then – 'I am getting on with my painting, that makes me happy' – and would have nothing to do with the woman. No details are known about this episode; it remains a tantalising glimpse into a different facet of Gwen's nature: a sudden infatuation, which is then just as suddenly dismissed. Augustus described Gwen's ruthlessness in certain romantic liaisons: 'She wasn't chaste or subdued, but amorous

and proud. She didn't steal through life but preserved a haughty independence which people mistook for humility. Her passions for both men and women were outrageous and irrational.' I can sense from this perceptive but high-handed judgement how freeing it must have been for Gwen to escape her brother's possessive scrutiny. She never tried to pin him down, as he did her.

She adopted a fierce tortoiseshell cat, which loved only her. Gwen gave the cat the name of the street, Edgar Quinet, even though the cat was female and went on to produce several litters of kittens. Once, when a kitten got stuck in the process of being born, she delivered the kitten herself, cutting the umbilical cord with scissors. She had to shut the windows of her room so that the neighbours shouldn't hear Edgar Quinet's terrible yowling. When the cat went missing one day, much later on, Gwen wrote a poem about her anguish in her typically erratic spelling:

Au Chat

Oh mon petit chat
Sauvage dans le bois
As tu donc oublié
Ta vie d'autrefois?

Peut-être que tu es
Fâché avec moi
Mais je tâche de comprendre
Tout ton petit Coeur

Je me sentais jamais
Ton supérieure
Petit âme mystérieuse
Dans le corps du chat

J'ai eu tant de chagrin
De ne pas te voir
Que j'ai pensée de m'en aller
Dans le pays de[s] morts

Mais je serais ici
Si tu reviens un jour
Car j'ai été comforté
Par le dieu d'Amour.

To the Cat

O my little cat
Wild in the wood
Have you forgotten
Your former life?

Perhaps you are
Angry with me
But I am trying to understand
All your little heart.

I never felt myself to be
Your superior

Little mysterious soul
In the body of a cat.

I was so sad
Not to see you
That I had thought of going
To the land of the dead.

But I will be here
If you come back one day
Because I've been comforted
By the god of love.

Never before or since has an artist managed to paint the soul of a cat as Gwen John has done. In *Wide-Awake Tortoise-Shell Cat* the cat's paws are tucked neatly underneath her and she is looking at her mistress expectantly; the cat is very content, she may even be purring, so pleasurable is it to her to have Gwen's quiet regard focused on her.

In *The Cat* her eyes are turned away from Gwen, but are conscious of her presence. The cat's ears are pricked. She wonders whether she'll come and sit on her mistress's knee to be stroked in a minute, or whether it would be more leisurely for her to shut her eyes, which look as though they have been circled with kohl, and curl up and take a little nap.

These studies were made much later, and in a different room from the one she had shared with Dorelia in the boulevard

Edgar Quinet, on their long walking trip heading for Rome, but failing to reach it. Augustus had been pining for Dorelia, and Ida realised that she would have to share her husband, if she was to make him happy. Gwen became involved in the drama, persuading Dorelia to return. She wrote in an exalted letter in early summer 1904: 'Dorelia, something has happened which takes my breath away so beautiful it is. Ida wants you to go to Gussy – not only wants it but desires it passionately.'

Gwen's 'implacable nature when roused' was impossible to withstand, and Dorelia returned to Augustus, even though she had just fallen in love with a Belgian artist (Leonard Broucke). Dorelia soon became pregnant with Augustus's child.

When Dorelia wrote to Gwen early the following year to announce her pregnancy, Gwen sounded hurt: 'Dear D, No, I did not know you are making a *petit*, how could I?' And when the baby was born in May 1905, Gwen's letter seems deliberately distanced: 'I was surprised to hear you had your baby so soon . . . I should like to come over but I don't suppose I shall be able to.' She is standing on the outside of the family circle again. She had loved Dorelia. She must have missed her.

Gwen remained in Paris. She earned money by sitting for artists.

The first mention of Auguste Rodin is when Gwen wrote to Dorelia in late summer 1904, soon after she had started to pose for him. She refers to a group of people – 'four Toulouseans' – whom she and Dorelia must have befriended on their travels. She took them to see Rodin in his studio: 'He smiled

graciously upon them but he would not let them come into his studio, which was rather horrid of him.'

It wasn't necessary for me to go abroad to seek alienation. I had no home or family in London. Lucian symbolised both home and family to me, as Rodin did for Gwen. Lucian also understood the need to be alone.

When I first arrived in London as a young woman, I had strange encounters with men. I wrote in my notebook:

A very tall American man dressed in black with a walking stick and black hat sat down by me in the tube. He had a bushy beard and bushy eyebrows. At the roots of the sprouting hair there were red and irritated patches of dry skin. There was a rash of red around the curling banisters of his nose as well. His white hands on the walking stick were trembling. His legs in his rather baggy trousers were surprisingly short. He turned round and said to me: 'The rain doesn't wash the tubes but it certainly makes you appreciate the tubes more' (it was pouring with rain outside). And then he asked how old I thought the floor of the tube was. I said I didn't know. He said that he thought it was very old because there was not another tube floor like it in the whole world. There was a cigarette end lying in one of the laminated grooves. I would have liked to open up a flowering revelation about tube floors to him but I could think of nothing to say. My stop came. I said goodbye to him.

He didn't reply. Obviously I had not come up to his expectations.

I often came across 'les mauvais sujets'. I recorded another encounter in my notebook:

When I was coming back from Portobello market this morning, my arms full of carrots, an oldish gentleman in a black beret stopped me to tell me that my socks were falling down. He then engaged me in conversation for twenty minutes. He condemned the people today, how they have no time and no emotions, how they never laugh and never cry and never listen. He condemned religion too because, he said, everyone was so confused – and what good is confusion? He told me that I have an intelligent face and that whenever he saw a beautiful girl with an intelligent face (socks falling down? Arms full of carrots?) he waylaid her to speak with another of his kind about the more profound things in life. All the time he was getting closer and closer to me (his breath smelt) and he held me by the arm in an iron grip and was watching my lips. I was getting desperate. He then asked me to out to a late night film with him and then a drink. And then?

Even though Lucian made advances to me soon after we'd first met, he didn't seem predatory to me. He talked to me as an equal, and he respected my art.

He often compared me unfavourably to Gwen John. He told me how beautiful he thought it was that she stopped painting when she was most deeply in love with Rodin because she wanted to give herself up entirely to the experience. She told Rodin, 'I am not an artist, I'm your model, and I want to stay being your model for ever. Because I'm happy.' This is how Lucian would have liked me to be. He would have loved Gwen.

Five years before the walking trip with Dorelia, while Gwen John was still at The Slade, she went back to Tenby during the summer holidays. Her friends Gwen Salmond and Ida Nettle-ship decided to go to Paris, hoping to study art at one of the Paris academies. Gwen felt frustrated at being at home with no-one but her father for company, so in the autumn she joined her friends. The three of them found an apartment in the rue Froidevaux, which they nicknamed 'Cold Veal Street'. She attended classes given by Whistler, a controversial and outspoken personality in the art world. Gwen's *Interior with Figures* shows that she had learned a little from his technique. Whistler painted rapidly, using layers of thinly applied paint. The forms in Gwen's paintings are mistily sketched in and less defined than in her previous work. She uses her two friends as the models. They are leaning towards each other as if they are sharing a secret, as they stand together in a grand abandoned interior. Gwen Salmond is wearing a white dress, and Ida is in a rusty red ballgown. The atmosphere is fairy-tale, as if they are Rose White and Rose Red in an enchanted palace.

Whistler taught 'synaesthesia' – his term for the melding of different art forms: poetry and music and painting. He said: 'the musician gathers his notes, and forms his chords, until he brings forth from the chaos glorious harmony'. Augustus visited Paris briefly. He asked Whistler what he thought of Gwen's paintings, and if he didn't think she had a fine sense of character. Whistler replied: 'Character? What's that? It's the tone that matters. Your sister has a fine sense of tone.'

Gwen John, *Dorelia by Lamplight, at Toulouse*, 1903–4

Gwen John, *Dorelia in a Black Dress*, 1903–4

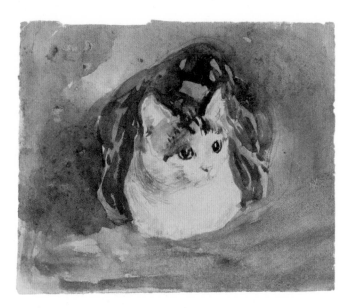

The Cat, c. 1904–8

Great Russell Street, 14 June 2019

Dear Gwen,

I heard about the intruder who came into your room in the rue Froidevaux. You had only moved to Paris a few weeks before. When you saw him standing in the middle of your room, you sat up in bed and exclaimed, 'Oh dear!' You and your friends loved to reminisce about this episode and you laughed so much.

I also know about the strange man who came into your room at night. The man had a cruel face and his skin was the colour of wax.

But this is not true, you say, I have misremembered and confused it with my own story. Graves, in their neat rows like houses in streets, their doors firmly locked, are our attempt at preserving the boundaries that identify an individual life. But the dead rise up into the upper air and are possessed by anyone who breathes. There is no such thing as respect for the dead and we are all grave-robbers. But forgive me, Gwen.

This is how it really happened.

You often exclaimed, 'Oh dear!' and were gently teased for it, but not on this occasion. You had been asleep in your room in the apartment in Paris that you shared with your two friends, Ida Nettleship and Gwen Salmond. It was the middle

of the night. Your friends had been away on a short trip together. They fumbled their way up the dark stairs that led to the apartment. Once they were inside, they needed to find matches to light the lamps. They thought the matches might be in the chest of drawers in your room, or perhaps on the sideboard. You were woken by the sounds they made, drawers cautiously being opened, papers rustling, but you lay quiet, in fear. And then you suddenly sat up in bed and said 'Oh!' and again 'Oh!' And then a stream of 'Ohs!' burst out of you in quick succession. Your two friends started laughing and then the three of you laughed until you cried, thinking what 'a queer reception for a burglar'.

A strange man with a cruel face did enter your room when you were asleep. You were living on your own then. You woke to see him standing in the middle of the room. But his face wasn't the colour of wax.

It was the year after my father's death. He had died in July and this was now the beginning of March.

I was sitting in my front room. The only item of furniture was my bed. I sat on the bare floorboards to eat my supper, which I'd bought from the local supermarket: some taramasalata, a bread roll, and what I was particularly looking forward to: a small can of figs in syrup. I had bought a carton of cream to go with them. (Afterwards I told myself that what happened must have been a punishment for such an anticipation of pleasure.)

The room was quiet but there were plenty of background

sounds: a fire engine screamed past. I could hear its siren between the high buildings in the street as it headed towards Tottenham Court Road, the sound slowly fading, like a seagull screaming as it flew into a cave, sending back echoes.

People's footsteps on the pavement, and voices talking and laughing as they passed my building. Someone asking directions from one of the guards outside the British Museum.

My room was lit by a single naked light bulb.

And then there was a sound that made me lift my head. I hadn't yet unloaded the bag containing my supper. I left it untouched now. It would have made a rustling noise.

It had been just a little creak. Probably nothing, I thought to myself. The sound was not repeated. But I had been made anxious and I decided to investigate.

I went into the big room that I use as my studio, the room next to this one. I had recently started painting the large family group of my four sisters, with my mother in the centre. Because I always began with the faces and then worked my way downwards, and because the paint was very thick, they looked almost sculptural, staring out fixedly at the viewer in their disembodied state. The electric light had been turned on. Standing underneath the bare light bulb was the terrified presence of a man. He was obviously completely bewildered at having found himself in such a strange space. He started talking very fast in some guttural foreign language. He gesticulated wildly and looked as if he was trying to plead with me.

I was surprised, when I thought about my immediate

response later that night, that I hadn't experienced even a tremor of fear.

I told him firmly, 'Wait there!' And I wagged my finger at him.

I rushed out of the room and downstairs to fetch my neighbour, an eccentric elderly gentleman, who always kept a stout stick by the front door of his flat, in case it was required for occasions such as this. We rushed back up the stairs together. He brandished his stick as he entered my studio, but my visitor had left. We searched the flat and soon found that the kitchen window was wide open. He had risked his life climbing out and over the rooftops. He must have entered by my kitchen window, too. I had always thought that I was completely safe because I was so high up, on the fourth floor, and I hadn't bothered to lock the window.

The unsettling thing for me was that I'd felt that I had been in a fortress, and that no-one could possibly break in. Now that I realised this was a false assumption, I felt afraid. I loved being alone, but now I felt nervous about it. I sought out company in a way I'd never done before. I listened out for strange sounds. I was on my guard the whole time.

It was at about this time that I became pregnant with Lucian's child. I connected these two events in my mind for a long time afterwards, though I admit that the connection may seem crass to you.

I had wanted to get pregnant so that I could comfort my mother, who was grieving for my father. I wanted to replace loss with love. She had become thin and withdrawn. I had

asked her what, in her life, had made her most happy. She had replied that it had been when we were all little. She said she was naturally gifted with children and that they always loved her. I asked her, 'If I get pregnant, would it make you happy to look after my child?' She told me that it would – very happy.

I was twenty-four. I had been with Lucian six years. I had suffered deep depressions during that time because of his unfaithfulness; my mother had witnessed my swings of mood and she had supported me by sitting for me: she knew how stabilising the act of painting was for me. She wanted to reassure me that she would take responsibility for childcare, so that I could continue to paint. Neither of us foresaw how painful it would be for me to relinquish the care. My intention, in having a baby, was to comfort my mother. Hers may have been to comfort *me*. My relationship with Lucian was destabilising: he was unpredictable and there was no regularity to our meetings. I never knew where I was. My mother may have hoped that, by having a baby, I might gain a new emotional focus that would balance me.

Lucian had said that he would love to give me a baby. It took a while for me to get pregnant. My mother and I were disappointed each time I had my period. Lucian said to me that I always held myself back and that I needed to open myself up to him.

I'll tell you about that soon, dearest, but for now I will say goodnight. It is getting late and my eyes are tired.

With a handshake,

Celia

Great Russell Street, 16 June 2019

Dearest Gwen,

How can I talk to you about the birth of my son and those early years of motherhood? I would like to try. I hope you won't assume that look of distant forbearance that I know so well. This familiar expression of yours suggests to me that, even though you hear the words being spoken to you, they can't affect you in the least. I would like you to pay attention to me.

My son, Frank Paul, was born in December 1984. From my hospital bed in central London I could see thin flakes of snow drifting gently past my window. The snow made the experience of holding this new life more secret and hidden from the world. He and I were alone in a warm cave, huddled together for shelter. We heated each other under the blankets until the sweat poured out of us. I wouldn't relinquish him, even to let him sleep in the cot that the nurse had put beside my bed. I knew that I wouldn't be able to hold him to myself for long: I had vowed not to be distracted from finishing the big family group painting, and my mother had prepared her house in Cambridge for my baby's arrival. She would be his main carer.

After a week in hospital, a friend of my mother's arrived to drive Frank and me to my mother's house. It was a Sunday and

the icy roads were mainly deserted. I held my baby to me. He was wrapped in a woollen shawl. He made contented sucking movements with his lips and he kept his eyes firmly shut throughout the journey. He didn't cry, but occasionally made kitten-like sounds, half-squeak, half-purr. He had a faint raspberry-coloured line between his eyebrows where he must have been pressing against my hip-bone inside the womb. The nurse said that this would fade.

When we got 'home', my mother was there to welcome us.

It is a small house, which my mother had moved to when my father died the year before Frank was born. She had installed an Aga in her tiny cramped kitchen because we'd had one in our spacious house in Bradford where my father had been bishop. The Aga in my mother's house heated the water so that it came out boiling from the tap. The central heating was always turned on to full capacity. Now, with my baby in my arms, I felt that I would never be able to leave the warm womb-like fug. I stayed in my nightie for three weeks and never, during that time, ventured out of doors.

Lucian phoned me every day. My mother had a Siamese cat who was jealous of the new arrival. He used to clamber over me, digging into me with his sharp claws and covering me with pinpricks of blood, which stained my nightie. He had a penetrating wail, more like the cry of a baby than my own. Frank hardly made a sound. I proudly told Lucian, who confused the yowling of the cat for the baby, that my son was too contented to cry.

The few weeks that I'd put aside were drawing to a close.

I soon had to return to London, to my painting, and continue to sit for the portrait that Lucian was in the middle of: *Girl in a Striped Nightshirt*.

I often wonder what my life would have been like if I hadn't returned to London. My *Family Group* painting would have been discontinued, I'm sure. Or if, after a year or so, I had continued with it, the feeling would have changed: it would have lost momentum and the intensity would have been driven out of it. And Lucian's portrait of me would have been left unfinished with its arms truncated, like the abandoned statue that Rodin made of you.

On the train, the evening of the day I left Frank for the first time, the image of his face was in my mind. I tried to escape the loss I felt by looking out of the window at the dark Cambridgeshire landscape, but my anguished reflection was all I could see.

When I arrived at Lucian's studio we were awkward with each other. There was too much to say that he couldn't, or didn't want to, understand. I felt changed. The outward physical signs he noticed and was alarmed by: the milk leaked out of my breasts and stained the nightshirt I was wearing for his painting. And there was a livid scar above my pubic hair: the surgeon had given me an emergency Caesarean because the baby had been facing the wrong way. He had thought that the power of the contractions might have righted the baby's position, but it hadn't.

I resumed my position on the sofa. I rested my head on the

curve of its arm and placed my hand in front of it. Lucian said that the atmosphere was very different. I had looked pregnant before, not in my physical appearance – Lucian hadn't painted my belly – but in my air of calm before the storm. The storm had truly broken now and everything looked and felt different, heightened and damaged.

In the morning I went back to my own studio where my *Family Group* awaited me. I had placed it on the easel when my first contractions had started, nearly a month ago now, preparing for this moment of my return. My four sisters and my mother stared out of their carved paint marks like Easter Island statues. They were waiting patiently for me to enter into their stillness again. I thought of you then, dearest Gwen.

My sister Kate was going to sit for me that first morning. I had bought her a grey shirt to wear from the tartan shop in Great Russell Street. I placed it on the bed in my front room for her to change into. In my painting she is the sister who is lying down, next to my mother.

After she put on her grey shirt, Kate lay down on her pillow on the brass bed in my studio. She closed her eyes and fell asleep. I started to paint.

When I returned to Cambridge again it was still snowing, more heavily now. I was eager to see my baby, so I got a taxi from the station. When I was nearly at my mother's house I saw my sister Jane, on the pavement, pushing the pram through the snow. She was looking down at my baby and

smiling. I arrived before she did and waited for her inside the front door. When she saw me, she lifted Frank out of the pram and handed him to me. He started to cry. He aimed his head for my breasts. My mother was waiting anxiously behind me in the narrow corridor. I moved out of her way, so that she could hold Frank and comfort him.

I returned to London the next day.

I have been thinking again of that photograph of you with Ida and Augustus and their new baby son. You are self-contained and remote. You also appear untouched and intact. Nothing about you has been damaged or deflected. You are a rose drawing up the essential holy water through your single stem. In your *Self-Portrait in a Red Blouse* the lush crimson material of the dress is on fire, as if lit from within. You hold a sacred secret. You have no needs other than this holy water.

Did you ever long for a child? Did you ever envy Ida and Dorelia and Winifred? You never speak as if you do. Rodin's work, and later your work, you called your babies.

You painted children often. They are always wonderful paintings, some of your best. You understood children and empathised with them. You were a child yourself.

In becoming a mother, I feared that I had lost, for ever, this privileged view of the world from a child's perspective. Jane Austen, Emily Brontë, Charlotte Brontë, Virginia Woolf, Emily Dickinson – all the women I revere – remained daughters and sisters, never mothers. They could sit in the living room surrounded by their family and never be called upon,

never be riven in two by anxiety for a child who is dependent on them. They could observe quietly without being distracted.

When I was with my son I could only think about him. I couldn't work when he was with me. I have never been able to share my actual space with anyone and I've never lived with anyone as an adult. This has been the only way I have remained true to you, Gwen.

So you see that I end this letter by coming back to you.

But I will quote to you the last words Vincent ever wrote to his brother:

Well, my own work, I am risking my life for it and my reason has half foundered because of it – that's all right – but you are not among the dealers in men as far as I know, and you can still choose your side, I think, acting with humanity, but que veux-tu?

Vincent craved to be reassured that, even though his brother's profession as an art dealer was dependent on financial success and the world's approval, the bond between them was of a higher order. Vincent wanted Theo to understand that Great Art requires Great Sacrifice.

When you were deeply involved with Rodin, you stopped painting because you wanted to give yourself up to love. When art resumed its central place in your life, you deprived yourself of the ordinary pleasures: comfort and security, just as Vincent had done. There's a definiteness to all your decisions. Whereas I – I have been conflicted and nearly torn apart by opposite

desires: between loving and being loved, or by being alone. I have had to be ruthless about keeping my space to myself, but the barriers that I have put up between myself and the outside world have never been as secure as yours.

I am suddenly worried that you might feel that I am trying to break down a barrier through writing to you now. I could read disapproval in your silence, if you were still alive. Please show me some sign.

You say – I must get back to my painting.

I'll do that now.

With a handshake,

Celia

Gwen John, *Bust of a boy*, late 1910s

Celia Paul, *Frank*, 1991

Great Russell Street, 17 June 2019

Dear Gwen,

I do need to talk to you now. It will help me with my painting to understand what happened during those years of Frank's growing up, and the tensions that arose between Lucian and me. I will be able to gain some clarity and distance, which I need for my work. Even though my experiences during this time veered far from your own, I think you would hear me with sympathy.

The first years with my son were difficult, though punctuated with intense joy. When I returned to my mother's house after several days of absence, my mother would hold Frank out to me and his face would light up with recognition and love. While I held him to me and fed him his bottle of formula, I would often sing to him. He would recognise the tune, stop feeding, look into my eyes and break into a laugh. I was never the one he wanted when he needed comforting. Only my mother could do that. He cried inconsolably if I tried to. This made me feel sad and excluded. But the delight of being with him lit up my life and lit up my painting. When, at nearly five years old, Frank started school, it became easier for me to balance painting and being with him. I went back to my mother's house in Cambridge at weekends. I could then focus properly on my work and my son.

I devoted myself to him at these times. I think he might have preferred it if I had been less intense and more casual, like the other mums he observed when he went round to friends' houses, who spent a lot of time speaking on the phone or were preoccupied with housework. I didn't spend much time on either of those things. My mother mostly shopped and cooked for us all. Generally the mothers of his friends didn't leave home to go to work. Most of them didn't work. I felt ashamed of my ambition, and I felt ashamed to be a single mum, I was ashamed of being younger than them. I couldn't explain to most of them what my work involved. When I told one of them that I was a painter, she said, 'That must be very relaxing.' I know you were indignant when people reacted to your work with similar incomprehension. I didn't feel indignant; again, I felt only shame. How could I excuse myself by saying that I often lay curled up on the floor of my studio, just thinking and planning and trying to quiet my soul, until I was focused enough to start work? If I didn't feel still, I couldn't paint. I wasn't prolific and I don't often paint on a large scale. Both these attributes of painters, with a different energy to mine, would have gone some way towards justifying my activity. My energy flows inwards, not outwards.

My role was to be a playmate. I played with Frank and drew with him, read to him, watched television, videos and films with him. We were happy together, and the three of us – my mother, Frank and me – laughed a lot. He made us laugh, more than anyone. To him, I was often a comic character. He had various nicknames for me. 'Bloaf' was one, an abbreviation of

'blundering oaf'; and he often called me a 'dim, dumb, dolt' and invented tunes to these words, to which he drummed out the beat with his bare feet on the lino, while sitting in my mother's armchair, in her sitting room.

His teasing was reassuring. I was warmed by the feeling of intimacy: the intimacy, and compassion, entered my work. When I left the clutter and homeliness of my mother's house on Sunday evenings to return to the sparseness and emptiness of my London flat, I felt energised by Frank's affection for me.

My real difficulties began when he became a teenager and my mother handed the practical responsibility for his care over to me. This is where you and I would have lost touch with each other, completely.

My situation was complicated by trying to make arrangements for Frank to see his father, when Lucian hadn't given me his phone number after we separated. He had given his daughter, Bella, his phone number, so she had to mediate between us.

After Lucian's death, boxes of my letters to him were returned to me. I have been depressing myself these last few days, with you in my mind, by looking through them to see if there is anything that I could quote to you that wouldn't make your eyes glass over with boredom. Here is an example of one – there are many more of the same nature:

Dear L,

F is seeing an orthodontist next Tuesday to see about having a brace fitted on his teeth. He hopes very much

to see you for tea afterwards, if you are free. I have left a message on Bella's answerphone but I haven't heard from her. I know she is very busy. I wonder if you could speak to her about it and ask her to ring me? He is looking forward to seeing you very much.

love,
Celia

You would never have had to write a similar letter, Gwen. Your letters to Rodin continued to be passionate and pleading, like mine had been fifteen years earlier. Here is one I wrote to Lucian before my son's birth:

Dearest Lucian,

Here is a photo of me – I am waiting with longing to see you again. I am trying very hard not to think about you too much – I have been reminding myself that the watched pot never boils – so, by trying to think of other things (SO difficult!) – I am hoping to bring the time I next see you closer to me. And then won't the pot boil! Here is a drawing of me sitting very well for you. [*I drew a little sketch of myself in my striped nightshirt, sitting in the right position for his painting.*]

All my love,
Celia

The letters I wrote to Lucian when Frank was a teenager were very clipped in tone because I was careful not to convey

any emotion that might arouse his sexual interest in me – I was no longer in love with him, and I dreaded the thought of all the subterfuges and secrecy that would, as a matter of course, follow on from being involved with him again; I was also careful not to make Lucian offended or angry, in case it impacted on my son: I couldn't make any remarks that he might possibly construe as being accusatory. I knew that he did truly want to be close to his son and to be admired by him.

Even my handwriting, in these letters to Lucian, shows how strained I felt: it had become small and tight, unlike my own. Usually my handwriting is large and forward-slanting.

I was full of conflict. Lucian was central to my life, but he had wounded me too deeply by his constant unfaithfulness. The wound had almost healed and I flinched at the prospect of opening it up again by resuming any intimacy. He began to resent me when I resisted his advances, which were very persistent.

After a while, Lucian thought that I was getting between him and Frank and that my being present at their meetings was inhibiting. I began handing Frank over to Bella, so that I wouldn't upset Lucian by my presence. On one occasion, Bella came to collect Frank from me. I saw that Lucian's Bentley was parked to the right, a few paces from my front door. On impulse I rushed out into the street with Frank and Bella and waved to Lucian, whose face and shoulders I could see above the steering wheel. He didn't acknowledge my wave and he turned his head deliberately away.

I realise, as I try to talk to you about these years, how

inarticulate I feel now, and felt at the time. I didn't write anything in my notebook that I can refer back to. There's just blankness. Even my memories are cloudy and confused. Language dried up in me. I struggled to finish a painting. I was weighed down. I would like to be able to communicate to you how particularly dark and tangled these years were for me. Lucian once wrote me an angry note, saying, 'Why do you have to make everything so complicated, shifty and shameful?'

I paint my sisters and I painted my mother. Why did I, and do I, feel inhibited about painting my son? I think my love for him disarms me. I want to serve him and look after him. I don't want to stand above him at my easel.

You and I feel motherly towards men and boys, and men as boys. It is this motherliness that keeps us shackled. We are also reluctant to lose our status as daughters. We know that, in order to be an artist, you need to see the world with the detachment of a child.

You wrote to Ursula on 1 June 1908:

I have had some scenes with Rodin and he is always adorable in the end. I see these scenes are necessary to him, but I wish they did not make me so ill. I have been very stupid in never scolding him enough, I see now I should have done so much more – there is no one else but me to do it, everybody spoils him. I scold him therefore now, but what I say runs off him like water off a duck's back. I have been inspired to write things, to

make them more serious, and found it answered only too well – he came like a poor little punished child and then I had remorse . . . I adore him and so it is dreadful to be angry with him – I see that it must be so, though.

Lucian used to say to me, when we were still romantically involved, that I was 'a natural mother' and he often used to call me a 'tyrant', affectionately. He also treated me with fatherly concern and, like Rodin with you, he worried if he felt I wasn't looking after myself or eating properly.

What interests us is the spirit world: our inner world. Our instincts may be maternal or daughterly, but our deepest desire is for our art. Your aim, always, was to lead a more and more interior life. We remain remote.

You have spoken about how you prefer to live your life in the shadows. We have lived our lives overshadowed by our own choosing. We can be free if we are unseen. We are like nocturnal animals.

As a single parent of an angry adolescent son, I was in the spotlight, out of the shadows. Everything about me was exposed and judged. This exposure, and the world's judgement that came with the exposure, is what prevented me from working truthfully. I was judged by Lucian, by my son, by my mother, by Bella. I lost confidence. There was no way, in the world's eyes, that I could be a good mother – and I wanted to be a good mother now – while at the same time being a painter wholly committed to her art. I should be straightforward and make a proper home for my son, said the world. But my desire

was for the shadowy crime of painting. I longed to be alone and free to create my secret unsettling art.

Painting is different from writing. A notebook or a laptop is a compact space for creativity. In order to paint you need paraphernalia: a palette, brushes, canvases, easel, and a room to yourself where it's possible to be uninhibited – you need to be unconcerned about drips of paint landing on the carpet or staining the walls. We use words all the time. But painting is an acquired language that you need to practise every day, like playing an instrument: if you don't, you lose your gift.

Your sister Winifred had children. In the catalogue entry for the book by Cecily Langdale about you there is a quote from one of Winifred's daughters: 'Mother was a small, shy, and very gentle person, who disliked crowds and abhorred publicity, but she was a most wonderful friend and companion . . . She had a deep natural feeling and understanding for all the arts.'

If you and she had been able to speak on the phone when Winifred was living with her husband and her family in California, I'm sure she wouldn't have bored you with details of her domestic life: her trouble trying to get her children out of bed in the morning; difficulties at school; were they eating properly? Were they getting too fat? Or too thin? Victor wasn't getting on specially well with their son Dale at the moment; the plumber charged too much and Victor wouldn't pay for a new boiler . . .

You would have made it very clear that you weren't interested. Winifred would then have asked you about your painting. You would have asked her about her violin and if she performed in any concerts, or did she just teach the instrument now . . .?

So, since I'm writing to you, and it's only you I want to write to, I'll bring this letter back to the theme of painting.

My mother continued to sit for me, but the mood in the paintings I did of her during these years was very different: all the warmth and humour left them.

I did a painting of her that epitomises this new shift in my work: *My Mother Looking Away*. The colours are smoke and mother-of-pearl, her head is small on her shoulders, and the buttons on her shirt are carelessly fastened so that there are gaps in the seam running down her chest and belly, like a gash, or a wound that has been roughly sewn up and hasn't healed. Her head is turned away from me, to the window. Her gaze is remote. She looks as though she wouldn't recognise me if she turned towards me. She has drifted into some lonely place where I am no longer known to her as her daughter, or even as another human presence.

The really sad thing is . . . that each of us is enclosed. Each one of us holds our life within us, shut in as if by a prison wall. We only have words. We break open the barrier of skin with our mouths and try to utter some sort of grotesque caricature of the woundedness we all of us feel.

I needed stillness. I would look out of the window and focus on a leaf of my plane tree.

My son would have felt more at ease if I'd bustled about.

I have come back to talk to you about Frank, again. If I were your sister, Winifred, talking to you on the phone from California, you could hold the receiver far from your ear.

Even at that time, when there seemed an unbridgeable gap between us, I knew he loved me. And he knew I loved him.

When he was little, Frank decorated the walls of my flat with charcoal and pastel drawings. He concentrated on drawing on the walls in the area around my bed. He drew monsters and spooks to try and give me nightmares when I was sleeping. On the wall, above my chaise longue, he drew a big colourful square, which he told me was a television screen. Within the frame he wrote the word, in pink, green and yellow chalk: 'WONDERS'.

When my flat was redecorated, all the monsters and 'WONDERS' were painted out. The redecoration coincided with Frank becoming a teenager and with the new trend in the art world towards conceptual art. My work was no longer selling and I was anxious about money. Marlborough Fine Art, the gallery that represented me, gave me a small stipend, but I needed to be very careful.

Lucian had paid for the flat to be done up, to make it more habitable for when Frank stayed with me.

The empty, echoing walls looked sterile.

When Frank was sixteen, he did a drawing of me on the

wall where the fireplace had been, before the renovation, in the front room where I sleep (the ghost of it remains in the cracks in the plaster, which delineate a large rectangle). He was very short-sighted but refused to wear glasses, so he instructed me to stand very close to him. Our heads were almost touching. He used charcoal and drew my head and neck boldly on the wall. He instructed me to look down.

It is a very tender image. I am looking at it now, as I write. I had to cover his drawing in transparent plastic because pigeons nesting in the roof-gutter frequently cause the room to be flooded. Since the drawing is in charcoal, the water leaking through the ceiling would wash it away.

He did another charcoal drawing of me on the wall in the corridor, by the entrance to my studio. This one is more cartoon-like. He has exaggerated the bobble on the end of my nose so that it almost looks like the beak of a mother hen. It is a very good likeness.

He is a wonderful artist and writer, Gwen. He brings his complex humour and edgy, surreal view of the world into his precise ink drawings. His small delicate watercolours, which you would love, have a real feeling for nature, for light and air. He records every blade of grass, leaf on a tree, meticulously, yet without pedantry. And he brings the same precision to his writing, which is often very funny, and frequently moving. He has a linguistic brain and sets cryptic quizzes, which he illustrates with his spiky, immaculate drawings.

He rings me up sometimes, though not very often. I envy my sisters whose daughters ring them every day. I try to visit

him every other week in his house in Cambridge – my mother's house, where he grew up and where he now lives with his wife and two children. He is a dedicated father and a loving husband.

Because we are no longer physically close, we only have words.

I only have words to give you, my dearest. You have no words to give back to me.

I imagine I hear the click of the receiver being put down and hope you have been listening to me, after all.

With a handshake,

Celia

Great Russell Street, 20 June 2019

Dear Gwen,

I've wondered what it would be like to have a brother. I think it would have helped me to understand men better. I envy you this. I am always conscious of my femaleness – how different I am, how differently I think – when I am with most men. I fell in love with Steven because of his femininity. Lucian remained mysterious to me. My son is often an enigma to me, too.

Your brother Augustus was younger than you. When your mother died, were you in any way a maternal presence to him even though you were only eight? He was protective of you, aware of your physical fragility, but I suspect he realised that your will was indomitable. These quotes from the penultimate chapter of *Sons and Lovers* by D.H. Lawrence, where Paul Morel describes his feelings of love and concern for his dying mother, remind me of Augustus's feelings for you:

And all the while her blue eyes watched him . . . At night he often worked in her room, looking up from time to time. And so often he found her blue eyes fixed on him. And when their eyes met, she smiled – he worked away again mechanically, producing good stuff without know-ing what he was doing . . . She was holding herself

rigid . . . He never forgot that hard, utterly lonely and stubborn clenching of her mouth.

The physical description: the hard, lonely way you held yourself very upright, the blue of your eyes, which everyone commented on, the stoic tightness of your mouth. I think you helped Augustus work, just by being in the room with him. He loved the feeling of peace you gave him when you fixed your blue eyes on him. You were chary with your praise. He sensed that you always looked down on him.

You wrote to Ursula about Augustus's paintings: 'I think them rather good. They want something which will perhaps come soon!'

Did you feel threatened when he became an artist? Were you aware from the start that it would obviously be so much easier for him to gain recognition than it would be for you. Did this make you melancholy? You had to move away, to France, to escape your brother's influence, and his inhibiting power over you.

He wanted to possess you and your quiet talent. You addressed him as 'dear love' in several letters, but you eluded him.

I'm beginning to feel unbearably sad, writing about this to you. I'll stop now. I hope you'll hold me in your thoughts, as I hold you in mine.

With a handshake,

Celia

When Gwen's paintings were accepted for the New English Art Club, but not hung, Augustus spoke up for her and defended her work to the committee. He organised a joint exhibition. There were forty-eight paintings by him and just three of Gwen's, one of which she withdrew before the exhibition opened. Her work was ignored. Augustus spoke up for her again: 'Gwen has the honours or should have – for alas our smug critics don't appear to have noticed the presence in the Gallery of two rare blossoms from the most delicate of trees.'

He wrote, in reference to several paintings of hers that were exhibited in a group exhibition at the New English Art Club, at his insistence (she was always reluctant to show her work): 'To me the little pictures are almost painfully charged with feeling, even as their neighbours are empty of it.' Her paintings' 'neighbours' included his own. He predicted that in fifty years' time he would be known simply as the brother of Gwen John. After her death, Augustus was keen to write a memoir of her. He made quantities of notes extolling her talent: 'Few on meeting this retiring person in black, with her tiny hands and feet, a soft, almost inaudible voice, and delicate Pembrokeshire accent, would have guessed that here was the greatest woman artist of her age, or, as I think, of any other.' Winifred

persuaded him not to publish; she wrote to him: 'Gwen would wish to be forgotten.'

Gwen was always wary of his support. Many years later she wrote from Meudon to her Slade friend Ursula Tyrwhitt, who wanted to organise an exhibition: 'Gus offered to arrange an exhibition for me . . . (he may be offended if we have it without his patronage as he is offended at everything I do or don't do).'

While at The Slade, Gwen briefly lived in a basement room in Howland Street, off Tottenham Court Road, which Augustus disapproved of. He described it as: 'a kind of dungeon . . . into which no ray of sunlight could ever penetrate'.

Gwen wrote to Michel Salaman in March 1902 from Liverpool, where she was staying to help Ida look after her newborn baby (and from where the photograph of Augustus, Ida, baby David and Gwen was taken): 'People are like shadows to me and I am like a shadow.'

This was her vision and the calling that she had to follow. It was a calling that differed in all ways from her brother's. Augustus needed an admiring audience; Gwen needed solitude.

Great Russell Street, 22 June 2019

Dear Gwen,

It's your birthday today! It gave me a jolt to think you would have been one hundred and forty-three. Your paintings live in the constant present, so I always feel you are present, too.

Frank Auerbach has said that an artist is like a passenger on a train. The landscape outside the train window changes, but he or she doesn't.

During all the years I have lived in my studio, the world around me has had many transformations. But my inner life remains the same.

I wrote to my sister Kate in 1982:

> I have just been horrible to Lucian on the phone. He said that he'd like to buy me a flat in London. I blew up at him and said that he only wanted to do this so that I could be available to him and so that I didn't have to stay with him so much. I said that I didn't want to spend my time waiting for him to come to see me, never knowing when that would be. He replied that he liked to be alone sometimes. I slammed the phone down on him.

I wrote this letter to Kate from the house in Bradford where my father was bishop. I had finished at The Slade the year before and I had come home so that I could paint my mother, which I did every day. Every ten days I would go to London to stay with Lucian and to sit for him. I usually spent around four or five days with him, in his flat in Holland Park, which was also his studio. Lucian was very entertaining company when things were going well between us, and sitting was punctuated by going out to dine in fancy restaurants. I didn't want this routine to change.

So you see, Gwen, that I was reluctant to accept what has become the main security of my life and the only way it has been possible to continue to work throughout the years, some of them very turbulent: a room of my own.

I have grown to love this area, near the British Museum. I had been lonely when I lived in more residential areas of London where I had been conscious of families in the houses around me: I felt my isolation and lack of a domestic life more painfully. Here, in Bloomsbury, everyone is accepted.

Eventually I agreed to accept Lucian's offer, despite my initial reluctance. The flat that Lucian bought me, when I was twenty-two years old, is in a mansion block directly facing the British Museum. My flat is up eighty stairs. There is no lift.

When I first moved in, there were gas fires in all the rooms and I had to put coins into the meters to keep them alight. The pipes connected to the fires were ill-fitting and there was a

constant smell of gas. I have installed central heating now, my one concession to luxury.

My studio and the room next to it, where I sleep and also receive visitors, look out onto the forecourt of the Museum; at the back, where my kitchen, bathroom and smaller bedroom are, the windows look out over rooftops and towards the spire of St George's, Bloomsbury. These are the rooftops that my intruder scaled to get into my flat through the kitchen window.

There is a tiny balcony leading out of my kitchen. In those early years I looked down from my balcony onto an open space, like a quarry, but it was actually a building site (now occupied by a hostel). When Lucian first visited me he wanted to do a painting from my balcony of the building site. I was alarmed that he presumed he could invade my territory. I told him that I needed to keep this place for myself, for my own work, and that it would inhibit me if he also worked here. I didn't let him have a key to the building or to my flat. He understood and told me that he would feel the same. Did Rodin ever draw in your rooms, which he paid for? I haven't seen any drawings by him of your interiors. Perhaps you were equally strict with him, letting him know that you would find it intrusive. He visited you in order to make love to you. This was how you wanted it to be.

Throughout the thirty-eight years I have lived here I have kept this space as inhospitable as possible in order to ward off any potential intrusion. There is nowhere comfortable to sit, I don't have curtains or double-glazing, I don't have a television,

I don't hang pictures on my walls or keep house plants or vases of flowers. The rooms are empty.

I would love to show it to you. I hope you wouldn't be intimidated by my austerity. You became more austere in your last years – more austere even than me – when you no longer needed to prepare a welcoming room for Rodin's visits. I wish we could have been friends in real time. I know how much you like tea. My mother once gave me a little blue teapot for a birthday. She said it reminded her of the brown teapot in the painting by you in the Fitzwilliam Museum in Cambridge, near where she lived. If you visited, I would make sure to serve the tea in this teapot.

 With my love,
 Celia

Gwen John, *A Corner of the Artist's Room, Paris*, c. 1907–9

Celia Paul, *My Chair*, 2020

Celia Paul, *Room and Tower: Dialogue*, 2014

When Gwen wrote to Ursula that 'R suggested my leaving my room this afternoon and taking an unfurnished one – wasn't that kind of him? It would be nicer to be chez-moi and he is going to pay the 3 months rent', she set about making a domestic interior to entice her lover to spend time with her. She hung Rodin's portrait on the wall, together with her drawings that she had framed. She put up curtains and asked the landlady to fit window boxes to her windowsills so that she could grow flowers. She bought a beautiful wicker chair. She told Rodin that her room was 'charmante'.

We have both painted pictures of our rooms and our paintings highlight the difference between us.

Gwen tended her room like a bower bird tends its nest, beautifying it with feathers and flowers, precious-looking twinkly stones and bits of shell picked up from the forest floor, making it into a seductive place for a luxurious and aesthetic sexual encounter.

When Rodin first visited her, he complained of the 'saleté': he noticed the dust on the windowsill and the stains on the carpet. Her cat was chewing an old fishbone on the bed. Gwen apologised profusely and felt mortified by his criticism. He

advised her to change to more salubrious lodgings, which he offered to pay for.

The subsequent rooms that she inhabited in Paris she furnished with her lover in mind. Rodin wanted her to be peaceful and restrained. She knew not to buy anything too flamboyant: no oriental rugs or brightly patterned curtains. The sister that he had loved and lost, whom he compared to Gwen, had been a demure young woman who had died in a convent. Gwen chose furnishings that were discreetly tasteful, as would befit an elegant nun.

She painted quietly radiant pictures of her interiors for his delectation, to prove to him how calmly self-contained she was. The honey-coloured light that fills her room is fragrant with the scent of summer flowers drifting in through the open window. On a rainy day the light is enclosed like a pearl in its shell. Her pretty little umbrella is propped against the wicker chair, closed like the bud of a flower about to open and echoing the flowers on the table, flounced with small pink frills. The chair, gilded with sunlight, is openly inviting.

In her painting *La Chambre sur la Cour* Gwen has represented herself sitting in front of the open window of her room. She is dressed in a long black gown. Edgar Quinet – her cat, her familiar – is sitting compact and dozing on the chair opposite her. The cushions on the chair are sun-drenched: a burnished orange colour. Her straw hat is hanging from the arm of the wicker chair. She has just come in from a walk in

the sunshine and now she has thrown back the shutters, fed the cat and is sitting down peacefully, her head bowed over a piece of sewing – she seems to be mending a garment that needs to be seen to, a dark coat that flows over her knees and gives her a sort of tail when it reaches the floor, as if she is a mermaid and wants to lure some lost sailor to her peaceful abode. She is waiting for her lover and she wants him to see what a delectable welcome he will receive: a shelter from the storm.

In this same room she made two similar paintings: one she titled *A Lady Reading* and the other *Girl Reading at a Window*.

In the first one, *A Lady Reading*, she used a reproduction of a face of the Madonna by Dürer instead of her own face. She laboured over this painting and felt that she was doing something excitingly new. She had it photographed and sent an image to her friend Ursula Tyrwhitt, who criticised it. Ursula pointed out that the figure seemed to be sitting on the table, but that it wasn't clear. Gwen was taken aback by Ursula's words. She reassessed the painting and thought that, on the whole, Ursula was correct. Gwen wrote to Ursula:

Thanks for your criticism. I am so pleased you like my pictures. How dreadful, though, that you should think that girl is sitting on the table and that she is me! . . .

When I read that you thought my pictures are not artistic I was so surprised because you seem to like them

but now I am beginning to understand the new signification of that word – didn't we used to think it was a good quality?

You are so right about that head, I tried to make it look like a *vierge* of Dürer, it was a very silly thing to do, I did it because I didn't want to have my own face there. The picture I have done for Mr Quinn [*whom I will speak about later in the book*] is the same pose and I have put my own face in and it is more fitting.

In *Girl Reading at a Window*, the second version, she has used her own face and has clearly defined her raised leg, with her foot resting on the chair. The position is similar to the one that Rodin required from her with his sculpture for the tribute to Whistler – the chair serving as a substitute for the plinth to support her raised leg – but this time her head is lowered over a book, which she holds in her hand; in Rodin's sculpture her gaze is cast downwards and self-conscious, because she is trying to do what her master asks and she is aware of his regard. In this painting, her lover is in her mind, but she is self-contained and independent in the bright lemon-coloured shell of the interior space that she has made for herself.

There remains a stilted quality to this second painting, as if she hasn't quite shaken off the restraint of the first, where she had been striving consciously to do something new. Her best works are an immediate response to what she sees – the meticulous planning for a painting involves tone, texture and

space – and don't involve planning the composition or 'motif' (as Cézanne would say). The craft and deliberate skill that she brings to her later work only add to the spontaneity of her mercurial response to the seen world.

The rooms of my flat are a contrast to Gwen's. The chair in my room is not welcoming, like hers. If any lover sat in my battered wood-framed chair he would be scratched by the horse-hair bursting through the material of the arms and seat, or he would be spiked by one of the broken springs curling like Medusa's snake-hair underneath the chair and dragging its coils on my paint-splattered linoleum.

I have done many paintings of the front room where I sleep. I have wittily contrasted the horizontal position of my bed with the vertical position of the BT Tower, which I can see rising up to the left of my window behind the British Museum. I am constantly aware of these great male icons of architecture outside my window in central London, and they have taken on a significance for me. Virginia Woolf, on entering the British Museum Reading Room, wrote in her feminist essay 'A Room of One's Own': 'The swing doors swung open, and there one stood under the vast dome, as if one were a thought in the huge bald forehead which is so splendidly encircled by a band of famous names.'

I am on a level with the dome of the Reading Room, which I can see from my room; it rests like a head on the stone shoulders of the triangular front pediment, which is decorated with massive statues dressed in classically flowing robes. My life, in my room, is carried out under their watchful eyes: they are like

gods presiding over my fate. I have done self-portraits of myself in a supernatural dialogue with them.

I don't cook myself meals, though I used to love cooking and prided myself particularly on my baking. I buy my meals, often ready-made, from the supermarket situated diagonally across from me, by the north-east side of Russell Square.

When Gwen went to Paris, in her mid-twenties, she found work as an artist's model. She posed mainly for women artists: Mary Constance Lloyd, Isobel Bowser and Hilda Flodin.

Hilda was a sculptor who posed for Rodin. She introduced Gwen to him. (I often wonder if Gwen found it funny that the name Flodin and Rodin echo each other? Did she laugh privately to herself about it, to give herself courage?)

There were several other models in his studio when Gwen arrived, paid professionals like her. She was keen to please Rodin from the start. He asked her to undress and told her that she had an admirable body. He was concerned about her, and hoped she was comfortable and asked her if she was warm enough. She showed him how biddable she was and how flexible. She assumed complicated poses, which she held for a long time. He was very pleased with her. He was interested by 'Englishness'. He talked to Gwen about some upper-class English friends and patrons that he knew. He explained that he liked English models because 'no women have such fine legs as the well-built English girl'.

*

I am imagining Gwen at this first encounter with Rodin. She was intrepid and shy, at the same time. She was alone. When Hilda Flodin escorted her to Rodin's studio, Gwen didn't know what to expect. How could she foresee the intensity of the attachment that would develop between her and this famous sculptor? She already admired his work. She had always loved Greek sculpture and she could see how this had influenced Rodin's own work, which was nevertheless deeply romantic and un-Greek in sentiment: he often represented athletic naked men, but he was obviously more erotically interested in the female body.

She doesn't record how his physical appearance struck her when she first saw him – I wish she had. In fact she never once described to any of her friends what Rodin looked like. It was his attitude to her that captivated Gwen, surely. His eyes took her in and she knew at once that he understood her.

She was honoured that he asked her to help translate some of his writings into English. She felt that he respected her intellect, not just that her body was useful to him for his art. She wrote to him later, 'I was a little solitaire, no-one helped me or awoke me before I met you.'

She felt cherished and needed. She arrived every day at Rodin's studio to sit for him. He always asked her how she was. He wanted to know about every detail of her life. He wanted to hear about her cat, Edgar Quinet, and he asked her to draw it for him and bring the pictures to show him. He wanted to know what Gwen had eaten for breakfast, and

he was worried when she confessed that she hadn't eaten anything.

Once when she arrived she was very cold. I imagine her shivering because she'd walked to his studio and there had been a biting wind. She didn't have gloves or a hat and her lips were blue. He took both her hands in his and rubbed them with his own to warm them. Then he led her gently and solicitously to an armchair by the stove in the corner of the studio. He ordered a cup of coffee to be made for her and, when one of the assistants brought it, Rodin insisted on giving it to her himself. He told her that she was to tell him when she was warmed through and then he would start working from her. Gwen was anxious to please him and assured him that she was ready to start posing whenever he needed her. He said, 'Are you sure?' and she nodded and looked into his eyes, which were deep and kind, full of humour and affection for her. She looked down, overwhelmed by the pleasure invoked by his attention. She went behind a screen and took off her clothes. When she came out from behind the screen he was waiting for her. He looked at her and appreciated her in her nakedness.

Had she read Rodin's impressions on seeing a woman naked for the first time? Did she, from the start, have an intimation – a secret hope – that he would find her desirable and that they would become lovers? He had written:

It is like the sun breaking through the clouds. The first sight of that body – the general impression – comes as a blow, a shock. Momentarily taken aback, the eye darts

off again like an arrow. The whole of nature resides in every model, and the eye capable of seeing can discover it there and follow it so far! Above all, it can see what the majority are incapable of seeing: unknown depths and the very substance of life – beyond elegance, beyond grace . . . But all this transcends words . . .

It was only natural that Gwen very soon became dependent on him, alone as she was. When, one day she arrived to sit for Rodin and he wasn't at the studio as she expected, she felt a deep despondency. She was abject and cast down and couldn't think how she could cope with her disappointment. She wrote a letter to him:

> Cher Monsieur,
> I don't know what to do this afternoon, because you are not here. I want to come at least one day a week for ever, just as you said, until I am an old lady, by which time I'll be an artist, but if you told me you didn't need me any more I couldn't bear it. I'm worried about annoying you when you see me on Saturday because I'm not particularly amusing.

And she signed her letter 'G.M. John'.

Rodin was concerned that he'd hurt her feelings. He was apologetic and especially caring when she next arrived to sit for him. He was charmed by her British restraint. He was disconcerted by Gwen's passionate outbursts, but hoped to encourage

her to structure her life and to look after herself, so that she could acquire some equilibrium.

She wrote to Ursula: 'I am at Rodin's nearly every day now – he has begun a statue . . . Rodin says I am too thin for his statue and that I don't eat enough – but I rarely have time to eat!'

Rodin described to her the pose he wanted her to assume. He instructed her to raise one leg and place it on a plinth, which he put beside her. He told her to stretch out her neck and to look down. Gwen complied readily. It was an uncomfortable pose, but she was only too keen to show how patient and humble she was. She wouldn't have dreamt of complaining when her foot on the plinth went to sleep and she got pins and needles in her legs and arms. She kept her head bowed and she studied a spot of dust on the studio floor. She tried to go into a trance, so that she could elevate her mind above the physical suffering she was enduring for his sake.

She was lost in her own world, so she started when she felt his hands moving over her breasts and his lips upon her own. She nearly passed out with the unexpected pleasure of his touch. She hadn't experienced such pleasure in her life. She had never been touched so gently before. It had been a long time since she'd had a sexual encounter with a man. Ambrose McEvoy may have been the last, back in the dingy basement room in Bloomsbury. But he hadn't really counted, because he was only a boy. This contact with Rodin stirred something new in her. She was intoxicated by the sensation of being loved and touched by her master.

She knew that he desired the female body, that she wasn't unique to him. He had written: 'feminine sexuality, its movements and impulses . . . because therein woman is psychologically revealed'. I'm reminded of Lucian saying to me that the writers of the Old Testament had got it right when they talked of sex: that David 'knew' Bathsheba. It doesn't seem to occur to these great male artists and prophets that the women might also 'know' their lovers through the sexual act.

Rodin got to know that Gwen was very sensual, despite her nun-like exterior. He liked to cultivate her demureness. Gwen tried to restrain herself – she tried to be undemonstrative and biddable. She kept her eyes lowered and she only did what her master asked her to do. She realised that it would put him off if she told him what she wanted and needed, unprompted. If Rodin asked her what would please her, then, second-guessing his desire, she told him that it would excite her to sleep with other women. She did have these impulses and she was so happy that Rodin encouraged her.

She wrote to Ursula on 30 July 1908, 'I am drawing myself nude in the mirror, or rather painting – watercolour mixed with Chinese white – but I have not energy and hardly do anything.' She resolved to draw herself in the mirror every morning, but these mornings she only had enough energy to 'faire ma ménage' (do my housework) and she stayed in bed late instead. A day or two later Gwen was pleased to have done a drawing to show 'Mon Maître' so that she would prove to him that she wasn't lazy. These drawings are all of herself in the mirror. She said how difficult she found it to draw.

The difficulty she felt isn't apparent in her drawings at all. Her *Self-Portrait, Naked, Sitting on a Bed* is simply and clearly rendered. She is looking down, and her mouth is pulled to one side in a gesture that one knows must have been characteristic. Her breasts are depicted using a minimal amount of paint, yet we are sure this is exactly how they were shaped. The nipples delicately echo the knobs on the bedhead behind her. She looks very young and vulnerable and alone, and needing someone to take care of her and love her.

Her *Autoportrait à la lettre* is a masterpiece of delicate control. Even when she was nearly derailed by her infatuation, Gwen managed to keep the balance in her work. She has represented herself holding up a letter to her upper chest, where it meets her throat. Her lips are parted in anticipation of pleasure. She must have just received a letter from her 'Maître' and she has the presence of mind to want to record her joy. She used watercolour and pencil – the immediacy of the materials match the spontaneity of her emotional response. The freshness of the wash and the clear definition of the lines are astonishingly beautiful.

She was beginning to spend more time with Hilda Flodin, Rodin's other model and assistant. Gwen wrote to Dorelia in May 1905: 'I went with M. Flodin [*sic*] to Surennes [*sic*] yesterday, we slept under the trees and drew each other and came home at night when all the river was illuminated with lanterns and windows.'

One day Hilda Flodin wrote Gwen a note saying that she must come quickly to her studio because she would find her

'Maître' there. When Gwen arrived, I can picture Rodin starting to undress her slowly, as Flodin watched. He laid Gwen on the bed and made love to her in front of Flodin. When it was over, he got dressed but instructed Gwen to keep still. He then asked Flodin to lie down with her and caress her, and for Gwen to respond. He stood beside the bed and drew them both. He then left.

When he saw Gwen the next day, he asked her if she and Flodin had continued to make love after his departure. Gwen admitted that they had and although it wasn't the same as having sex with him, it was 'quelquechose'. Rodin was amused and quietly delighted.

The Rodin Museum owns more than seven thousand of his watercolours and drawings: a number of them are of women masturbating each other. Rodin was excited by the animal nature revealed in a woman's body. Was Gwen aware of how many of his models Rodin instructed to make love with each other? He wrote: 'Look at those slim legs, look at those clever feet. With these she could have lived and climbed in trees.'

Perhaps Gwen did know, and also knew Rodin saw that sex with a woman could be an empowering experience for her, as he wrote that she 'is no longer the forced or unwilling animal. Like man, she is awake and filled with longing, it is as if the two made common cause to find their souls.'

Hilda Flodin was stimulated by her part in this erotic drama between Gwen and her 'Maître'. She handed Gwen a cigarette and lit it from her own. She said, 'Do you know what that means? It means I'm going to kiss your favourite lover.' Gwen

was distraught and pleaded with her not to. She wrote a beseeching letter to Rodin: 'Oh mon Maître, don't ask her! Oh mon Maître chéri you are the whole world to me, *promise* me that if you love anybody else you won't tell me, or if you kiss anybody else I'll *never* know about it.'

It must have been as a way of getting some balance and power over Flodin that Gwen asked her to sit for her, but Flodin refused. Gwen sensed it was a game that Flodin was playing with her, to make her seem elusive and difficult to pin down, and therefore more desirable. She wrote to Rodin, 'We're like that, women, aren't we, Mon Maître?' She wanted to keep him implicated in the tangled sexual drama because she knew it turned him on.

Gwen was besotted with him. She stopped painting. She just wanted to be swept away by passion, even if it drowned her. He was urging her to be calm. He wanted her to look after herself. He began to feel anxious about her dependency. He suggested that she should try and distance herself. He suggested to her other male sculptors for whom she could sit. But she wanted only him. Rodin was her whole life. She wrote to him: 'What gives me a joy which stays with me more or less are the thoughts and sentiments or half-thoughts in my heart, which come from making love with you.'

She wrote him letters every day. Rodin complained that they were repetitive, always about love and expressed in a melodramatic style. Gwen replied, 'Maybe if I loved you less I'd have "more idées variés"'; but she couldn't see why she should, because he was all that mattered to her. He tried to

bring her down to earth by encouraging her to write to him descriptions of her daily life: her cat, her friends, her neighbours, her walks. He suggested that she wrote them to an imaginary female friend. Gwen invented 'Miss Julie', resembling her sister Winifred in her imagination; she addressed many letters to 'Julie', which she sent to Rodin. He complimented her on her writing, very relieved that the style was more natural now, less florid and overwrought. He told her she was a gifted writer when she wrote about her observations. Included in one letter to 'Miss Julie' was a fourteen-page novel, narrated by a young woman to her sister and describing a love affair with an artist, written in an eighteenth-century epistolary style. Rodin was very impressed and said that Gwen's writing reminded him of Samuel Richardson. Her feelings often broke through the constraints, however.

She wrote to him: 'Come yourself Mon Maître to my room, I will be your little Marie and ask nothing of you except un embrasse and I'll be so happy, happier than you can possibly imagine.'

But her master was preoccupied by other commissions, other sculptures, and he often went for long weeks without communicating with her. Gwen stayed in her room, craving a visit from him. Once, when she had gone out briefly to walk in the Jardin du Luxembourg, she returned and found a note from Rodin saying that he'd called, but had missed her. From then on, she dared not go out. She became a prisoner in her room, unable even to work because her anxiety and her longing distracted her.

She wrote to Ursula on 30 April 1908: 'I had a visit from Rodin yesterday morning and still feel rather faint after it. As you thought, he likes to make me furious, or at least it seems so. That was the second visit since you left, it was an engagement he didn't keep for three days . . .'

After a particularly long and unendurable stretch of waiting she wrote to him, 'Will you come soon? Or ask me to come to you? It doesn't feel natural to me to go for so long without caresses from the man I love! The days are hard . . .' Another letter followed shortly afterwards: 'Please, please, don't say we can't be alone together again.' Rodin had tried to withdraw from her. He told her that love-making gave him headaches. He confessed to feeling old. He described himself as being like a cracked vase that would fall apart at the slightest touch.

Gwen was in despair. On 13 November she wrote to Ursula: '. . . everything I was doing, which was not much certainly, in the usual way which you know. The worst of it is I don't know how I can begin to live again. (Oh it is not for want of money – in case you may think it is that).'

She became aware that she didn't hold a central place in Rodin's life or heart. She wrote to him that she wanted to die. He became concerned about her. He thought she was mad. He needed to reassure her. He feared she might be near suicide. He wrote a calming telegram to her: 'Pardonner moi mon intention est bonne affectueusment. Lettre suit Rodin' ('forgive me my intention is good affectionately. Letter to follow Rodin'); and in the letter that followed he wrote, 'je vous aime, et je vous désire heureuse' ('I love you and I want you to be

happy'). Gwen was quieted by his concern, but she knew there was now no possibility of true intimacy between them.

She was steadied by her correspondence with her Slade friend Ursula Tyrwhitt, who wrote to Gwen when she was nearly out of her mind with yearning. Ursula wrote sensibly, 'Don't be soft on the subject of R.' She advised Gwen to channel her feelings into her art. Gwen responded to Ursula (in a continuation of her letter written on 30 November 1908): 'I have just read your letter again and your advising me to work and not care has made me want to try to. I think that is a beautiful idea, that we dig out the precious things hidden in us when we paint – and quite true.'

Ursula suggested that Gwen drew some little children whom she had talked to her about. Gwen was grateful to her, writing to Ursula on 4 September 1912:

I am in just the same state as when I saw you, I cannot paint or sleep and in the morning I have a headache which lasts all day more or less. It feels so strange, I was quite uneasy about it this morning, but I suppose it will go soon.

You have given me so much encouragement, Ursula.

Gwen began to feel calmer. Slowly she returned to her painting. She needed to make images that were peaceful and silent and still, so that the disturbance in her mind would be quieted. She began to fear the intensity of her emotions and that she might become deranged unless she was able to order

her thoughts. She acknowledged her gratitude to Ursula. She wrote to her: 'You belong to a part of my heart & mind – the same part where my love of art is – which is undisturbed by the events and difficulties of life.' And Gwen told herself to 'keep down the animal nature'.

In November 1910 she wrote to Ursula:

> I have taken a flat in Meudon. I have not paid anything for it yet as I am only going to possess it in January . . . it is the top storey of an old house quite near the forest. I shall sleep there and come into work in Paris nearly every day. I cannot sleep here well now, so I should have had to have some country air.

Meudon is on the outskirts of Paris. Gwen was oppressed by being in the centre of the city and needed a change. She counselled herself, 'Don't expect anything more from life. Love the difficulties.' Meudon was where Rodin lived with Rose Beuret: his steadfast companion, to whom he always returned and whom he would eventually marry in the last year of his life.

Gwen had walked to Meudon one day and had seen Rose in her garden. So this was Rodin's home. She wandered into the forest that bordered onto the old fortifications that formed part of the area. She loved the ancient feel of the place. The air was clear and she could hear the birds singing.

She wrote to Ursula in November 1911: 'Last evening I walked in the forest in the dark and rain, it was lovely walking through

the fallen leaves. I picked up a bundle of wood for my fire; there was much wind too.'

Augustus had shown her paintings to John Quinn, an American collector, who had been enchanted by her work and wanted to acquire some for his collection. Gwen had an offer of some money; she started to feel she might be able to be independent and need not rely on modelling as a source of income.

She began going to church. She needed religion to replace romantic love as the focus of her thoughts. She was captivated by the children from the local orphanage who sat in the front pews of the church. She sat at the back and drew them, together with the nuns who looked after them. She began to feel more peaceful.

She still thought obsessively about Rodin. He would some-times give her a lift in his horse and cart when they were both going to work in their studios in Paris – she had kept her room at rue de l'Ouest for this purpose. She would try to visit him, as she used to, in his studio, but Rodin had a new lover: the Duchesse de Choiseul, an American socialite, who took a dis-like to Gwen and banned her admission and diverted her letters. Gwen was shocked that Rodin was attracted to such a superficial person. She didn't see that he was old and that she exhausted him with her heightened emotions.

Sometimes he visited her in her room in Paris. He never made love to her in Meudon, because he felt inhibited about being so close to his home. Gwen liked it that she knew never to expect him there. She was not out of control, as she had

been. She loved the quiet that Meudon offered. She began to lead her life apart from him.

She wrote in her notebook on 18 November 1911: 'I am better alone. I have not been collected those days of getting my picture sent and I have got tired. The result is I feel further from God.'

Gwen John, *Self-Portrait, Naked, Sitting on a Bed*, 1909

Arthur Symons, the poet and critic, reviewed an exhibition by Rodin: 'sex, sex . . . bodies violently agitated either by the memory of, or the waiting for, sexual pleasure . . . [the model] turns on herself in a hundred attitudes, but always on the central pivot of her sex which accentuates itself with a fantastic and terrifying monotony'.

Lucian had Rodin's sculpture *Iris* on his sitting-room table. Iris is a messenger of the gods in Greek mythology. Rodin made several versions; Lucian owned the headless version. The ecstatic bronze figure of Iris has one leg raised and held by her hand, so that her genitals are exposed and form the central focus. Lucian was inspired by this work to paint nudes lying and sitting in a similarly exposing position. He said that he'd like the head to be just another limb. He was obsessed with genitalia, both male and female. Lucian worked from one point, and the rest of the painting developed and radiated around it. When he worked from a nude where the legs were splayed, he would always begin from the pubic area and work outwards. He started from what interested him most.

The performance artist Leigh Bowery, who sat for a series of portraits, asked Lucian, 'In your work the pictures of naked women are always straight women while the pictures of naked men are always of gay men. Why is that?'

Lucian replied, 'I'm drawn to women by nature and to queers because of their courage.'

Then Leigh Bowery asked, 'Do you like there to be a sexual possibility in your pictures?'

And Lucian replied, 'The paintings that excite me have an erotic element or side to them, irrespective of subject matter – Constable, for example.'

Lucian's replies were evasive. Although he had remarked to me that he found the thought of women making love to each other 'soothing', it wasn't what excited him. He said that he didn't like the direct, unflinching way that gay women returned his gaze. He needed to out-stare his models and lovers – he wanted them to look down, abashed. He needed to get the intimation of a sexual response from his naked sitters.

I was never a professional model. Lucian was a visiting tutor at The Slade. I met him when he came into the life-drawing class in the basement of The Slade, where I was working. I was keen to show him the recent studies I had made.

We became lovers a long time before I started to sit for him. When, after two years, he started a painting of me, I was not a good sitter. I felt alternately claustrophobic and resentful for most of the time. I sat for him because I needed to be with him, and because I loved him.

The first painting Lucian did of me he titled *Naked Girl with Egg*. He instructed me to take off my clothes and lie down on the narrow bed in the studio. Above me was a skylight. I hoped to be able to look up at the clouds and the wheeling seagulls, but he wanted me to look away, towards the fingers of my hand,

which I held up to my cheek. The other hand cupped my breast. My breasts were what Lucian was interested in. He used to be astonished by them and say, in wonder, 'You're SO voluptuous!' When we were in expensive restaurants, he would often comment on women's appearances as they passed our table: 'She is very well made.' He invariably meant that they were tall and broad-shouldered, with small breasts and narrow hips. I knew that this was his preferred type. I knew that, although Lucian commented on my curves, I was not his type. This knowledge made me feel especially downcast and undesired when I lay naked in front of him.

As he painted, he stood very close to me. He tucked a piece of rag torn from an old sheet into the belt around his waist. I feared that belt. It was made of plaited leather and the metal of the buckle was very sharp. He wiped his brushes onto the rag as he worked, so gradually it began to look like a butcher's apron smeared with blood. I never knew when he would decide to remove the rag and lie down on top of me.

He never removed his shirt, even during the night. While in bed, he wore the same mustard-coloured soft cotton top spotted with brown paint marks that he had worn when painting me. He never removed the silk scarf from around his neck, either.

Clay or marble, when depicting flesh, does not convey its vulnerability to the extent that pigment can. The colour of flesh exposes its defencelessness: the strange luminosity of skin

tones, the surface of the skin masking the underwater life of the red blood, the purple and brown of the tissues and organs.

Auguste Rodin was born on 12 November 1840 into a working-class family in Paris. As a young man he earned his living as an ornamenter. After his beloved sister Marie died suddenly in a convent in 1862, he was overcome with grief and turned to religion. He briefly entered a holy order, before resuming his work as an ornamenter and sculptor. In 1864 he started living with a young seamstress, Rose Beuret, with whom he had a son, named Auguste-Eugène Beuret. Rose's sister Thérèse looked after the son and Auguste never formed a relationship with him. He began to get commissions for his sculptures. In 1833 Rodin joined the studio of the sculptor Alfred Boucher, where he met eighteen-year-old Camille Claudel, also a sculptor, with whom he fell passionately in love. Auguste could never abandon Rose and this created terrible conflicts. He continued having a tempestuous relationship with Camille until 1898, when they finally parted. He had numerous relationships throughout his life, including his involvement with Gwen John. He married Rose Beuret in the last year of his life, when he was seventy-seven. By then he was world-famous. He had received the *Légion d'honneur* and all the highest accolades.

Camille used to watch Rodin secretly as he walked in his garden at Meudon with Rose. Camille and Gwen sometimes encountered each other, haunting the area around Rodin's home. They never spoke to each other but, when they silently crossed paths in the shadow of the walls surrounding their

lover's garden, I wonder what emotions they experienced. I wonder if they kept their eyes lowered as they passed, or if they looked at each other. If so, I wonder what their eyes betrayed.

Both Rodin and Freud consciously staged their own appearance: Rodin gazed at the camera with the dreamy, clairvoyant eyes of a mystic monk, a Rasputin, while Freud sucked in his cheeks and looked into the lens with the wide-eyed intensity of a bird of prey.

Rodin also had his preferred physical type: broad shoulders and narrow hips. He was most admiring of Greek classical sculpture, and this is what influenced him. Gwen fitted his type perfectly. She was a very good model for him in every way. She was free of shame about her nakedness and was prepared to do anything he asked.

It must have been thrilling for Gwen to witness the way he conjured up her presence by pressing his thumbs and fingers speedily into a small lump of clay propped on a tall plinth in front of where she was standing naked for him. He worked almost like a blind man feeling a form through touch.

A canvas often shields the painter from a sitter. A sculpture modelled from clay is exposed during the process: the sitter is able to observe every stage of its coming into being. Gwen must have felt more directly involved, for this reason. She referred to his sculpture of her as 'my statue'. I always felt very disassociated from Lucian's depictions of me. They were 'his' paintings, never 'mine'.

Rodin's erotic watercolour studies are some of the works by

him that I love most – the way he put down instinctive, fluid pencil marks in response to what he saw and then traced the lines onto another piece of paper and added flat washes of watercolour. The results are both free and specific.

I think this technique of his was the only way he influenced Gwen's art. This, and his gift to her of a book of Japanese drawings. She was not inspired by the ecstasy and drama of the stone-bound figures in his sculpture. She wanted something more muted, clear and definite. She started to use this method of tracing and watercolour. She produced urgent and fragile studies of young women, children, cats, flowers. Her work, including her oil paintings, became distilled and simplified as a result.

She described this practice to Ursula in a letter dated 15 February 1909:

I am doing some drawings in my glass, myself and the room, and I put white in the colour so it is like painting in oil and quicker. I have begun five. I first draw in the thing then trace it onto a clean piece of paper by holding it against the window. Then decide absolutely on the tones, then try and make them in colour and put them on flat. Then the thing is finished. I have finished one, it was rather bad because of the difficulty of getting the exact tones in colour and hesitations, and not knowing enough about water-colour. I want my drawings, if they are drawings, to be definite and clean like Japanese drawing. But they have not succeeded yet.

> I think, even if I don't do a good one, the work of
> deciding on the exact tones and colour . . . and the prac-
> tice of putting things down with decision ought to help
> me when I do a painting in oils – in fact all is there –
> except the modelling of flesh, perhaps.

The 'modelling of flesh' is something she did less and less as she became more and more interested in light and tones.

Lucian Freud was the supreme modeller of flesh. He was fascinated by the blood and veins that pulsed and glimmered beneath the skin's surface.

In my soft-ground etchings – a process not dissimilar to the tracing technique Gwen described – I want to include my 'hesitations'. I want to preserve the sense of searching and dis-covery. I don't want these prints of mine to be 'definite and clean'. I'd like the image to be fretted with pencil marks. I'd like the form to emerge gradually. I want these prints to be an intimate and true record of my questioning encounter with my subject matter.

Lucian only made hard-ground etchings. He wanted his prints to be 'definite and clean'. He drew in the image by scor-ing the surface of the inked plate directly with an etching needle. The plate was then bitten in acid and printed on paper. A soft-ground etching plate is prepared differently: a layer of beeswax is rolled onto the copper plate and when the wax has hardened, a thin piece of tissue paper is placed over the wax. The image is drawn in pencil onto the tissue paper – the pencil marks leave an impression in the wax. After the plate has been

bitten in the acid for several hours, the print will reveal the delicate marks of the pencil. It always feels like a miracle when it works.

When I met Lucian, I already knew that I wanted to work from people I loved. The way I think Lucian influenced me most was by his obsession with balances of power within the dynamics of a relationship. My art was deflected from its purpose on several occasions because of this influence. I am not interested in balances of power. Or, rather, I am interested in balances of power, but not of an obvious kind.

I did a painting of a young man and his girlfriend. The man is standing and the young woman is lying at his feet. I painted the whole of the man: he takes up most of the canvas. The young woman's head is all one sees of her, at the very bottom of the canvas. They split up before I had finished the painting. It remains unfinished. I would never have painted such a work if I hadn't been close to Lucian.

Not long after seeing my painting, Lucian started one of two men. In his painting, the standing man is taking up most of the space. His arms are raised and crossed behind his head. The other man's head, lying on a pillow at the base of the standing man's feet, is only just visible at the bottom of the canvas. Even though Lucian created his painting after seeing mine, I know that it was his subject matter really.

There is another way I was diverted from my true intention. I am sure, if I hadn't been involved with Lucian for so long, that I would have found my way back to working from

nature – from landscapes, places, the sea – much sooner. My paintings from nature were my first paintings and the ones I showed Lawrence Gowing, the Slade professor, when I was sixteen, and which persuaded him that I needed to devote myself to my art.

I started to focus on people through the discipline of life drawing at The Slade, which I rejected, to work from people who were close to me. This principle of solely working from people who mattered to me was further endorsed by my association with Lucian, who mostly held the same scruple, though – being more sociable than me – his circle of sitters was much wider than my own very small circle of family and friends.

Lucian said to me that 'Concentration is everything.' It was the method taught to me by my tutors in the life class at The Slade. I battled against it when I first started to paint more visionary works.

I think of a painter like Dürer, whose intensely focused studies of tufts of grass, of fur on a hare's back, on the skin of an old woman, are the epitome of all that is aimed for in the art of existentialism; and yet Dürer also dreamt up great visionary paintings. His Christ-like *Self-Portrait*, his *Lamentation of Christ* and *Christ among the Doctors*, are created from his inner world of dreams. I think of Rogier van der Weyden, of his *Deposition*, which hangs in Madrid's Prado Museum, where the deposed Christ flows into the agonised form of Mary, dressed in watery blue, so that their two figures are bound into a tidal wave of grief; and of Matthias Grünewald, whose crucifixions – both the famous one in the

Isenheim Altarpiece and the lesser-known one in Karlsruhe – break through all barriers of familiar representation to create the most profound expressions of loss ever painted. All these painters gave substance to their visions. These are painters who mean a lot to me.

My mother used to claim she could never have been an artist because she had been short-sighted since childhood. She thought that I became a painter because my eyesight has always been good. This assertion used to annoy me. I would tell her that eyesight had nothing to do with it, and that it's the artist's fresh response to the world that counts, together with their critical awareness; I cited the example of Degas, who went almost blind in old age and produced some of his greatest works when his eyesight was deteriorating; Bonnard and Chardin, too, must have been short-sighted: they sometimes depict themselves peering out at the viewer through round spectacles. But in my own case, I think the difference in eyesight between my left eye and my right may have had some influence on the painter that I am. I am long-sighted in my left eye and short-sighted in my right. When I'm working from life, I stand at a distance from my subject and I only look with my left eye. When I paint images from my inner vision, I look with my right eye, and I paint standing near to my canvas. I am both observer and dreamer.

In April 1913 Rodin visited Gwen in her room in Paris. She sensed a 'faiblesse' (feebleness) in them both, which depressed her. She was thirty-six and Rodin seventy-two, exactly twice

her age. She wrote to him afterwards: 'perhaps, mon Maître chéri, it was your coming to my room to make love to me that has made me feel like dying'.

Four years later she heard news of Rodin's death from her friend Ursula, who wrote to her saying that he had died at 4 a.m. on 17 November 1917.

Gwen responded on 22 November 1917:

Dear Ursula,

I have just got your letter. Thank you so much for it. It is good of you to have written it. It does me good. I will write to you again soon. I don't know what I am going to do.

Yours with love,

Gwen

She never referred directly to Rodin's death in her letters. She never spoke about how his death had affected her.

In the last years of his life I visited Lucian regularly. His earlier coldness towards me had thawed. Frank grew closer to his father, too, through sitting for a portrait.

Lucian and I would go for lunch in the restaurant next to his house in Kensington Church Street. He was very different. Sometimes his earlier face would superimpose itself onto my vision when I was talking to him and I would see again how he used to be – intense and challenging – and be astonished by the transformation into this well-meaning, gentle old man

who wanted to entertain me with anecdotes about all the famous people he'd met.

On the day that he died in 2011, my son and I visited him in his house. His daughter, Rose Boyt, guided us up the stairs to the bedroom where Lucian was lying in bed with his head on the pillows turned towards the window. His eyes were tightly shut. Straggling black hair covered his chin and jaw. The colour of his skin was like candle wax covered with ash.

Rose said that a nurse had told her that the last sense to leave a dying person was the sense of hearing and that we should speak a few words to him.

I said to him, gently, 'I hope you can sleep now.'

Frank remained silent. Rose and I left him alone in the room with his father, so that he could speak to him if he chose to, without being overlooked by us.

That night Rose texted me to say that Lucian had died. I woke my son, who was sleeping in the back bedroom of my flat. We stood in the kitchen together, he by the window. I knew not to go near him.

Great Russell Street, 25 June 2019

Dear Gwen,

What is this longing about, my dearest? Did you ever find an answer? Why does 'he' embody this yearning? Why is it necessary for us to gorge ourselves on this particular poison that only he can offer us? This lethal combination of fatherly concern and neglect. How has he learned to make this brew? What can he get from offering it to us?

Last night I had a dream about my father. He has been dead now for more than thirty-six years. I used to feel that I could conjure up his spirit by concentrating on him – not just my memories of him, but his true living self. But I think he has disappeared now into the dark for good. I dreamt that he was in a room isolated from the rest of the house, which was all on the same level, by a long corridor. I was with my mother and I wished she would go and make sure he was all right. But she said that we were having too much fun and she would visit him shortly. We each had a glass of wine. I was anxious about him and I left my mother to go and find him. I walked down the corridor to his room and peered through the glass door to where my father was lying in bed, his head propped up on some pillows. He was gently smiling, his eyes were infinitely sad and directed at some spot far in the distance.

I sensed that he knew he had lost his moorings and that he was already drifting out towards death. I woke feeling inexpressibly shaken.

I never really knew my father. I was never close to him, though I understood him and, in some ways, I think I resemble him: his self-discipline and his solitariness.

I have been painting the British Museum this morning. There are blue shadows across its façade and I have streaked the branches of my plane tree from left to right across the entire width of the canvas. The building looks as if it could be underwater as a result. I have been using a lot of Prussian Blue. Some of it got into my hair. It's such an intense colour – I have washed my hair twice and it still hasn't come out.

You had never been close to your father. In childhood you were imperious, and dismissive of him. You found his opinions too conventional. You rarely mention him in adult life. He was absent from your thoughts. He didn't interest you.

When you gave your daughterly affection to Rodin, your love turned into an obsession. Your anxiety about Rodin – his absences and unpredictability – often affected your health. You wrote in your notebook, 'Today I woke unwell. I have hurried dreadfully to meet R. He did not come. I have a headache and long for the sea.'

But you slowly started to channel your erotic obsession into your work; eight years later you wrote:

Faded roses (3 reds)
Nuts and nettles
Cyclamen and straw and earth (large slabs)
Faded primroses and dandelions
Milky bluets
Grey and yellow plaid

I imagine the calm and the silence as you write these notes to yourself.

After writing this to you, I must rush out to buy some paint. I hadn't realised how late it is . . .

It is the next morning. I look out of my window at my plane tree. The two bluetits that I've been seeing almost every day since the beginning of spring are hopping about on the branches, squeaking to each other, a tinny sound like a miniature saw cutting through a sheet of silvered glass.

I will write again soon.

With a handshake,

Celia

Celia Paul, *Narcissi*, 2021

Gwen John, *Faded Dahlias in a Grey Jug*, 1925

There is a passage in the Bible that Gwen John and I have thought about a lot: Luke, chapter 10, verse 38:

> Now as they went on their way, he entered a village and a woman named Martha received him into her house. And she had a sister called Mary who sat at the Lord's feet and listened to his teaching. But Martha was distracted with much serving and she went to him and said, 'Lord, do you not care that my sister has left me to serve alone? Tell her then to help me.' But the Lord answered her, 'Martha, Martha, you are anxious and troubled about many things; one thing is needful. Mary has chosen the good portion, which shall not be taken away from her.'

There is a painting I love by Velázquez of this scene. In the foreground a pudgy Martha is at the kitchen table preparing the supper. She is looking directly out of the canvas at the viewer. She is smouldering with resentment; Velázquez painted her as a sensual woman, her lips pouting sulkily. Behind her head, through the kitchen door, we can see Christ speaking

animatedly to Mary, who kneels at his feet, her head looking up at her Master with a rapt, adoring expression.

I have always desired to be Mary, not Martha. I want to have 'the good portion'. I want to keep in mind that only 'one thing is needful': my art. I haven't wanted to be the one who serves, I haven't wanted to be 'distracted with much serving'. But by being a mother, I have had to. I like to think that my painting has become more compassionate because of it. I comfort myself with the examples of Rembrandt, Vermeer and Constable, who all had family to support and struggled through the pressures, both financial and emotional.

Women are supposed to be better at 'multitasking' than men, but I can only focus on one thing. I have tried teaching at art schools. I have given my students my whole attention. Afterwards I have been so completely drained of all energy that I've been unable to concentrate on my own work for several days. For a lot of dedicated artists, the opposite is true and they are energised by their teaching.

Gwen identified with Mary, not Martha. But during the First World War she becomes a very different, less reclusive person. The tone of her letters to Ursula is more spirited and she wants to be actively involved. During the war she briefly became Martha, and appears to have enjoyed it.

She wrote to Ursula a month after the invasion of France:

The French papers say very little. There are often white spaces left, which is a bad sign. It means the authorities

who control the press have forbidden certain paragraphs for fear of depressing and frightening the public. Many wounded come in now. One died in Meudon. I may be useful if English wounded come here. Monsieur le Curé organises the placing of the wounded. I don't know how I could help him but I said I should be delighted of course.

She vividly describes her experiences of hiding with other Meudon residents, in a house used as an air-raid shelter. I am amused by how particular she is about the company she chooses to keep, even in a crisis. She wrote to Ursula in 1918:

There is a feeling of suspense here, I think, or perhaps I only have it, but I think more raids are sure to come. When the Gotha [*German bomber aircraft*] come one thinks more about them than the war. One shouldn't of course. We sometimes have false alerts and get up all the same of course. I found the people in my house so tiring, to listen to their uneducated talk and nonsense in the cellar. I can't stay when the bombardment is very loud, in my *logement*, because it sounds almost overhead. So I go to some friends, a man and his wife, rather old, a good long way off. I can't get dressed in time always before the tir de barrage [*barrage fire*] commences and I feel rather frightened in the roads . . . In these moonlight nights the

bushes have dark shadows and look as if there were mauvais sujets hiding in them, to spring out at me as I pass.

I get a real sense of Gwen, watching from her window, as the fighting intensifies. She wrote to Ursula:

It is strange living in a bombarded city. We have two dangers now, the avions and the canon à longue portée [*long-range artillery*] . . . From my window here I see the lights of the avions and sometimes I see a ball of fire falling I don't know what it is. I go down to the cellar when there is a great noise. It is much worse in Paris, the noise and all . . . I feel as if I have been ill for a long time and am getting better.

The last sentence is in reference to her grief over Rodin's death. Her active involvement in the drama of war helped her to overcome that grief. It healed her.

During this time she worked on a series of drawings that are unlike anything she produced, either before or after. She drew from photographs by war officials and military men. They are strong and strictly representational. There is no melancholy or mystery to these works. Ursula told her that she shouldn't be doing 'such stuff'.

If Gwen had continued to be public-spirited and actively involved with community life, she would not have become the great spiritual artist that she did. She would have become

Martha, not Mary. Her talent would have been dispersed. She would have lost her gift.

The Second World War began on 1 September 1939. Gwen John died in Dieppe on 18 September 1939. She had not been well. Augustus claimed, after her death, that she left Meudon and travelled to Dieppe by train, even though she was seriously ill, because she wanted to see the sea one last time. But possibly she was also trying to escape from the war, perhaps she was trying to get home. She didn't have the stamina to withstand another onslaught. She wouldn't have had the strength, by then, for any active participation.

Active participation in the war effort contributed to Gwen's recovery from grief over Rodin's death. After Lucian's death, I too longed to connect to the wider world.

For twenty-five years I had been represented by the same gallery, Marlborough Fine Art. I decided that a change was needed. I wrote to various galleries, which resulted in the offer, from Simon Martin at Pallant House Gallery in Chichester, for a joint exhibition with Gwen John. Victoria Miro saw this exhibition and I am now represented by Victoria. My life has been transformed since joining her gallery.

I had heard of the legendary writer and curator Hilton Als, through my friends Angus Cook and Jonathan Caplan. Angus had been studying English at University College London at the same time as I was at The Slade. We have been close friends ever since. His husband, Jonathan Caplan, had been at college

with Hilton in New York and often spoke of him admiringly. I had read Hilton's essays in *The New Yorker* as well as his two books: *The Women* and *White Girls*. When he agreed to Victoria Miro's invitation to write a catalogue essay for my first exhibition at her gallery, I was amazed. Hilton wrote a visionary text about his response to my work. I first met him when Victoria arranged for him to fly over from New York to London to do an in-conversation with me in the gallery space.

Great Russell Street, 7 July 2019

Dear Gwen,

I have been reading Vincent's letters to Theo again today. My three navy-blue volumes of more or less equal size – the size of bibles – are covered in splatters of paint marks and my hand-prints, where I must have snatched them up mid-painting to consult them about something. Vincent's relationship with his brother, Theo, sometimes reminds me of yours with Augustus. Both Theo and Augustus acted as emissaries to the world on behalf of their unworldly siblings. Hilton has four sisters, like me. Perhaps he could be like the brother I never had?

There is one of Vincent's letters that is particularly scored with paint: letter number 133. He hasn't written to Theo for a very long time. He has failed as an art dealer and he has failed as a school teacher. When he had then decided to follow in his clergyman father's footsteps and become a priest, his zeal had shocked his congregation. He starved himself and he never washed. He slept in abandoned sheds or outside in cabbage fields. He didn't cover himself with blankets, even in the harshest winters, but slept in the same rags that he wore by day and night. He believed he was truly following in Christ's footsteps. He urged himself on with sayings from the Bible about how,

in order to reach the kingdom of God, one must give up all worldly possessions, and that one must cut oneself off from all affections and appetites.

But his father, who always had misgivings about his tormented son being ordained into the priesthood, was now convinced Vincent was insane and tried to get him locked up in a lunatic asylum. Vincent had no sympathy from his mother, who remained self-righteously distanced from him. She had fatalistically observed that 'Vincent was always insane'.

He has had a violent quarrel with his father and has bitterly saddened his mother. Both the women he had been infatuated with have rejected him in the strongest terms. 'Never, no, never!' said one. Vincent feels that he is an outcast. He has lost all sense of the direction his life should go in.

He tells Theo that when one is going through such accidie, 'It is not at all amusing' and that the only way to preserve any shred of dignity is to isolate oneself.

Vincent describes how he feels like a caged bird when the spring arrives. The bird instinctively knows it is spring and batters its breast against the bars of the cage, to no avail. People look into the cage and wonder what is ailing this bird. Why can't it sing prettily and take little sips from its drinking saucer, as it ought to do? Vincent says that he, too, longs to be free and to be accepted into some sort of real kinship with his fellow men. To be respected and believed in. Not to be distrusted and regarded with such contempt that it would be better if he were put behind bars. He knows there is a world waiting to

accept him, if he could be released from this prison of disapproval that he finds himself in.

Vincent also likens himself to a house: inside there is a roaring fire in the hearth, but all anyone can see from the outside is a thin wisp of smoke.

It was soon after writing this letter that he turned decisively to painting. He dedicated himself to it for the rest of his short life.

For me, his paintings are more moving than anyone's. What do you think of his work, Gwen? Do you feel, as Sickert did, that looking at a painting by Van Gogh is like trying to walk through a newly ploughed field in dancing pumps? Do you think he should have been more restrained? If so, I think this is where you and I are very different.

But you have been almost as extreme. You have starved yourself 'for some bloody mystical reason', as your brother remarked, and you have isolated yourself from your family and from all who cared for you.

For you the only thing that mattered – what you sought more than any other thing – was to lead a more interior life. You wrote: 'be alone, be remote, be away from the world, be desolate. Then you will be near God.'

You were supported by, and yet you felt confined by, your brother. In a letter to Ursula dated 4 September 1912 you wrote:

You have given me so much encouragement, Ursula, you seem to agree with my decision to live as much as I can

in a way that I can have collectedness of thoughts. Gus worries me so much, and others, about it, and sometimes I think I ought to go and stay with him. I think that only when he worries me – there is no reason in the idea, in visiting a man who is not sympathetic to one – even if one had no nerves, it is a waste of time.

Augustus wrote an autobiographical book titled *Chiaroscuro* in which he included his description of you:

Gwen John's apparent timidity and evasiveness disguised a lofty pride and an implacable will. When possessed by one of the 'Demons' of which intrusions she sometimes complained, she was capable of a degree of exaltation combined with ruthlessness which, like a pointed pistol, compelled surrender: but the pistol would be pointed at herself.

It's a brilliantly vivid description, but I can't help feeling that you would have been irritated by it; I think I would, if he'd been writing about me. There's a sense of entitlement, of ownership. I think he has also misunderstood your masochism. You were not self-destructive out of a desire to be a victim in a narcissistic way. Your goal was Great Art and you knew you had to make sacrifices to attain it.

Vincent became more and more dependent on his brother, not only because of the money that Theo sent him and the art materials, but also for his understanding and concern. Theo

was his sole emissary to the world. You had a brother who supported you and believed in you, though he didn't understand you, or didn't want to understand you. You held yourself aloof from him, fearing his control. But who knows if, even with your genius, you would be recognised now, if it hadn't been for his influential help and encouragement?

Augustus introduced you to John Quinn, who bought your work for his American collections.

Let's talk about these American men who have helped us both so much.

I'll describe to you my first meeting. Hilton Als came into my life rather in the way that Augustin Meaulnes entered the lonely life of the narrator in *Le Grand Meaulnes* by Alain-Fournier: he burst into it, changing a solitary existence and opening up a whole, previously unimagined, range of experiences. He wanted to share America with me, too. He wanted me to see the New World.

But first I'd like to talk to you about John Quinn. I know you promised him paintings and then withheld them, saying that they were too ugly or they were still unfinished.

On 10 July 1914 you wrote to Quinn: '. . . I am going to keep you waiting still a little longer for the second picture, I am sorry to say. Let me tell you how sorry I am to be so long and uncertain in my work and let me thank you again for giving me the time.'

I have heard that you hid in your house, pretending to be

out, when he visited you to look at your work. Quinn promised you exhibitions in America, which you were excited about, but when the time came you made some excuse and pleaded with him to understand that you couldn't possibly interrupt your painting, which was only just beginning to break through. It wasn't a ploy on your part. You weren't playing hard to get. You needed and feared his attention. Both the need and the fear were intensely at war within you. The fear always won in the end.

No, that's not how it was. It wasn't fear, I know. It is presumptuous of me to suggest it even. You were guarding the sacred flame of your art, which can so easily be blown out by the merest breath of disturbance. You guarded it all your life.

On 27 March 1922 you wrote to Quinn:

I am quite in my work now and think of nothing else. I paint till it is dark, and the days are longer now and lighter and then I have supper and then I read about an hour and think of my painting and then I go to bed. Every day is the same. I like this life very much.

But it wasn't John Quinn you were interested in; it was his partner, Jeanne Robert Foster; you developed a deep attachment to her. You wrote to Quinn: 'I hope I shall paint Mrs Foster in March. I shall not be satisfied till I have done a portrait which you and I really love.'

*

I think our experiences – our excitement about this new contact with people who believed in us, yet came from so far away – held a significance for both of us.

I'll tell you about my meeting with Hilton when I next write.

With a handshake,

Celia

Jeanne was a poet. Gwen wrote to Quinn, 'I have never met a poetess nor any woman writer. I am tortured by shyness with strangers but I am sure I will like her.'

Jeanne had her own reasons to befriend Gwen. She wanted to acquire one of her paintings for herself. And she hoped Gwen would paint her portrait for Quinn's pleasure and approval.

On 14 September 1920 Jeanne arrived at Gwen's apartment in Meudon unexpectedly. Gwen never had visitors, so the knock on the door startled her. When she opened the door she saw a glamorous woman wearing a chic hat and coat, who greeted her effusively. Gwen had hastily thrown a dressing gown over her nightdress and her hair was loose and dishevelled. She apologised profusely for her lack of preparation. I imagine her putting a hand up to her throat to pull her gown more closely over her flimsy nightdress. Jeanne apologised in turn. She told Gwen that she would go for a little stroll while Gwen dressed. Gwen watched her saunter along the terrace and take out her camera to photograph some children who were playing there.

When she returned, she told Gwen how charming she found everything. Later that day she wrote to Quinn describing the

location and the interior of Gwen's apartment. Jeanne wrote that the house was situated along 'a crooked lane that backs up against the great terrace of ancient fortifications' and that, once inside the apartment, she had been astonished by the lack of material comfort. She detailed the uncarpeted stone floor, the lack of furniture apart from one very hard couch, a miniature coal stove and a rusty oil stove, a small bookcase against the wall, a pine table with nothing on it, an easel and three simple chairs. Since Rodin's death, Gwen no longer needed to make an inviting space to entice a lover – this interior sounds as bare as my own. The hall was completely empty of any furniture. When Jeanne looked into the adjoining room she saw a few cupboards. 'Nothing else, no comfort, no heat, no bath.' She did note the exceptional peace and the view over the old fortifications and the immense trees, and the silence.

She didn't direct her camera at Gwen but she observed and recorded for Quinn every detail of Gwen's physical appearance, that her eyes were 'almost Chinese in shape and of a clear extraordinary blueness' and that her hands were 'the slightly swollen pointed graceful hands of the heaven-born artist'. She described Gwen's dark hair parted simply in the middle and framing her face 'in an oval rim of shadow'. She said that the shape of Gwen's face was 'a pure oval' and that her complexion wasn't very clear. She used the word 'oval' several times when writing about Gwen's face, as if the word symbolised both purity and strength, as an egg seems to do; she noticed this dichotomy between timidity and fearlessness in Gwen's way of speaking, too: her quiet, hesitant

voice 'occasionally broken by contralto notes of a fantastic determination to live as she pleases'. She remarked on Gwen's quick but awkward, rather self-conscious way of moving. For Gwen, the intense attention of this sophisticated stranger must have been very momentous and exciting: her usual routine being so solitary. Jeanne's impressions convey an understanding which indicates a reciprocal intimacy between them: 'She is perfectly poised, a great lady in a way, proud, savagely proud, yet childish, very affectionate, wanting love, yet refusing it.'

Gwen intrigued Jeanne: she was surprised by how close she felt to Gwen from the start. When Jeanne eventually returned to New York, she drafted an article aimed for the American art market, treating Gwen as her own rare discovery: 'Personally she is rather a shy person, extremely modest about her painting and she prefers to live the life of a recluse in order to have more leisure for her craft. Her hair is black and she arranges it simply in a low knot. Her face is oval, her eyes brilliant, and her figure slim and delicately rounded.' She wanted to emphasise Gwen's femininity, knowing this would be more likely to appeal to a largely male audience, writing that Gwen had developed the Modernist technique to suit her own 'feminized charming manner entirely individual to herself' and that 'she has no theories. If she were to say anything on theory, she would say "Be truthful, be natural."' Jeanne was careful to place Gwen in the context of women artists such as Marie Laurencin and Irène Lagut, already established names in artistic circles in Paris, but knew that the public would be most

interested to hear of her associations with the two famous men in her life, introducing the article by describing Gwen as 'English' and the sister of Augustus John, following this by asserting that Gwen's arrival in France and involvement with Rodin had inspired her to leave behind 'the worship of mere skill in representation'. She commented that Gwen was 'a slow worker who often draws and paints the subject several times before she is satisfied to exhibit her work'. She knew how often Gwen had delayed sending Quinn works that she had promised him and, when Jeanne wrote the article, she understood, from her own personal experience of sitting for Gwen, how often a beautiful start to a painting remained just that – a beautiful start.

Now, on this still September morning, as the light intensified over the castellated forms of the fortifications, Jeanne was thinking about how to put into words the magic of this first encounter. She wanted to share her experience with Quinn and she wanted the world to know how uniquely Gwen lived and ordered her life.

The two women sat together on the terrace, dreamily sipping the tea Gwen had made, and talking about the things that mattered most to them both: art and religion and love. Gwen's company and conversation, seemed to weave a spell over Jeanne: she willingly gave herself up to the enchantment.

They spoke about the men they loved. Jeanne told Gwen how important Quinn was to her, how he had guided her tastes and values. His appreciation of Gwen's art had made

Jeanne long to know more about her. In response, Gwen got up and went into the studio to retrieve some letters Quinn had sent to her which had moved her deeply. She wept as she read out certain passages. Jeanne realised how lonely Gwen was and how crucial Quinn's support must be to her. Jeanne reported to Quinn later: 'I felt that you have given her back to the world'.

Jeanne noticed Gwen's look of pleasure when she confided in her how much she and Quinn admired Augustus's paintings: she had observed that the only painting that Gwen had hung on her studio wall was one by Augustus. Gwen talked to Jeanne about her recent commission by the nuns of the convent at Meudon to paint their foundress, Mère Poussepin, using an old prayer card with an engraving of her portrait as a template. She was excited by the challenge, describing the increasing hold that religion had on her life and how she was 'in love with the Catholic faith'. Jeanne understood – she was interested in religion, too, and was a member of the Theosophical Society.

Jeanne said that she and Quinn were fascinated by the art being produced in Paris at the moment and that they were keen to get to know contemporary French artists and to acquire their work: Picasso, Brancusi, Derain, De Segonzac, Rouault, Rousseau, Matisse, Laurencin. Gwen said that, of all of them, Georges Rouault was the artist who meant most to her and she intended to make paintings using a similar black outline to define the forms, filled in by bright, flat washes of colour. She described how her mother had taught her to fill in the outlines of colouring books and this method of painting

had inspired her all her life, and she saw a connection between her own work and Rouault's for this reason: the simplicity and purity. Jeanne intended to spend the next week or so in Paris, meeting the artists whom Quinn was interested in. She hoped Gwen would be willing to meet up with her again. She then approached Gwen about the real reason for her visit this morning and said that she would love Gwen to paint her portrait. They agreed to meet in two weeks' time at a small restaurant Gwen liked in order to discuss the portrait. Gwen had been prepared for Jeanne's request because Quinn had written to her: 'I am sure that you will make a beautiful, very distinguished and noble thing of your painting of Mrs Foster. Don't let anything interfere with it. She has postponed her sailing until October 1st in order to have it done.'

When they met two weeks later, Gwen wasn't well. She explained that she was too ill to start the portrait of her. Jeanne wrote to Quinn about the strange encounter that day:

> She may not be able to paint me. I have been looking about to find rooms with a north light, or a studio, this morning. She wants to paint in Paris, not Meudon . . . She came in half-dressed – her face drawn and colourless. She ate practically no luncheon but drank a little wine. I'll do my best to comfort her and get the portrait done.

Gwen talked to her wildly – some fantastic story about her infatuation with a priest who had just died. She told Jeanne

that it was he who had made her an artist, not Rodin, and that it was he who had commissioned the portrait of Mère Poussepin for the convent. The nuns had sent him to Versailles. He was stricken with grief over the death of a beloved older sister. She told Jeanne that she hadn't realised how much he needed her and she was distraught that she hadn't written to him. But she visited him on his bier because she wanted to draw him. When she moved down the sheet, which had been drawn up to his chin, so that she could see his neck, she saw a livid purple bruise on the side of his neck and realised that he had hanged himself. A newspaper report confirmed her suspicion that he had strangled himself with the window cord. She was mortified. She felt that if she had only visited him more often, he would never have killed himself.

Gwen felt that she had been beset by evil forces and she started to weep. She told Jeanne that she would like to die, but that she knew it would be a sin to commit suicide. She sobbed that she had had to drive nails into her shoes to keep them together; that she had lived in abject poverty and she'd had 'no warm clothing of any description'; that her 'hardships had been inconceivable'. Jeanne said she knew how much Augustus loved her and wanted to protect her – perhaps her state of mind was caused by extreme loneliness; perhaps she would be happier being in England with her family? Gwen fiercely defended her choice to live alone, saying that she couldn't bear to live anywhere near Augustus – or anyone – who might be able to come in every five minutes and advise her to paint 'in this way or that way'.

Jeanne wrote to Quinn that 'one interesting fact emerged' from this peculiar meeting: Gwen knew 'the mysterious country of flowers' that she had always dreamt about since earliest childhood. Gwen had described to her the strange forms and the size of the blossoms – white star flowers. Jeanne had responded to her by saying that she also had dreams of flowers, and she described to Gwen the flowers in the Apocryphon 'the flower fields of Araath'. Jeanne went on to confide in Gwen that she firmly believed in the existence of these fields and that only the pure in heart or children could visit them.

Jeanne tried to distract Gwen from her melancholy thoughts, but Gwen became depressed again. She said:

> I have become corrupted and depraved. I am eating food now and thinking that it is good. I am lying – that is, I lie sometimes; I no longer desire to live a religious life. Had I gone to Versailles to be with my friend as I intended, I might not have been able to endure the long hours in the church. He was intensely religious: he really had faith. There, I like to torment people sometimes.

Gwen then reverted to her hardships and said that she had been hungry for several years, and that Augustus never did anything to help her.

Jeanne explained to Quinn that the reason for her suffering was because 'Miss John's mind is extraordinarily fluid. She flows into that which is nearest. She is more myself than I am when I am with her.' Eventually Gwen calmed down and

thought that she trusted Jeanne enough to paint her portrait in Meudon, after all.

The sittings were arranged for the following September. On 26 August 1921 Gwen wrote to Jeanne:

I am so glad you can stay longer and that I can do your portrait . . . I have never done a portrait in less than a month (not working quite every day). I do several canvases before the one that remains . . .

You said you would take me for a voyage to some strange land. Better even than that I should like more days for my portrait. But I will do my best in what time you can give me . . .

Her *Woman in Profile*, an unfinished charcoal sketch, is all the evidence there is of these sittings. The location of the drawing is unknown and the only record of it is a photograph.

Jeanne described sitting for Gwen in her letters to Quinn:

I have sat for Gwen John this morning. I have been sitting for her three days. I have posed for drawings in every corner of her studio but she has not begun to paint. I go for a while in the morning and she makes a drawing of me in the morning light. In the afternoon she makes another drawing before tea. After tea she does another one. I have not seen any of them. She is impatient if the pose grows stiff and she says that she would rather not do me at all if I am going to pose. I explain

that my posing is quite unconscious and ask her to teach me 'not to pose'.

Gwen took down Jeanne's hair and arranged it in the same way as her own. She showed Jeanne how she would like her to sit – she wanted Jeanne to resemble her as much as possible. Jeanne wrote to Quinn that she felt 'the absorption of her personality as I sit'. Gwen instructed Jeanne to take off her necklace and bracelet. She was exasperated when Jeanne interrupted the session by taking off her watch, which she suddenly realised she was still wearing.

Jeanne was staying at Villa Calypso, a small hotel in Meudon. One day when she arrived to begin the sitting, Gwen had decided to go away for a few days. She loved to take long walks in the forest and sleep under the stars when the weather was warm. Jeanne was disconcerted by her absence and informed Quinn that Gwen had made 'one of her mysterious disappearances'.

Somehow Gwen was reluctant from the start to make this portrait on commission. It was not what she wanted to do. Yet she felt torn, because she wanted to please Jeanne and John Quinn. The painting never happened.

After Jeanne's return to New York, Quinn wrote Gwen a comforting letter:

Mrs Foster has told me all about her sittings at Meudon. I am sure that if there had been more time you would have done a fine thing for her. I understand perfectly

about the painting. I am sure you both tried very hard. I always said that a good portrait that is also a work of art is a miracle, and miracles don't happen often.

Gwen was lonely when Jeanne left. She pined for her company. She wrote her a letter pleading with her to come back: 'You won't find me sad now . . .'

When Jeanne failed to respond to her letters, Gwen was very hurt. Jeanne had written, not long after her return, that Quinn was suffering from a liver complaint but she didn't convey the seriousness of his condition. When at last she heard from Jeanne, Gwen was reluctantly forgiving. Jeanne's excuse was that she had been ill. In her responding letter, Gwen wrote to say that illness can be inspiring and that one can have thoughts of an elevated kind that one wouldn't have when well. She wrote, 'I'm sorry you were ill, and for so long, when I think about it in the ordinary sort of way.' Despite Gwen's insensitivity to Jeanne's physical state, Jeanne was mainly distressed at having hurt her feelings. 'I shall always love you just as I have loved you in the past and I am very much troubled that I have lost a part of your love. It was and is very precious to me.'

Gwen tried to turn Jeanne's absence into a merit, so that she wouldn't miss her so much: 'My mind is very slow and in your absence I can think of you without myself coming forward to interrupt as it does when you are here.'

A few months later, Gwen opened a letter from Ursula which shocked her with the news that Quinn had died. Ursula

had read of his death in the papers. Gwen wrote immediately to Ursula: 'Is it really true that John Quinn is dead?' And to Jeanne: 'Is it true that he is dead? I am dreadfully unhappy and you must me [*sic*] more unhappy'. Jeanne replied: 'I wish I could come to you now and beg for comfort and consolation (although I think there is none in the world now)'. John Quinn had died of cancer of the liver on 28 July 1923. Jeanne was devastated by his death. She was consoled by the thought of Gwen, in her solitude, understanding her grief. They were both comforted when they realised that, if they had unintentionally hurt each other's feelings, everything was harmonious between them now.

Despite her apparent timidity, Gwen was always certain of her talent. She had written to Quinn, after Jeanne's visit and after her failed attempt at painting her portrait: 'I don't think I told you that when I went with Mrs Foster to see the pictures you have bought at Pottier's I was very pleased and proud of my Mère Poussepin. I thought it the best picture there, but I liked the Seurat landscapes.'

This encounter between Gwen and Jeanne moves me particularly. Jeanne's description of Gwen as 'wanting love, yet refusing it' could be applied to me, too, as well as her self-imposed hardship. The sudden connection Gwen feels to a stranger is something I have experienced, though rarely. Because she and I are so solitary, the emotion we feel on discovering these rare unions is distilled to an almost unbearable intensity, which our fear of being taken over, and

intruded upon, only adds to. We question ourselves, our motives. These connections to people with whom we suddenly fall in love – out of the blue, as it were – shock us and make us lose our bearings. We strive to maintain our equilibrium at all costs.

Celia Paul, *Hilton*, 2014

Great Russell Street, 10 July 2019

Dearest Gwen,

It was the end of June, over five years ago now. I waited for Hilton Als in his hotel lounge, in Clerkenwell. He had arrived from America the night before. When he entered the room he stretched out his arms to me and embraced me warmly. He was luxuriously scented (he explained that he'd just had a bath) and his grey jumper was very soft.

He said that when two friends meet for the first time they might feel shy with each other, so, as it was a beautiful bright June morning, did I feel like taking a slow walk? Then we can talk as we walk, and get to know each other more easily than if we were in a confined space. 'Do you know?'

I agreed and we made our way out into the street.

He held my hand as we walked slowly in a westerly direction towards Bloomsbury. His large hand was very warm and soft. My hand, in his, felt fragile.

We would eventually arrive at my studio, but first we sat down on a bench in a churchyard close to Smithfield Market. We watched two dogs playing on the grass in front of the church. He said how easy it was for them, implying how complex human relationships were.

He held on to my hand as we sat. He asked me questions

about myself. He seemed to be listening intently. He asked me about my mother. We decided that we should like to travel together to visit her in her house in Cambridge. He asked about my relationship with my son, who now lived with his girlfriend in a flat around the corner from my mother, so that he could look after her: she was eighty-seven and beginning to find the daily practicalities too challenging to cope with on her own.

He talked to me about my early years as a mother, and how difficult it must have been to give up breastfeeding after only a few weeks so that I could get back to painting, and how hard it was for me to leave my baby to be looked after by my mother. He seemed to fully understand and empathise with me about how painful this decision was.

I noticed that he didn't want to talk about himself. If I asked him a question he would pause and then look away for a moment and say, 'Uh . . .' and then laugh and turn back to me with another question. His eyes were melancholy, wounded-looking, and there were deep shadows underneath them.

We resumed our slow walk, through the narrow streets of Clerkenwell where the tall buildings cast black shadows across the narrow streets and pavements. Everything opened out and lightened as we entered Bloomsbury, with its wide avenues and squares, filled with trees in full leaf. When we turned into Great Russell Street, suddenly there were the crowds of tourists. Hilton held my elbow as we walked, just on the funny-bone. He had let go of my hand.

We climbed the stairs to my flat together. He commented

on how much he preferred the bare stone of the steps that led to the door of my apartment. The lower stairs were carpeted.

When we entered my apartment we were silent. He looked slowly around him. As we walked here he had taken photos on the phone, his fingers flickering over the little gadget, which he held low down so that I was hardly aware of it. Now he was still. He said that this space reminded him of his grandmother's house. He was thinking of his father's mother.

We moved into the studio. Spontaneously I picked up a small canvas propped against one of the walls (one of many that line the walls of my studio, all with their faces hidden and the cross-bars of their stretchers showing), and I asked him if I could do a quick drawing of him. He sat on the chair in the corner of my studio, by the window. This is where all my sitters sit when I am painting them. This particular corner of the room holds the light like a container filled with liquid. The air around the sitting figure washes around it, like a stream flowing around a rock. The mood and form of the sitter affect this fluid light and air, staining the wall with washes of colour picked up from the clothes they are wearing and agitating or settling around the head, depending on whether the person is quiet or unquiet in spirit.

Hilton looked at me. Usually, my sitters look away from me. But he looked straight into my eyes. The directness of his gaze made me feel like I was on a tightrope above a great height and might fall at any moment. My charcoal would steady me, I hoped. I made lines on the canvas in response to what I saw, without interpreting the contours of his face, or the set of his

eyes, but entirely through touch, like a blind person feeling her way. I put one hand on my heart to try and calm myself. I didn't look at the marks I was making. He asked me if I ever cried when I worked. I think I must have looked as if I was anguished as I drew him. I showed him what I had done. I had caught something of him, after all.

A day or two later, we went to the café in Russell Square and sat outside at one of the small tables underneath the great plane trees. Pigeons circled and swooped. They landed on an abandoned plate of chips on the table next to ours: a teeming maggoty hoard of voracious claws and beaks. He flapped his hands at them and they rose up in a panicky whirring of wings, as one body, before they dispersed.

Hilton held my wrist. He tightened his grip. He said that this is a technique he often used on a boyfriend to help him to relax. We were due to do an in-conversation together in the gallery space where I had an exhibition. It was my first exhibition at the Victoria Miro Gallery, which had started to represent my work a few years after Lucian's death. Hilton knew that I was nervous about this very public event.

He told me that he'd like me to go with him to San Francisco one day. He had close friends there. He said that it was often misty and he asked me if I had ever seen *The Birds* by Alfred Hitchcock, which had been filmed in San Francisco. I told him I had and that the setting had left a strong visual impression on my mind – not just the threat of the birds, but the enclosed landscape of the bay and the misty sea, which had made me feel claustrophobic; also as if I was in somebody else's dream.

We made plans to visit my mother in Cambridge. We decided to go on 10 July, because that would be the thirty-first anniversary of my father's death. It is the same date as this letter I'm writing to you, Gwen, five years on.

The first night I had spent in my mother's house I had lain awake listening to the wind moaning behind the blocked-up fireplace in the bedroom that I had chosen to sleep in. I felt lonely here. It was her house, not mine. It was January and very cold.

My father had died the previous summer. We had always lived in big houses because they were properties owned by the Church. After his sudden death, the Church allowed my mother to remain in the bishop's house in Bradford until she had found a property of her own. My sister Jane, who lived in Cambridge, had found her this small terraced house close to the river. When the house had first been built, it must have backed onto Midsummer Common, but now it was divided from any glimpse of grass by a flyover connecting north and south Cambridge.

My mother loved this house. It was hers in a way that nothing else in her life had ever been. She had never been interested in housework or interior decor and, over the years, the walls became stained with damp, starlings roosted in the chimney, slugs left silvery trails over her dusty carpets. None of this bothered her at all. I have inherited her lack of regard for the material look of a room. The walls in my flat are similarly stained with damp, but my rooms are almost bare, whereas her

rooms were bursting at the seams with furniture and every form of household detritus. It was always too boring to think about clearing up or throwing things away. She wanted pleasure of a different kind from anything that a tidy room or a well-painted wall could offer her.

She would start every morning with the Bible. When I came downstairs each morning that I spent with her, she would always be ensconced in her big armchair by the window. Her open Bible and lectionary would be in her lap and her eyes would be closed. I was usually quite irritable with her. I thought she looked smug and self-conscious, and I would try and break her out of her religious thoughts by talking about more down-to-earth things: what were we going to have for lunch? For supper? I wanted her to concentrate on Me, not God. She was never resentful of my deliberate attempts to distract her from her prayers and she would whole-heartedly enter into more mundane discussions, without delay. She would gently close the books on her lap.

Because this house belonged to her, I was never able to work from her there. I felt too inhibited and cramped.

In her last years the sitting room and narrow corridor leading to the front door were crammed with a variety of Zimmer frames, shopping trolleys and walking sticks. She became very bent so that, from the back, you could only see the top of her head – a dark smudge above her rounded shoulders: her hair never went completely grey. Her spine was twisted by rheumatism into an S-shape, and her ankles and feet were swollen with oedema. As her thoughts began to muddle into dreams,

in the early stages of dementia, her face was rinsed clear of anxieties and her expression became serene. She developed a new habit of pushing forward her lower jaw slightly so that her top and bottom front teeth met and, with her lips closed in a smile that was hard to read, she looked past me, unaware of my presence in the room.

The walk from Cambridge station to my mother's house is as familiar to me as the lines on the palm of my own hand. It takes exactly twenty-five minutes, through narrow streets of small terraced houses, almost identical to each other. On this day, 10 July, we discussed walking, but my American friend and I decided to take a taxi; he had bought a huge bunch of flowers from Marks & Spencer at Cambridge station: a gift for my mother. As we approached the house, Hilton passed the flowers to me. I sensed that he felt it would be too demonstrative and showy for him to present them to my mother. He has a modest tact, at all times. He stood just behind me at her front door. He photographed the back of my head with the flowers blossoming out above my shoulders, in expectation. I rang the bell.

My mother opened the door. Her gnarled feet were bare. She gave him a radiant smile.

That morning my mother, sitting in her armchair, opened up like a flower in its pot, under the influence of my visitor's attentiveness to her. The big vase of flowers that Hilton had brought, which I had placed in the hearth at her bare feet, echoed her own face, blooming in the light of his regard. He was deferential to her, calling her 'Mrs Paul', listening carefully

and appreciative of everything: he noticed every detail. My mother, confusing him with some memory from her past, called him a 'great theologian'.

Frank prepared lunch for us: an elaborate three-course meal, which we ate from plates balanced on our knees in the tiny sitting room. Hilton said, after finishing the last spoonful of homemade kulfi, that he wouldn't be able to eat again for a week!

On leaving, my mother said that it had been such a pleasure to meet 'Celia's man-friend'.

In the train, on the way back to London, Hilton sat opposite me. He took a photograph of me as I slept, with the Cambridge landscape flying past me beyond the window: a blur of horizontal green and blue-grey.

When we arrived at King's Cross I knew that I wouldn't be seeing him again for a while. I told him how I hated saying goodbye. He stood on the platform, where we had alighted by the carriage door, and told me that I should walk on ahead. Whenever I looked back he was still standing there, and each time he raised his arm and waved, until I lost sight of him in the crowds as I exited the station.

I know that you suffered from this particular pain of parting. The uncertainty. The way that images and words from the time spent together rotate in one's brain, gathering intensity.

It makes me feel less alone to know you understand.

With a handshake,

Celia

Great Russell Street, 16 August 2019

Dearest Gwen,

Your mother's gift to you was art. She instilled in you its importance from the very beginning. You watched her and imitated her. You resolved to be an artist, like your mother. After her death, it was through your art that you remained connected to your mother.

My mother had no talent for visual art, though she always had a deep understanding of it. She remembered her visit to the Tate to see a Van Gogh exhibition as one of the pivotal moments of her spiritual life. She thought that he painted the essence of a tree, so that it signified something more – something undefinable, beyond visual description and beyond words. She became ecstatic and her face assumed a rapt expression when she talked to me about the moment of her first contact with Vincent's art.

My mother more often sought spirituality in literature. She was more at home with words than with images. She would have been pleased to know that I've started writing, old as I am. Perhaps I've turned to words now so that I can be closer to her, after her death.

A few months before she died, my mother gave me her copy of *The Swan in the Evening* by Rosamond Lehmann. On the

frontispiece my mother had written, in her particularly feminine, rounded handwriting, a quote from the Irish folk song from which the title of the book is taken:

And then she went homeward with one star awake
As the swan in the evening moves over the lake.

My mother loved this book. She had first read it when she thought I was dying. I had been diagnosed with leukaemia when I was three years old, but was pronounced cured when I was five and a half.

In this book Rosamond Lehmann describes the sudden death of her beloved daughter, Sally, from poliomyelitis at the age of twenty-four. Sally had been a radiantly beautiful and gifted young woman, who had only recently graduated from Oxford before travelling to Indonesia with her newly married husband. Her mother would never see her again. The shock of the loss nearly broke her. But then she had the strangest experience. She was aware of a perfume in the room, the sweetest of scents, and she began to receive messages of comfort from her daughter. I know that my own mother was comforted by this story when I was ill. She wanted me to be similarly comforted, when she had gone.

There is an early painting by you titled *Landscape at Tenby*. Tenby was your home when you were a child. It was where your mother had died. It is by the sea. You have painted the sea as a sort of rudimentary backdrop. Several stick figures are primitively painted playing in the sand in the far distance. The

main focus is on the woman and child in the foreground. The woman is dressed in black. She is self-absorbed and her expression is remote. The little girl, her hair blowing in the wind, is looking up at her beseechingly, longing for her attention, longing for her to join her.

You and I are that little girl. I always craved my mother's attention. She often seemed to me to be withholding it, and I suffered because of what I interpreted as her indifference to me.

I hope that if we meet I won't appear remote to you, like the woman you painted on the beach: I think, of the two of us, you remained more of a child than I have. I do have the habit of appearing aloof as a way of guarding my inner life. You would understand. Perhaps, in real life, we would pass each other by, without speaking. But now, in this letter to you in death, I reach out my hand.

With a handshake,

Celia

Celia Paul, *Charlotte*, 2019

Celia Paul, *Emily*, 2019

Great Russell Street, 10 September 2019

Dear Gwen,

Your correspondence with John Quinn and Jeanne Robert Foster lasted many years. My collaboration with Hilton lasted a long time, too. It was exciting to me to be so understood and supported. His belief in me energised me and gave me confidence, as John Quinn's encouragement gave you confidence.

To correspond and coincide with my exhibition at the Yale Center for British Art, Hilton Als made an installation in the long upper gallery of works from the Yale collection that he thought related to mine. He chose portraits by Gainsborough, Reynolds, Freud, Auerbach, Kossoff, Sickert and landscapes by Constable and Turner, and he arranged them in an ordered cluster so that they spoke to each other. Queen of them all, and outnumbering any other painters, were five by you; and a small unfinished portrait of a girl with a far-away, steadfast expression was at the very top of the house of cards, the mounted group of masters. I had told him that you were my favourite.

Hilton had selected seven paintings from my studio that he planned to exhibit first in Yale and then in Los Angeles. He chose three seascapes, a painting of a rose bush, a self-portrait and a painting that I did of the Brontë Parsonage; the central

picture in the exhibition was to be a big group portrait of my sisters, titled *My Sisters in Mourning*, a muted painting charged with grief, of my four sisters sitting together in a close semi-circle. There are two absent presences in this painting: my mother, and me.

There is a famous image of the three Brontë sisters, painted by their brother, Branwell. It is sometimes titled 'the pillar portrait' because, where he had represented himself between Emily and Charlotte, there now stands a vertical, luminous column of light where he painted himself out. He remains a permanent absent presence, cast out from the family circle by his own choice.

There is a similar feeling of grief and loneliness in this group portrait to the mourning one that I have painted of my sisters. In the Brontë portrait, it is almost as if they are portrayed as relics of some disaster, the figures still overlaid with ash as they were caught mid-action like the people overwhelmed, in the midst of their daily tasks, by the eruption of Vesuvius in Pompeii. The painting is badly preserved, the paint flaking and the cross-bars of the stretcher are glowing through onto the surface, enmeshed with the figures as another ghostly presence, a symbol of absence in the shape of a cross.

Branwell didn't bother much with the bodies of his sisters: they could all be identical mannequins draped in conventional prim Victorian costumes with neat little white collars at their throats. The face that leaps out at us, a living likeness, is the face of Emily, the sister he loved best. Anne is not looking directly at the viewer, but it's clear that his portrait of her is also a

good likeness. He has made other studies of her, and the particular way her eyebrows stoop down to the bridge of her nose and then lift up, like wings, is marked like a sign saying, 'This is how Anne's interesting eyebrows look.' The sister that has no physical resemblance at all to a living presence is Charlotte. Branwell has made a schematic token of a portrait of her. She openly disapproved of his drinking and drug-taking. They had been particularly close as children but later they resented each other. His crude depiction of her in the group portrait was a way of negating her. He absented himself from her completely by withdrawing his attention from her.

Male absence is the central theme for all of the books that the Brontës wrote. Romantic yearning is the fuel that powered their work. Heathcliff, Rochester, Monsieur Paul Emanuel, Arthur Huntingdon: all, in different ways, represent an unattainable promise of a union that is never completely fulfilled. All these absent men, of the Brontës' imagination, are prone to violent and unpredictable swings of mood and, by their erratic acts of violence, leave a trail of suffering victims in their wake.

The yearning in *Wuthering Heights*, by Emily, underscores the whole plot. The invisible thread that connects Cathy to Heathcliff is never broken, even by death; it is pulled by them both as they attempt to separate, until it nearly snaps, but never quite. They share their childhood memories. Their closeness has always been threatened, from the start, by their relation to each other, almost as brother and sister. Their agonising love is torture to them both. Their union would break

some fundamental law. And yet they belong to each other, irreparably. Heathcliff is a morose and terrifying presence, a sort of Caliban, an outcast. Cathy's own wayward, wild nature is a match for his own and she is never over-mastered by the force of his character. Yet the violence of his jealousy and his act of vengeance do finally destroy her.

I have already spoken to you, Gwen, of the saddest and greatest book of them all, *Villette*, by Charlotte, where, at the end, poor Lucy Snowe waits and waits for her irascible lover who will never return.

When my father was Bishop of Bradford I lived close to Haworth, where the Brontës lived. My bedroom window, which was also my studio window, faced the Yorkshire Moors, towards the Brontë Parsonage. The sisters and their disturbed, and disturbing, brother were often in my thoughts. I wondered about their lives and I felt connected to them, in a similar way to how I feel connected to you, Gwen. I felt connected to the loneliness and how the circumstances of this isolated life, for all of us, seem to be the inevitable atmosphere that helps us all to create. Charlotte compared herself and her sisters to potatoes growing in a cellar. Sometimes this lot that we have chosen, or to some extent been landed with, seems very abject and almost unbearably solitary.

Charlotte longed for letters from the man she was in love with, the professor at the school she had studied at, in Brussels: Monsieur Héger. She wrote to him passionately and compulsively until Monsieur Héger's wife put a stop to their

correspondence. You and I know, don't we, Gwen, about this particularly addictive poison: the waiting and the yearning? But what would we do if it was requited? I fear that my talent would shrivel up inside me. I know that I would channel my love away from my work and I'd be lost. I might continue to paint, but some vital ingredient – the intensity and edge – would be gone.

I went back to Haworth recently. I stayed in a guesthouse that looked onto the side of the Parsonage. In the early morning I went and stood in the graveyard in front of the house and looked towards the windows where the sisters had lived and worked. Tall pine trees grew among the graves. I thought of Charlotte's 'pining' and of how this emotion was what had driven her to write her great works. Leading away from the Parsonage was a thin silvery path, wet with rain, that was known as 'Emily's Path': it led to the Moors. For her, the emotion that fired her soul was more twisting and undefinable: she longed to be part of the natural world, she longed for an untainted innocence and she longed for freedom.

On that February morning the rooks were cawing in the tops of the pine trees, clattering and squabbling among the branches. That was the only sound. The air was still and grey.

Later that day I returned to the bishop's house, where I had lived as a young woman. I felt almost the same trepidation that Jane Eyre experienced when she returned to Thornfield Hall after a long absence, to find it a burnt-out ruin, her beloved Rochester presumably dead.

When I had lived in the bishop's house, I had been most deeply involved with Lucian. I waited for his phone calls every day with anxiety and was often shredded with agitation afterwards, feeling that I should have said other things than I had. I had been attuned to every modulation in Lucian's voice to indicate whether he loved me or not. My father sometimes answered the phone when Lucian rang, and he was often cold to him. My father felt that I should be more independent and not go running off to London whenever Lucian summoned me. Ursula advised you not to go 'soft' on Rodin. My father advised the same to me, when I was as infatuated with Lucian as you were with Rodin.

The bishop's house had changed: an Indian family lived there now and they had built on various extensions to the front of the house. But the back of the house remained the same as when I had left it, after my father's death, thirty-seven years ago. I looked up at my studio window where I had first started to make real works of art, where I learned to escape from the dry discipline of life drawing at The Slade and the existential dogma that Lucian stood by. I created more mystical works. I placed my mother in dream landscapes and I painted her eyes lit up like stars. She sat for me every day.

The lawns leading up to the windows were unchanged. I stood on the grass and looked up at my mother's and father's bedroom window. This bedroom was where my mother and I had found my father after he had had his stroke. He was lying in bed with his eyes staring rigidly ahead of him, unable to move. When he was taken to hospital, it was discovered that

he had a brain tumour. When it was operated on, two months later, the surgeon said that the operation had been successful. But my father never left the hospital. He never recovered. He contracted pneumonia in the intensive-care unit. He died three weeks after the surgery.

On the day I revisited the bishop's house I went to Bradford Cathedral to see if I could locate my father's plaque, which I had never seen. It had apparently been placed, over his ashes, somewhere in the interior of the building.

The cathedral is a modest construction built of blackened stone, with a small turreted square spire. I entered the building and walked up the aisle. I asked the verger where I might find the plaque for my father, and he indicated a side aisle to the right of the altar. I came across it, almost by chance. It was a discreet rectangular flagstone that fitted in with all the other flagstones on the floor of the aisle, but differed from them because carved into it were the words *IN PACE CHRISTI*, followed by a simple cross, and then my father's name, GEOF-FREY JOHN PAUL. Beneath his name was the date of his birth and the date of his death: 4.3.21–10.7.83; and then, finally: BISHOP OF BRADFORD 1981–1983.

I never knew my father properly. It always seemed as if he was preoccupied with something far more absorbing than me. I never found a way to engage his interest in me. He was proud of my art, but we never had proper conversations. I always felt a tight knot of self-consciousness in my stomach if we ever tried to speak about anything that mattered personally to me.

I was very affected by the sight of his gravestone – by its simplicity, by its absent presence. The cross on the stone reminded me of the cross-bars of the stretchers on my canvases. I have done a painting titled *Canvas-Back* to signify just this particular powerful presence of the lasting absence of death.

You never formed a close bond with your father, either. One of your very last paintings is of a woman looking out of a window. The cross-bars of the window-frame, in your painting, suggest to me that you didn't use a window at all, but the back of a canvas.

It's getting late now, my dearest. I'll write you more about Hilton tomorrow.

With a handshake,

Celia

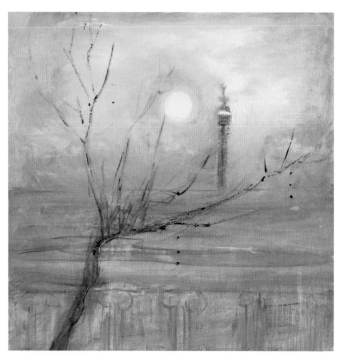

Celia Paul, *Full Moon, Bloomsbury*, 2021

Celia Paul, *BT Tower, Museum, Stars*, 2020

Great Russell Street, 2 October 2019

Dear Gwen,

Please forgive the delay in writing to you. I know I promised that I would write again the next day, in my last letter, but I haven't been well. I have been suffering from terrible headaches. I think it's because of the fumes from heavy traffic outside my window. The sound of the traffic doesn't flow smoothly – I could ignore it more easily if it did – but stops and starts abruptly. Great Russell Street is too narrow, really, to accommodate all the heavy lorries and buses that travel through constantly. There are always traffic jams. I hate the sound of an engine throbbing at standstill. It really distracts me when I'm trying to work.

Anyway, I haven't forgotten how I ended my last letter to you with a promise to tell you more about the exhibitions that Hilton curated for me . . . I think it will interest you because of the ideas that Hilton was working with, in relation to my art, which could just as easily be applied to your own art.

The first exhibition that Hilton curated of my work was in New York, in the gallery connected to the Metropolitan Opera House. The gallery stages regular exhibitions to coincide with the theme of whatever opera is being performed at the time. The opera that was playing concurrently with my exhibition

was *Otello*. Hilton selected several works from my studio that he felt could tie in with the themes within Shakespeare's play *Othello*: female innocence, male oppressiveness, longing and jealousy. He distressed the walls of the gallery space in pale ochre to resemble a Venetian interior.

I told him that I couldn't do work for commission, that the thought of doing something for a 'project' and for a deadline was against my working method. Hilton said that he would never dream of asking me to do anything so vulgar! I felt I'd been rather haughty and he had gently cut me down to size.

Hilton wanted to focus on the character of Desdemona. He chose paintings of mine of women and young girls alone in rooms, as if waiting for love.

The first painting that John Quinn managed to buy of yours, after many months' delay and much prevarication, was titled *Girl Reading at a Window*; the second painting of yours he bought is titled *Girl in a Blue Dress*. Both of these images would have fitted perfectly into the exhibition, dearest Gwen.

John Quinn was full of patience and respect for your working method, as Hilton was for mine. Quinn wrote to you: 'Take your time with it. Whenever it is ready, at your own time . . . let me know.'

Your paintings of women alone in rooms are cloistered and appear tranquil. They seem to be inhabiting a sacred space. To break the seal, by entering, would be a violation. And yet these women, despite their air of self-possession, are full of longing. Their dreams are of romance.

I know you loved Shakespeare, and you knew the plays very

201

well. It was one of the few things that drew you to your father, when you were a child. He used to read the plays of Shakespeare to his children, and you were riveted by the language and the images that it conjured up in your mind. My own father loved Shakespeare, too. I used to go regularly to Stratford-on-Avon with him, my mother and my sister Kate. Tears streamed down his face during Lear's speech to his dead daughter, Cordelia. I wondered at my father's emotion. He was undemonstrative to me, but perhaps he deeply loved his daughters?

Was *Othello* one of your favourites? I know you loved *Hamlet* and responded to the sad story of Ophelia, her madness and her death. You drew your exquisite friend from The Slade, Chloë Boughton-Leigh, as Ophelia. I'm sure you know the plot of *Othello* very well. I think you must have been struck by Brabantio's description of his daughter Desdemona, near the beginning of the play, and you must have identified with her: 'Of spirit so still and quiet that her motion / Blushed at herself'.

Hilton chose two big seascapes for my exhibition, too. I love the way that the image of the sea, and of water, echoes throughout the play: a restless, untameable force, an impending and unrestrainable violence lying in wait to be unleashed: the first storm at sea is described as 'It is a high-wrought flood' and, later, Othello likens his murderous jealousy to waves: 'Like to the Pontic Sea / Whose icy current and compulsive course / Ne'er feels retiring ebb'. And, after he has murdered her, Othello says of Desdemona, 'She was false as water.'

The tragic intensity of the plot is bound up with its inevitability. Desdemona has been swept away by Othello's tales of his adventures in battle. He, in turn, is enchanted by her interest. She wants to share in his exciting world. I picture her gazing up at him in wonder, like Mary at Jesus's feet in Velázquez's painting of Mary and Martha. Through marrying Othello, the commander of the army, and accompanying him in battle, Desdemona isolates herself: she is alone among men in a strange land. Her only female companion is her maid, Emilia, the wife of the treacherous Iago who will bring about the downfall. Iago is a terribly sinister creation, isn't he? I know how much you loved Dostoyevsky's books. I think that Iago could be a character in *The Devils*. Through well-crafted scheming and innuendoes, Iago makes Othello believe that Desdemona is having an affair with Cassio, Othello's lieutenant (Iago's motive is envy and ambition; he is only Othello's steward and craves promotion to lieutenant in Cassio's place). The seeds of jealousy are cleverly planted by Iago, soon becoming for Othello an obsessive self-inflicted torture – a poison – driving him to murder his beloved, the innocent Desdemona.

The ending is very bleak, desolate, isn't it? Somehow Desdemona appears more abject in her dying than any other Shakespearean heroine, to me. In the last days of her life, Desdemona has intimations of her fate. She is overwhelmed by loneliness and unable to think by what means she can bring her beloved back to his senses, and to her. She has been most unjustly accused and yet she doesn't feel anger; instead she is racked by the most unbearable sadness.

In the scene of her murder and just preceding it, she sings the song that her mother's maid used to sing to her when she was a little girl:

> *The poor soul sat sighing by a sycamore tree . . .*
> *The fresh streams ran by her, and murmured her moans,*
> *Sing willow, willow, willow.*
> *Her salt tears fell from her, and softened the stones,*
> *Sing willow, willow, willow . . .*
> *Let nobody blame him, his scorn I approve . . .*
> *Sing willow, willow, willow.*

Hilton chose a pencil study of some willow branches dipping into the River Cam, which I had made soon after my mother's death. He chose a small pencil study of a swan, also done in Cambridge after my mother's death, as a companion piece.

My son used to take me punting in the evenings and, as the light faded, swans used to drift up to us out of the darkness, ghostly, silent presences, leaving a plaited wake as they floated past the willow tendrils bordering the banks, before disappearing again into the darkness.

I do love the beautiful studies you made of Ophelia with Chloë Boughton-Leigh as your model. Her eyebrows are raised and arched over her heavily lidded eyes, and her loose watery hair streams out behind her back. I would have liked to see a drawing by you of Desdemona. But perhaps her death would be too heavily melancholy for you. Ophelia is a gentler

heroine. I could paint Desdemona; though I didn't make an obvious portrait of her for Hilton's exhibition, my portraits of women alone in rooms are harbouring heavier yearnings, more suited to a Desdemona than an Ophelia.

The image of Desdemona, alone and helpless, at the mercy of such unforeseen violence, has made me have sad thoughts . . .

The light is too dark to work, my dearest. I have been sitting in my front room listening to the wind stirring the leaves of my plane tree. I feel uneasy.

Gwen, I need to talk to you about something. You won't want to remember. There are memories we share that we've tried hard to forget. We've succeeded in forgetting, haven't we?

There's a little sculpted head he did of you, only a few inches tall, just your head and neck, no shoulders. But your mouth is clenched in shyness, self-consciousness: you were being looked at and didn't want to be. Did he rub the knuckle of his forefinger hard against your lips, angrily, wanting you to relax your mouth? Did he then lie you down on the bed?

And then did there ensue the most violent and passionate episodes?

But really you had never been so aroused in your life. Like being dropped three times from a high cliff – the terror of height, of letting go and then the blissful flowering of the parachute. Three times over, the terror and then the bliss.

And then, when it was over, did he dispassionately say, 'Oh,

there's blood' and get up, without looking at you, to open the windows, and lie down again and fall asleep immediately?

Did you so want to wake him to say, 'Be gentle with me'?

Was that why you tried so hard to be 'recueillie', so withheld?

Oh, Gwen. I can hear the thin cry of a child. I've woken you.

Your *Girl in a Blue Dress* is so beautiful. It is a porcelain cup filled to the brim and would overspill if there was a tremor. But all is still and poised.

Your flowers evoke the scent of blossoms, still shimmering from the dew. You went into your garden this morning to pick them. You didn't arrange them in the long-necked jug, you let them freely find their own arrangement – like wild flowers that a child has picked for her mother and then brings into her bedroom on a breakfast tray as a surprise for her.

Let's rest now, Gwen.

Please forgive me. You say, 'Letters are rather cowardly things sometimes, like throwing stones that can't be sent back to you.' You are indignant. Your maître was a gentle lover, unlike mine. He cared for you and wanted you to look after yourself and eat properly. He admired your painting and told you that you were a true artist.

With a handshake,
Celia

Celia Paul, *Swan, Cambridge*, 2020

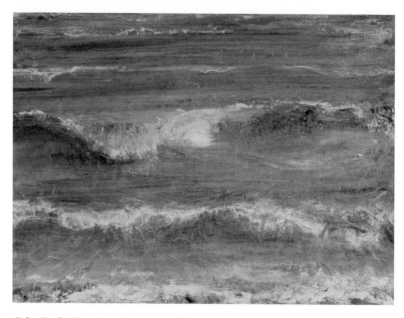

Celia Paul, *Waves Breaking on Lee Abbey Beach*, 2014

Lee Abbey, North Devon, 10 October 2019

Dear Gwen,

I thought that a change might be good. I haven't been able to shake off my headaches, but now I'm beginning to feel better. The weather is very beautiful. The leaves of the trees are turning gold, it is already autumn but the sun is bright and clear. There is a slight undertow of chill, which just adds to the feeling of purity and stillness. There is no wind.

I have come back to Lee Abbey to make studies for sea paintings. And to have some rest. London can be exhausting. I think that when I am tired I have darker thoughts.

'I said to my soul, be still . . .'

Let me describe to you what it's like here. Lee Abbey is an evangelical religious community where my father was warden. I lived at Lee Abbey from when I was eleven until I was seventeen. I went to boarding school. I had no privacy either at home (we lived and ate with the other community members) or at school. I became an artist here. I was inspired by the beauty of nature around me, and I needed art so that I could be alone, with my inner world. I may have been present in my body, with the community or with the other pupils, but my mind could be elsewhere.

Garden Lodge is the little house behind the main religious

community building and separated from it by a small flight of steps. This is where I was living when I first went to The Slade.

The front windows of Garden Lodge face the sea: a long view stretching steeply down past wind-contorted pines, fields of grazing cattle and ending in the protecting headland of Lee Abbey Beach. I know each bump and curve of this headland, and my exact knowledge makes me feel as if every irregularity in its profile is intended. If I need to feel peaceful, I picture its outline, even now.

From the lowest field before the beach, looking back up the hill, the Big House looks very stately. The high tawny crags of the Valley of Rocks form a dramatic backdrop to it. As you walk towards the Big House, up through the steep fields, the impression it gives is less dignified and more strange. You realise it is not that old and has an institutional feel. It is made up of many narrow blocks of brickwork walls supporting diagonal roofs concertinaed together, and hundreds of windows gazing seawards.

To the left and right are dense and ancient woods, threaded through with paths, which are kept in good order so that Lee Abbey guests in search of peace can follow them into the heart of the woods and feel restored by the silence found there. The woods stretch all the way from the house to the sea on a steep incline.

In the heart of the left-hand wood there is a deep pool fed by a stream whose source must be high up on Exmoor. A stronger stream bleeds off from the pool, gathering strength as it courses down through the trees until it finally cascades

and plumes out onto Lee Abbey Beach, where it is united with the sea.

If you take the right-hand path from the Big House through the woods, and if you carry on at the same level until you reach the end, you will be confronted by a sheer drop down to the sea. You will be prevented from falling by a flimsy iron railing. You feel dizzy looking down onto the ceaseless waves crashing on the rocks below and the seabirds circling and mewing. This point is known as 'Jenny's Leap' because, according to a story that may be true, a girl who had been jilted by her lover once jumped to her death here.

If you branch up to the right from Jenny's Leap you will reach 'The Tower': an old flint fortress that you can enter through a sturdy wooden door with a heavy iron latch. Once inside, with the door shut, it is completely silent and you can no longer hear the pounding of the waves. The peace is profound and it enters your soul to the extent that, even when you step outside, all sounds seem to be at a remove. The silence of the great ancient yew trees surrounding the tower seems to be at one with your own inner silence.

If you take the downward path from Jenny's Leap, you are guided through old woodland until you reach the lowest field above the beach. This is where I am staying now, dearest Gwen, in a little hut. It has one room with a bed in it, a little kitchen and a shower room attached. From my bed I can look out of the window and watch the sea. You approach the hut by following a narrow pebble path through the ancient trees that border the lowest field.

When I lived at Garden Lodge with my family, I shared a bedroom with Kate. Our bedroom window looked down past the twisted pines towards the bay. The house had been recently built. It felt flimsy and hardly strong enough to withstand the battering of the gales that regularly beat up from the sea. There was a temporary feel about it.

The sea, in its small cove, gently washes and laps like milk tilted from side to side in a bowl. The incoming waves obediently follow each other, like sheep brought home to the fold. The absolute peace of the scene stills my heart. In the evening the whole surface shimmers like one taut length of silver satin. The waters scarcely stir, but give out the gentlest of sighs to indicate that the world is alive still, but sleeping and peacefully dreaming.

I make studies of this sea to re-create into oil paintings back in my studio. I always write in the visitors' book, 'Please may this peace stay with me where I live in central London.'

I have been thinking of you as a child growing up by the sea on the coastal town of Tenby. Your brother says that you never lost your Pembrokeshire accent. The essential part of you remained a child. You saw the world anew every day. You were never deflected.

I wish you would write back to me and describe it all: your house, the beach, playing with your brothers and sister. Were you a joyful child? You look just yourself in a photograph I have seen of you. You didn't dream of trying to smile for the

camera. You are self-contained, not shy, but very quiet. You are patiently putting up with the demands of the photographer, but there's an air of wry superiority about you as if you find the whole process tedious and unnecessary. You are slightly amused by the fatuousness as well. You have an inner life and that's what counts. How could this person under his black hood, peering at you, record your fantastical thoughts?

The sound of the sea has stayed with you and washes through all your work with its gentle rhythm.

I sense your peace now. I am restored by being here. I understand your burning need to visit the sea, in Brittany and Normandy, when you were in France; it would have been too arduous, as well as emotionally taxing, to travel to Pembrokeshire.

I will try and keep the sound of the sea, the silence of these woods, in my mind.

I will need to get ready for my journey home to London soon, Gwen.

With a handshake,

Celia

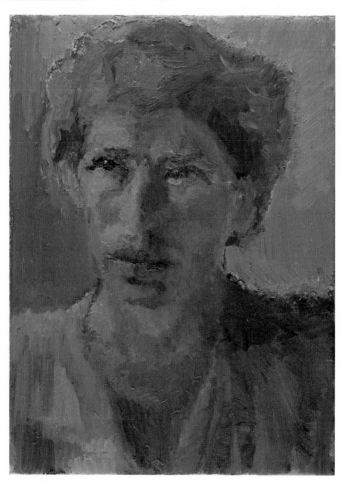

Celia Paul, *Steve*, 1994

Great Russell Street, 18 November 2019

Dear Gwen,

I need to talk to you about my husband. He is ill, though he still looks and feels well. He has had cancer for nine years now: first bladder, then lymph nodes, then bowel followed by liver, and a new tumour has just been detected in his lung.

I need your prayers for him.

I know that you never found a person who could return your love. I know that your great need was often frightening to other people. But maybe you also desired that distance and would have felt imperilled by proximity? I have also shared that fear. It took me a long time to be able to trust him and to put my trust in him.

We were married on 28 February 2011 in St Pancras register office. My son, my sister Kate and her husband, Rod, attended the ceremony. I had been going out with Steven since July 1993, but we decided to get married soon after he had first been diagnosed with cancer. He wanted me to inherit his academic pension when he died – the process being facilitated by marriage. He had been a lecturer in philosophy at the North London Polytechnic, later named the University of North London, until his retirement.

*

One day soon I will be alone again. Like you.

Loneliness is something you and I know about, don't we, but you have experienced complete isolation. This is something I'm frightened of and I'll need your help when my time comes.

When I first met Steven, I was scared of falling in love again. I had terrible nightmares. I needed to barricade myself against getting hurt. I have been hurt too much.

We never lived together and I have never let him have a key to my flat. It's essential to keep this as my private space. He has always understood. He is a private person, too. I have never met a human being who is so gentle.

He is a philosopher and a poet.

You and he would love each other. He had a little white cat that he called Maus. He adored her and they were inseparable. She used to ride around on his shoulders like a pirate's parrot. She loved only him. She would snarl and hiss at anyone else if they came too close and she would hit out with her claws if you tried to stroke her. Whenever she did this, he would say, 'Poor Maus!' You understand, because you would always defend your 'méchant chat' against any criticism. Steven still mourns Maus, even though it's now seven years since her death.

We go for walks on Hampstead Heath. Our long shadows on the grass, the two of us oddly joined. My love of nature reawakens, with him at my side. He stops to look at the intersection of branches silhouetted against the sky. He has his favourite trees: a raggedy rococo ash, a graceful silver birch, a

silent beech. I slow down and see things vividly. His presence enhances my vision.

When I was still at The Slade I used to go to a café in Charlotte Street. I always went with the hope of seeing the 'café man' there, seated at his usual table at the back of the cavernous room. He was completely absorbed in his writing. Once, when I passed him, he raised his head, but his blue eyes looked sightless. He was involved in his own thoughts and didn't see me. I was attracted to this lack of attention. I was tired of being scrutinised by Lucian. I didn't ever like to be looked at, though I've always craved attention. The 'café man' had a mysterious aura, at once sensual and modest. I thought about him a lot when I was alone.

I stopped going to the café in Charlotte Street after the birth of my son. My luxuries were whittled down because I now had no time to spare. But many years later I met him again. I recognised him instantly, even though he was very changed. He had lost his air of dreamy self-absorption. His blue eyes looked startled and his black hair had turned grey. He looked wounded. His open vulnerability, which he did nothing to try to hide, astonished me. His eyes would regularly fill with tears, as we spoke together. He didn't brush them away when they ran down his face.

Yesterday afternoon, in my front room as the already-overcast November day darkened into evening, I sat on my green chaise longue on one side of the room and he sat in a deep chair on the other side. The space between us reminded me of

the space in the Goya painting *La Junta*: an expanse of luminous absence / presence between the two groups of people.

I asked him first about his life. When and where were his parents born? How did they meet? How did they escape from Czechoslovakia?

The room became so dark I couldn't even make out his face. He wanted to please me by answering as truthfully as he could, but he was diffident about speaking of himself and regretful that there were so many things he should have asked his parents when they were still alive.

I worried that I was pressing on a bruise to ask him these questions. Which camps were his father's relatives sent to? Which, his aunt's?

I asked him about his earliest memories. He told me that from as far back as he could remember he had found a way of numbing himself against painful emotions. 'It's not good,' he said.

As a child, he wanted to read the Bible. What mainly attracted him to it was that he'd heard there were many books pertaining to it: he liked the idea of going to the library and coming out carrying armfuls of books and staggering home, barely able to walk because of their weight. But when he asked the librarian for all the books in the Bible, she replied that there was only one Bible and that all the books were contained within it. Steven was very disappointed when she handed him just the one book. When he got home he looked at the illustrations, which were saccharine in colour and sentiment. They nauseated him.

He told me that when he was still a child, he had a sudden realisation that God didn't exist. He suffered a terrible feeling of loss. He was shocked by this knowledge: he knew with absolute certainty that he'd discovered the truth and that God was simply an idea cooked up by human beings because they couldn't bear too much reality. The truth was that the world and the universe and the whole of nature were indifferent to anything we might experience and that we are merely specks of dust within the cold vastness of infinite space. There is no benevolent being with whom we could communicate. Just total unremitting indifference.

German is his first language and he still speaks it fluently. He and I have often stayed in a little house bordering the lake in Altaussee, in Austria. The lake is surrounded by great mountains, the presiding presence being the cathedral-like tower of Trisselwand, the tallest of the circle of mountains.

We love to get up early in the summer before the sun rises. The silence is intense. The dawn begins as a suggestion of light, gradually, almost imperceptibly, suffusing the sky. The sun is directly behind Trisselwand and we watch the way that the mountain darkens into a silhouette as the light behind it gains strength. Slowly the rocks and crevices at the summit begin to be accentuated until suddenly the sun explodes into the sky. At this instant, the mountain becomes invisible and we are nearly blinded.

The mountains contain sinister secrets. This area is called the 'Salzkammergut', the salt-mining district. The Nazis hid their stolen booty deep within the mines.

I wonder how this knowledge of the history of this beautiful place might affect him. All of his father's family were killed in Auschwitz.

His maternal grandparents had come to live with his mother and father. The grandparents reminisced, evening after long evening, with their daughter, about Ostrava, the place on the Moravian border that they had originally come from. Most of his mother's family had been able to escape to England via Poland.

My husband grew to think of Ostrava as 'home', through listening to their conversations, though he has never been there.

As his mother talked with her parents, sharing memories, his father felt his aloneness acutely and used to remain silent, thinking, or barely thinking, of all that had to remain unsaid.

Both Steven's mother and father, however, held no grudge and they used to vacation regularly in Austria.

Everything about this place is familiar to my husband, and everything delights him.

Soon after the sun has risen, he goes out from our house and unties a green boat from a post on the shore of the lake. He is going to row across to the 'bacherei' on the other side to get our breakfast of freshly baked rolls.

I stand on the bank outside our house and watch him as he rows further and further away from me until he is just a little speck, nearly overwhelmed by the vast expanse of water and the silent presences of the watchful mountains.

*

The room was quite dark now. And neither of us spoke.

Pray for us now, Gwen.

I am sending you love and hope that these words about my husband will reach you so that you will keep us both in your thoughts.

Your loving,

Celia

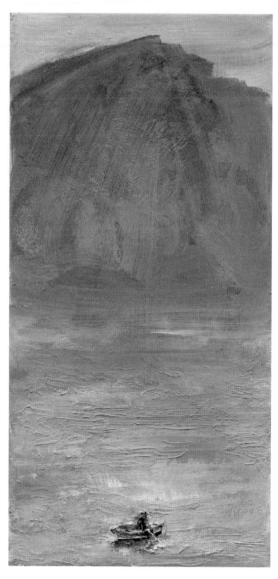

Celia Paul, *Steve in his Rowing Boat, Austria*, 2019

Great Russell Street, 10 December 2019

Dearest Gwen,

It's my son's birthday today. He is thirty-five.

In the last years of my mother's life, my son and his girl-friend Masha Cleminson (who is now his wife) were her carers. Frank has always been devoted to her. Her strength and compassion have had a profound impact on his own life. Her Christian ethic has guided him, even though he doesn't believe (in his grandmother's sense of 'belief'); Frank is unfailingly strong and compassionate in his own life.

Can I talk to you about this painting, which I've titled *My Mother and God*? I think it may be my best painting. I painted it when I was thirty years old.

For me, the really tragic thing about death is that the particularity of the person is lost when they die: their voice, their gestures, the tilt of their eyebrows, the shy covering up of too-protruding teeth when they smile. How can heaven ever replace such a loss?

My mother, like your Mère Poussepin, was deeply religious. I wanted to explore, in my painting, how her faith could be a comfort to her at this time: she was still grieving for my father; it was seven years after his death.

I prepared a long canvas. She sat for me on the battered and

torn sofa in my studio. She was wearing a dark-blue shirt. I asked her to turn her face away from the window.

I painted her head and shoulders at the bottom of the canvas. The area above her head remained unpainted for a very long time.

I worked and reworked the area around her left eye and forehead and the bridge of her nose. She sat for me week after week, but I couldn't get what I needed. I wanted it to be her – a likeness, but also her presence. I seemed to keep just missing the target: it wasn't near enough, it wasn't far enough. It was too tight or it was too undefined.

And then, one morning, it was as if God himself walked into the room. I captured her. I perfectly expressed her in the shape of her left eyelid.

After that, the painting came about very quickly. I painted the rest of her face. Her upturned nose (which she liked to define as 'retroussé'). Her wide mouth. Her comforting solidity. I painted the space above her head. I made it dark, with conflicting and energetic brushstrokes.

I wanted to suggest nothingness, almost the 'dark night of the soul' that St John of the Cross writes about: the necessary passage of loss that we must travel through in order to be reborn, when we have died to ourselves. St John of the Cross says that it is only through enduring this darkness and absolute loss, even of our own selves, that we can truly find ourselves and know who we really are. It is only then that we can find God. I wanted to express this idea of 'God', almost like the light at the end of a tunnel: there is

a thin horizon of light-gold paint at the very top of the canvas.

I painted this area of darkness and the narrow strip of light in one intense session. I was unaware of how arduous my mother must be finding this long sitting, with her neck tilted at a painful angle, as the hours passed.

When I at last put down my brush and said to her that I thought the painting was finished, she sighed with relief and exclaimed, 'That was quite a session!'

I only ever showed her my paintings when they were finished, never before.

Now she came and looked at what I had done. I told her the title. She was taken aback. She said that it didn't feel like her experience of God at all. 'All that weight of darkness.' And then, 'No, that's not how it is.'

I would like to know what you think of this painting by me? I know how much St John of the Cross meant to you. I know that you deliberately deprived yourself of material comforts and that you chose a life of solitude. My mother's faith was very different from yours. She valued worldly happiness. She took pleasure in eating and drinking, and she loved her family and was welcoming to all visitors. She believed in a gentler God than yours. Your God demanded sacrifice. My mother's God wanted his followers to be happy, in a simpler way.

I will write again soon, dearest.

With a handshake,

Celia

Celia Paul, *My Mother and God*, 1990

Gwen John, *Mère Poussepin seated at a Table*, mid-1910s

Gwen was commissioned by the nuns in the convent near where she was living in Meudon to paint a portrait of their foundress, known as Mère Poussepin. They gave her a small prayer card with an engraving of Mère Poussepin's image on it. The foundress is represented as an old woman with a long nose and a kind smile. Inspired by the image of the old woman with the long nose, Gwen begins a series of 'nun' paintings, the first one of which most closely resembles the face on the prayer card. But in Gwen's painting she uses a young woman as a model for the Mother Superior: the only concession to a likeness is that she elongates her young woman's nose and gives her a benevolent smile.

Old age is never Gwen John's subject matter. I wonder if it is because her mother died young, when she was still a child, and she remembered her as a youthful woman? She never paints an ageing self-portrait. In her later years she makes several studies of a subject that she titles simply *Old Woman*. But she is interested in the way the slab of the old woman's white headscarf contrasts with the narrow black line of material that trims the collar of her dress. She is not interested in recording the wrinkling of her skin, or even how the old woman must feel as she approaches her final years: there is no psychological empathy.

When Gwen was at The Slade she painted a portrait of the cleaning lady in the house she shared with her brother in Fitzroy Street. She dresses Mrs Atkinson in a black cloak and a black hat that resembles a collapsed chimneypot. She gives the old woman's eyes a far-away expression: this and a sheep's skull on the shelf above the fireplace (a childish trophy brought back from a walk in the Pembrokeshire countryside during the holidays) are the only indications that Gwen is attempting to understand the pathos of old age. What really interests her are the tawny and rust-red patterns of the wall-paper behind her head and the black fireplace, which resembles the fireplace that Lucian would later use as a back-drop to an early nude that he painted of Gwen's niece, Zoe Hicks – Augustus's daughter by a South American model named Chiquita.

Rodin made a sculpture that he titled *Celle qui fut la belle heaulmière*, which translates as 'She who was the beautiful helmet-maker' (or, more likely, 'helmet-maker's wife'). Her skinny arm is thrust behind her back and her tired dugs drip down like tallow grease onto her withered thighs as she sits, doubled-up with rheumatism; her head, on its scrawny neck, is lowered and her eyes in their hollow sockets are staring at the ground.

I once asked Lucian why he never painted naked portraits of old women. He replied that it wasn't his subject matter, but maybe it was mine. I have thought about this advice.

There is a painting by the artist Alice Neel of herself, naked in old age. There is no sentimentality in this depiction of

herself, no strained emotions. She sees herself as she is. All her work has this quality of acceptance. It is what makes her art uniquely uplifting. There is no overblown romanticism. She sees people – herself included – as they are.

I would like to do the same. I would like to see things as they are without the rose-tint of yearning through which I look at my outer and inner worlds. How did Alice Neel acquire this clarity of vision? If I too possessed this matter-of-fact clear-sightedness, would I lose some vital part of myself? Would my work become ordinary? I would like to try, nevertheless. Self-knowledge leads to self-acceptance. Rembrandt depicts himself in old age as he is – the squashy nose and sagging jowls – but it is clear that he accepts himself, that he loves himself. He doesn't flinch from the truth, yet he doesn't falsify his appearance with exaggerated cruelty or self-pity. An artist should love herself, if she is to be true. Once, when I was battling with self-hatred while trying to do a self-portrait, I had the idea of copying one of my favourite portraits by Frans Hals: *Portrait of a Woman*, in the Ferens Art Gallery in Hull. The woman's face expresses a transcendent goodness and kindness. I placed my copy of the Hals portrait on an easel adjacent to the easel that supported my miserable attempt at self-depiction, so that Hals's woman would look kindly upon me. My painting grew more compassionate as a result, and my self-portrait less falsely severe.

'Flesh', ageing or young, is almost impossible to depict impartially. Lucian's and Rodin's main subject is 'flesh'. Despite the power of their realism, the emotion is sometimes overblown

and theatrical. Rodin's Catholicism infuses his nudes with an upward strain: they are anguished or post-coitally inspired. Lucian was born in Berlin during the Weimar Republic. His art bears traces of the influence of Otto Dix and George Grosz. Even though this movement, named Neue Sachlichkeit (New Objectivity), aims to shun the romanticism of the previous era, their abstinence is tainted by a romantic warp.

Old age has always been my subject matter. When I was at The Slade, before I started working from my mother, I painted an old woman who was a resident at the old people's home near where we lived in Hull, where my father had been appointed bishop after leaving Lee Abbey. She was called Mrs Brown.

Mrs Brown was a small bird-like woman with huge, dark eyes that seemed to take up most of the space in her diminutive face. They often filled with tears as she was sitting for me. She sat very still. One day the tears spilled out and flowed down her cheeks. She told me that she was thinking of her cherished grandson, who had killed himself quite recently. She had doted on this boy, and all her fondest memories were of the time she spent with him when he was a child. But he had grown up to be an awkward and troubled adolescent. Mrs Brown and I became friends and she came to tea at the bishop's house.

Mrs Mawson was on the waiting list for the old people's home. I visited her in her one-bedroom house, which smelled of damp and urine. I set up my easel in her cramped sitting

room. Despite her shabby surroundings, she had a quiet dignity. There was something innocent and child-like about her. We hardly spoke. Her husband had died a few years previously and she was unused to talking. She sat in her armchair and gazed past me with an expression of gentle resignation.

I often think of those old women whom I have painted, my mother included, and I wonder at their quiet patience, and what inner reserves of strength they must draw on to keep up their courage and power to endure, riven as they all must be by memories and fear of the approaching dark.

In my own experience, women stay and men leave. Gwen's experience is quite different: her mother, not her father, left her by dying young; and, later, Gwen had to leave her brother in order to be free of his influence. She and Rodin never formally separated – he went on visiting her, though only rarely towards the end – until the final separation by his death in old age.

I have been wondering again why it is that Gwen never made an oil painting of a man, and that there are hardly any drawings by her of men, either. She had a brother whom she knew well and was close to – possibly too close. She easily formed friendships with men. Two of her closest friends at The Slade were male: Michel Salaman and Ambrose McEvoy. She was particularly attached to her nephews, not so much to her nieces. What inhibited her from working from men?

The only portrait she made of her brother Augustus was her

early watercolour and gouache study, *Portrait Group*; he is one of a number of figures – friends at The Slade – and you can't really see his face because it's shaded by a hat, under which it is possible to see the suggestion of a dark beard. The painting is derivative. It is clear that Gwen has been directly influenced by her brother: an anecdotal conversation piece that could have been painted by him. She made this work on paper when she was living with him in Fitzroy Street and it shows how susceptible she was to being taken over. It was a side of the intense empathy that she brought to everything she experienced, and why it was that Jeanne had written, 'Miss John's mind is extraordinarily fluid. She flows into that which is nearest.' Her thin skin meant that she took in more than most, but that she allowed others to invade, almost by a process of osmosis. It's as if she was inhabited by Augustus's spirit while she was living so close to him, and she couldn't truly be herself or speak in her own words. She wrote: 'I am ridiculous . . . I can't refuse anything that is asked of me.' This was part of the reason why she needed to separate herself from him. 'I suffered a long time because of him,' she wrote, 'it's like certain illnesses that recur in time.' These words make me feel sad and I wonder if, as well as fearing her brother's need to control her way of painting and the way she lived her life, Gwen also suffered from memories of a darker intrusive intimacy, which made her afraid.

In *Portrait Group* Augustus is standing beside a dark fireplace; the same fireplace appears in Gwen's portrait of their cleaning lady, Mrs Atkinson, which reminds me of the dark fireplace in Lucian's portrait of Zoe Hicks. Zoe was Augustus's

daughter. Lucian told me that Augustus had slept with Zoe, when he was an old man and she was a young woman. She also suggested to Lucian that Gwen's relationship with Augustus might briefly have been sexual, when they were both young.

When Gwen was living in Fitzroy Street with her brother, the boundaries between them weren't clearly drawn. As Michael Holroyd says in his biography of Augustus, when speaking of their cohabitation during The Slade years: 'they dared not stay too close – there was the danger of emotional trespass with all its trailing difficulties of guilt and regret'. I am reminded of Cathy and Heathcliff's tortured love, growing up together and treated as siblings from childhood. The intensity of their feelings for each other became intolerable when they reached adulthood. They had to separate. After Gwen left for Paris, she and Augustus met and corresponded regularly, but they were never intimate to the same extent, and they never painted each other again. She remained wary of him, and aloof. She never again wanted to submit herself to his influence.

Two years before Lucian's death, David Dawson, Lucian's long-term assistant, photographed me and Lucian when I was visiting him in his house in Kensington Church Street. Behind us, in the photograph and connecting our two figures, is a dark fireplace. I look tight-lipped and submissive. Lucian's legs are crossed, the upper leg swinging flirtatiously towards me, a dreamy look in his eyes. I did not feel submissive. I was, by this stage, free of his influence on me. I was aware, even as David was photographing us, of how I would appear: timid

and humble. These are two adjectives that were often applied to Gwen. They 'disguised a lofty pride', as her brother put it. She was a wolf in sheep's clothing, as I learned to be when I visited Lucian during the last years of his life. He and David would have thought I was too unsettling a presence as a visitor, if I had been more spirited. Lucian needed deference. He was an old man and I didn't want to upset him. The lowly attitude I adopted when I was with him made it impossible even to contemplate painting him.

Gwen never tried to paint Rodin and she made no pencil sketches of him. He was her 'Maître' and she was so over-whelmed by him that she wouldn't have been able to work from him. She was self-conscious in front of him. She wanted Rodin to look at her, but she didn't feel able to return his gaze. She couldn't see him for who he truly was. She, who knew how to capture the spirit of a child, a cat, a girl, was disempowered by a man.

The series of watercolour drawings of military and diplomatic officials that she made during the First World War are based on photographs in newspapers. She did them for John Quinn because she thought they might sell, as they were relevant to what was happening in the world. She didn't make them from an instinctive desire to record the person or thing that mattered to her. She needed the distance of the photographic image to work from when she made a study of a man. She couldn't work directly from one.

There are just three brilliant drawings by her of a man, all of them studies of her friend, the poet Arthur Symons, who

had reviewed Rodin's work and for whom Gwen had no erotic feelings. She captures him as a thoughtful, weary scholarly man, his effete hand with his long fingers held up to his forehead, his eyelids made heavy by too much reading. She was obviously comfortable in his presence and didn't need to be submissive, as she was with the men that she desired.

She was submissive with the women she was in love with, too. She never made a painting of Jeanne, though she tried to, and she never attempted to paint Véra Oumançoff. Her craving to be loved tied Gwen up in knots and prevented her from being true to herself.

I prefer to work from women because they are better at being still: stillness comes naturally. The men I work from have all found the silence that I require too challenging and they have had to insist on certain conditions, or certain strategies by which they can control the sittings. They can't just 'be there' for me, as my women sitters can. My friends Angus Cook and Cerith Wyn Evans, from whom I worked in the 1990s, and my son have all listened to audio tapes as they sat, as a way of distracting their thoughts. My husband learns clues for cryptic crosswords the night before, so that he can pass the time while he's sitting by thinking of the answers.

I drew Lucian always when he was sleeping. I started one painting of him. He was willing to sit for me and regularly offered to. But somehow it wasn't what I wanted to do and I never finished the painting. I think that my need to please

him inhibited me and I couldn't be true. Like you, desire often makes me lose my way.

If we had had a more equal relationship with these two men, perhaps we could have shown, through our art, some aspect of their characters that was known only to us. But Rodin was thirty-six years older than Gwen, and Lucian was thirty-seven years older than me.

Great Russell Street, 10 January 2020

Dear Gwen,

It has been exactly a month since I've written to you. I always find Christmas quite disruptive, though this year it felt special to be with my family. I spent most of the time playing with my three-year-old granddaughter and one-year-old grandson. I adore them.

It is always so good to return to my studio after a break. When I open the door to my flat and see my nearly-empty front room after a spell of absence, I am filled with excitement; my time is my own now, and the emptiness welcomes me with all the possibilities it suggests to me for private thought, for planning new paintings.

But after the first week of working very concentratedly, I started to expect the arrival of a visitor, and my thoughts became scattered. I didn't work so well.

I'm unquiet in spirit. My energy, which had been flowing in one direction, quietly but determinedly focused on my painting, has now branched off in tributaries of anxiety and longing.

In the morning, prior to his visit, I had tried to ward off any feeling of dispersion by starting a new painting, one I have been dreaming of for a while: the bishop's house in Bradford.

I will title the painting *My Father's House*, with its biblical allusion – 'In my Father's house are many mansions' – because the image of its many gabled windows signifies a multitude of in-dwellings, and the building lodges in my mind like a vision that stands outside time.

I went into my studio early this morning. The wind had been howling all night and the rain spitting against the windows, with a constant sizzle like a fire quietly dying. I had a sad dream about travelling across Paris with my mother and Frank – Frank was still a small boy. Somehow we became separated. My mother had told me the district of Paris where our hotel was situated, but not its name or the street it was in. I found myself in a café, trying to get help in finding them but knowing, with despair, that I had no information on their whereabouts. I'm still awash with sadness. I am an old woman now. And alone.

On the easel in my studio is the painting that I have been working on since my visitor's departure. I had shown him a few of my paintings, but not this one. My reluctance to show him this one made me question whether it worked or not. It is a painting of a willow tree that I often pass when I walk on Hampstead Heath. I have made pencil studies of it, and I took photos of it on my phone. When I first looked at it, after my visitor had left, I realised that the painting hadn't quite come alive. I have never worked well with the colour green. I often make it too acid, like sour apples. I don't know how Monet and Cézanne breathed such rich life into their green. I decided to paint over it and turn it into a painting of lake water.

I mixed Prussian Blue, Chrome Green, Vandyck Brown, Payne's Grey and Brilliant Yellow and spread it in a thin layer across my willow tree. It already suggested water. But then I started to feel haunted by the loss of my tree, and I scraped off the grey layer of paint with this scraper that I'd bought from a hardware shop. It left horizontal lines across the image, suggestive of water, and my willow appeared like a ghostly reflection. I thought maybe I'd discovered a mystical new interpretation to a way of painting. I want to do more paintings of reflections in water. I thought I needed to intensify the gleaming highlights of the watery streaks across the tree. I couldn't leave it alone, and I fear I may have killed it. It took all my courage to take it off the easel and place it, stretcher side out, against the wall. I'll look at it again after a while. I will return to *My Father's House* and to a painting I have started of a great copper beech (also a tree on Hampstead Heath). I need to gather my energy again into one tight knot. Please, Gwen, help me.

I had shown him three paintings. The first painting was of my sister Kate. It is the last *Kate in White*. I had planned it to be the last when I started it. So much will change this year. I am sixty now. I need to narrow down my vision and intensify it. I must allow no further distractions. The next painting I do of Kate will be in a year's time, when I will have been through a transforming fire. I don't know how this fire will present itself to me, or in what form, but I am certain of it – as certain as when in a train one is made aware, through the change in air pressure, that one is approaching a tunnel. The next painting of Kate will testify to this transformation.

You and I have often painted self-portraits by proxy. You made your sitters wear their hair like you did, and you instructed them to sit with their hands clasped in their laps – 'recueillie', as you desired to be.

The first painting I did titled *Kate in White* was more than ten years ago now. It coincided with my husband becoming ill. *Kate in White* signifies my strength in abstinence and solitude. I have hoped to be unassailable and complete within myself. Now, I feel something stirring within me. I want to be receptive, but I need your guidance badly.

The second painting I showed my visitor was a self-portrait, which I have titled *Overshadowed*. I had been inspired by a painting by Sofonisba Anguissola of herself and her more famous teacher, Bernardino Campi. She has portrayed him, brush in hand, in the act of painting her. She is depicted as a powerful portrait, as if painted by him, on his canvas. The directness of her gaze and the central position of her face make her the dominant presence in her double-portrait. One's eyes skim over him and are riveted by her. She has cleverly and subtly subverted the expected gender power-balance. I wanted to do something similar.

I chose a big canvas and I painted a self-portrait, slightly to the right of centre, sitting with my hands clasped in my lap. However, I am wearing my paint-encrusted painting dress and I am looking fearlessly and challengingly at the viewer. To my left I painted Lucian. I made a copy of his naked self-portrait (the one he did in later life with his arm raised, holding a knife) and I superimposed a portrait of him at the time when

I was most closely involved with him, copied from a photograph taken by Bruce Bernard in 1983. Lucian stood next to me, in my painting, as if in the act of painting me. My painting didn't work, however: it was too illustrative, too narrative. The great artist Paula Rego could have done a powerful narrative composition on such a theme, but not me. I was pleased with my depiction of Lucian, it caught him as he was, quicksilver and mercurial. But I painted him out. He left a shadow. I threw my own shadow on the wall against which I was sitting. Our two shadows interlocked and communicated with each other over my seated form. My eyes are alive and alight with challenge.

Male artists are very competitive with each other. As a woman artist, you can choose to enter the ring with the men. Or you can choose to step quietly outside the ring. You and I have done this, and all the women artists I feel most deeply connected to have done the same. Women hold this great, mainly untapped source of inner strength. We need to hold that and guard it. Only by being withheld ('recueillie') can we access this strength.

A woman painter needs to have all her wits about her when she is making a self-portrait. In my earliest attempts I often blundered into over-earnestness. I portrayed myself with my arm raised, brush in hand, touching the canvas, and my head is turned so that I am looking over my shoulder directly at the viewer with an intense outward stare. The feeling is false. I was inspired by the self-portraits of the great male artists who painted themselves in a similar pose: Goya, Rembrandt and

all. But women painters hardly even have a foothold in the history of art, so to represent themselves planted squarely in front of their canvas on the easel isn't right. They need to find oblique ways of self-representation.

You avoid over-earnestness in your self-portraits. You look at yourself truthfully. Your self-portraits are always painted on a small canvas. The scale helps you to narrow down your focus so that there is less chance of overblown false emotions entering in.

The third painting I showed my friend is a small, dark self-portrait of my head and shoulders. It burns with a quiet intensity. It is russet and grey: the colours of late autumn. I thought of you a lot when I made this image of myself.

I need you more than ever, Gwen. I need you to direct your calm regard upon me, to steady me. I am entering a time of turbulence.

I need to get back to *My Father's House.*

I'm continuing this letter later in the day. I have finished work now. I have been lying down on my bed in the back of the flat. I can hear the persistent whirring of the air-conditioning coming from the hostel that borders the back of my flat. The hostel is built above a Starbucks café, and I can hear the soothing tinkling of crockery as one of the staff does the washing up in the café's kitchen.

I was reading a book of your letters and notebooks, as I lay there, and the familiar sound of your voice has made me want to speak to you again. I love the way you withhold information

but suggest an atmosphere, so that I have pictures in my head of your life, your visits from Rodin, your preoccupations with your cat.

It made me laugh to read about your friend Elinor Mary Monsell, another Slade student, who had written you an odd letter, and you write, puzzled, to Ursula Tyrwhitt: 'Eily sent me a letter – I must answer it – she said she admires me because I have two aims, a life with two aims or something like that. What are they? Does she mean the cat for one?' You then go on to describe the carryings-on of your cat – this description really made me laugh:

> I am still searching and my sweet little outcasts were so hungry last night. Now the moon is full I am going to be out all night before the moon wanes and when the cats make love I run to see if my sweet is one of them (and there are always many onlookers besides the lovers).

My Father's House is beginning to emerge into life, if I can be delicate with it. I need to free it from its shell of paint, which is encasing the central image. I think there will be blossom trees obscuring the right-hand side of the building. I have been puzzling about how I should indicate that the windows and roof of the house extend behind the blossom tree without muddying the cloud of white blossom. When I look at a house with a tree in front of it, I always focus on the tree, so that I'll need to feel my way very gently into depicting the concealed structure. I'm trying to forget my *Willow Reflected in Water*,

which I fear I have killed, because it might inhibit me as I try
to bring this new painting to life.

It helps me a lot to write to you. It clears my mind. It helps
me to articulate what I am aiming for. Thank you.

I hope you won't mind if I write again very soon.

With a handshake,

Celia

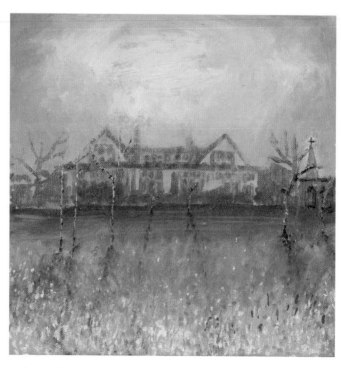

Celia Paul, *My Father's House*, 2020–21

Great Russell Street, 24 January 2020

Dear Gwen,

I woke again from a night of sad dreams. I can't remember them – they drift away from me like smoke that leaves an acrid taste in my mouth and mind. I drank too much wine again yesterday. I had two glasses in the restaurant with my husband and then I bought a bottle to drink alone on my little balcony, looking at the most beautiful sickle-moon with its accompanying bright star. The air was very clear and cold.

This morning, when I looked in the mirror, there were deep lines scored into the bags under my eyes. How to catch hold of this time, which is running through my fingers like water?

I need to prepare now for my painting. I need to return to *My Father's House*. Now that Kate won't be sitting for me for another year, I would like these letters to you, from now on, to be like the conversations I had with her during our breaks. I want to be honest with you.

It is the next day. I lie awake most of the night, feeling flayed with longing and loneliness. My insides are still burning with the most abject feelings of abandonment and loss. I wish I could regain my calm and self-sufficiency.

Yesterday I worked very hard on *My Father's House*. I need

to look and see what I have done. I need to leave it then, until the paint has dried, and then rework it and unify it. After I finished work on this painting, I put my *Willow Reflected in Water* back onto the easel. I heightened the tones of the water around the head of the willow. It still isn't right, but I think I know how to bring it together into one luminous whole. The paint is getting thick and I need to put the canvas to one side. Then I need to mix Burnt Sienna, Cadmium Yellow, Venetian Red, Nickel Titanium Yellow and spread it thinly over the surface to make a golden glow. I have put my *Copper Beech* back onto the easel. I need to resume work on it, if I dare. Of course I dare. It is already so strong that I need to keep the fire alight. Everything is to do with balance. One wrong move and the whole burning edifice of the tree will crumble away and die. The tree is its own balancing act: the leaves are stacked like plates on its many arms.

I read in your book of letters the one you wrote to Ursula after your father had visited you in Paris:

> I think if we are to do beautiful pictures we ought to be free of family conventions and ties.
>
> My father is here – not because he wished to see me or I to see him, but because other relations and people he knows think better of him if he has been to Paris to see me! And for that I have to be tired out and unable to paint for days. And he never helps me to live materially – or cares how I live.

Enough of this. I think the family has had its day. Don't you think so? We don't go to Heaven in families now, but one by one.

I have been thinking of painting a good deal lately. I think I shall do something good soon – if I am left to myself and not absolutely destroyed.

Please help me, Gwen, to work my way through these feelings of panic and fear – of ageing, of loneliness – somehow. Please help me 'to care and not to care'.

On 2 June 1925 you wrote to Ursula:

Tragedies have happened in my home lately and the cat I loved best has died, and another. It has stopped me in my work and all the flowers I was going to do pictures of have passed now. There remains the acacia trees that I see from my window but I cannot do them yet.

You continue, in the same letter: 'I liked the washed Ingres paper very much. Thank you so much for telling me about it. I have difficulty in pressing it but that may be because I needed big sheets, little sheets will come out flat better.'

Ursula had recommended that you soak Ingres paper in water and press five or six sheets of it together, and then keep them flattened under a heavy weight. You had been upset that a particular sort of Japanese paper that you had been

using was no longer available. You had written about the paper to Ursula:

> it is so exquisite for my drawings. The colour doesn't run into each other. The paper absorbs the colour and each touch of the brush has to be final, no retouching can be done. I feel quite ill when I realize that I've got to use some other paper.

The materiality of the painting process has always helped to stabilise me, too. I love the way that, in this letter, you move away from talking about the death of your cat and describe instead your delight in this new technique of pressing sheets of paper together to make a more absorbent surface for your watercolours.

I have just returned from buying paints from two shops near to my studio that sell artists' materials. Both shops are in short supply of a paint that I rely on. It has two names, depending on the manufacturer: Old Holland Yellow Light or Roberson's Naples Yellow Extra Pale. I managed to scrape together six small tubes from both suppliers. I hope and pray that their orders will arrive in the shops soon.

As I was returning to my flat, I noticed a couple walking in front of me: an old woman being supported by a younger, though grey-haired man. He held on to her arm solicitously. I recognised them as Paula Rego and her partner Anthony Rudolf. They were deep in conversation as they walked and I thought it would interrupt them if I caught up with them.

I stood and waited. I watched them walking slowly to the end of the street. When they turned the corner, I continued on my way.

I thought how much we need to cherish each other. I thought of my husband and how sad it is that we spend so little time together. We both need our separate space but, over the years, this distance has grown wider and wider. I love him very much. He has always understood me, and he has allowed me all the freedom in the world without once trying to own me or to compromise my art for his sake.

In your letter to Ursula, dated 7 August 1911, you write, 'I should like to go somewhere where I meet nobody I know till I am so strong that people and things could not effect [*sic*] me beyond reason', but in the same letter you also write, 'If you possibly can, Ursula, do come soon! I could now spend time every day with you . . .' I have often been daunted by how uncompromising you are, compared to me, but here you betray that you are as conflicted about loneliness versus companionship as I am.

I have been wondering how Paula Rego has balanced her life since the death of her husband, the painter Victor Willing, with whom she had three children.

But you and I are tragically wedded to our solitude. Our reclusiveness powers our art: it is what drives it.

You wrote in your notebook, 'Leave everybody and let them leave you. Then only will you be without fear.' You also wrote, 'Aloneness is nearer God, nearer réalité.'

*

We both crave and fear attention. We both lead solitary lives so that when we meet someone who understands us, we are swept away.

I once rang Hilton on his cell phone. I hadn't heard from him for a while and I was anxious. When I heard his voice, I cried. He was alarmed and concerned. He asked me if I was very lonely. I cried out, 'I AM lonely!' I felt a deep sense of shame to admit my loneliness. Why is this such a shameful emotion?

When Jeanne went back to New York, she was often very slow to respond to your entreating letters. You called her 'My sweet, my beautiful little Jeanne'. And you wrote, 'you will see how I love you always and have never ceased to though I pretended to (because I was hurt)'.

I sometimes envy you the peace you must be experiencing now that you are dead. How you are no longer racked with longing. I know this is wrong of me.

I wish I wasn't always so lonely, yet unable to be in company for long. Even the company of my most beloved husband, who I know I will miss unbearably when he's gone.

I know you understand and would forgive me my contrariness because I can't seem to help it. It's how I've always been, and so have you.

With a handshake,

Celia

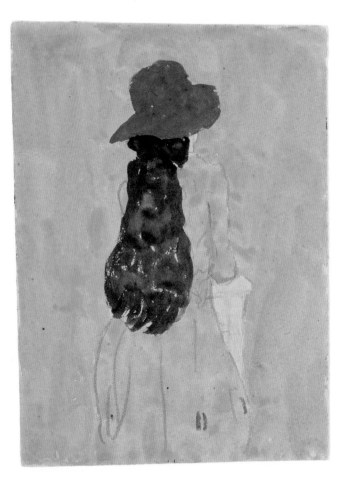

Gwen John, *Figure in Church*, c. 1910s

After the death of Rodin, Gwen became infatuated with a series of people – women and men. When her friend, the artist Isobel Bowser, died, Gwen comforted her sister, Nona Watkins, and her tenderness for Nona in her grief led Gwen to fall briefly in love with her. Gwen wrote to her, 'I need you Nona. I am a beggar at your door. I know that now. I know I wrote I don't ask for tenderness but only let me speak to you.' Augustus quotes a letter from Gwen to Nona in *Chiaroscuro*:

Dear Nona, my mind is suffering often with regrets that hurt me and other thoughts that hurt me and sometimes fears, and suddenly I heard your word[s], 'My dear, dear Gwen'. Nona, what angel made you say it? Nona, when you look at me so thoughtfully and write to me you don't know what you do.

Gwen soon transferred her love to her Slade friend Mary Constance Lloyd, who had posed for her nude at around the time Gwen was sitting for Rodin. Gwen had erotic imaginings about her: 'Let her draw you to her to kiss your hand. Later on you can kiss her more willingly with love & later still put your arms around her neck & kiss her, giving yourself.' Gwen

tortured herself with the unrealisability of her passion for her: 'Oh God, who has helped me in the past, oh help me now!'

She then became infatuated with a priest whom she got to know at church. She had confessed her feelings about him to Jeanne, in the encounter with her that I have written about. Rodin had been a monk before he became an artist. All the men Gwen was truly in love with were in, or had taken, religious orders. She wrote to the priest (she never mentioned him by name), 'Don't abandon me, I will never leave you. My lapses will not be taken into account but God will look into my heart and see my love and submission. You say you will be my love.' She became dependent on his regard and wrote in her notebook, 'Reasons to live: I may have the consolation of seeing him . . . Tell him everything. Wait for his answers and advice.' She wrote to him, 'Dear Father, when I come to you, I must. Don't think I could do otherwise than come, or be impatient. Little animals and birds do what they must I am like them.' And she signed her letter 'Mary', as she used to do with Rodin.

She had one last crush on a priest, which was requited to some extent. He was Canon Pierme, who was also affiliated with the church in Meudon. She called him 'Cher Maître' and they went on long woodland walks together. He asked her to hide the postcards and letters he sent her. She told him that she was his humble obedient Mary, and that she kissed his hands and feet in the name of Jesus. Canon Pierme started to worry that their liaison would be discovered. He asked Gwen to destroy not only his letters, but also the envelopes with his

handwriting. She told him that she missed him all the time so much that she sometimes didn't know what to do. But when she discovered that he'd moved elsewhere, she forgot about him. Her obsessions didn't last long and, when they were over, it was as though she hardly understood how she could have got herself into such a state over someone who meant nothing to her really.

Gwen wrote to Ursula on 6 June 1925: 'I've been two days in a hospital having an operation! And came home yesterday. The operation was having a needle taken out of my thigh!!!' In December 1925 Gwen confessed, 'I'm not painting and the time is passing quickly.' She sounds vulnerable in the letters she wrote to Ursula at this time, as if she's stressed and perhaps neglecting herself through loneliness.

In early summer 1927 she met Véra Oumançoff, the sister-in-law of the philosopher Jacques Maritain. They both lived in Meudon. Véra was an ardent Catholic. When Gwen burned her hand badly while lighting a lamp, Véra comforted her. It felt like a long time to Gwen since anyone had treated her with such gentle kindness. She responded by falling in love with Véra.

Véra tried to set limits to her demands. She agreed to meet Gwen once a week, on a Monday. Gwen did drawings for Véra, which she would bring for her when they met. But she longed for Véra all the time. She confided her feelings to the Mother Superior of the convent, who advised her that, if she wasn't able to see Véra, maybe she could channel some of her feelings into letters, which she could send to her. Gwen started

to shower Véra with letters – one was sixty-nine pages long. She wrote to her, 'Part of my heart imprisons me, I will die of hunger or be suffocated.' She often went for long walks in the neighbouring countryside. She wrote to Véra:

> At the moment I am doing some things which I see in the woods and the meadows and the roads around Meudon. Sometimes I am too tired to come back home in the evening or I'm too far from a station to return and sometimes I don't come home for three or four days.

In one letter Gwen described a dream she'd had while sleeping under the stars in the forest. She wrote to Véra that in her dream she saw brightly coloured anemones on the other side of the road and that she picked big bunches of them. She dreamt that she came back by a different path and saw that there were no longer any crocuses or violets growing there. She stopped to admire the view and called out to the grille outside Véra's house, 'Voilà la Seine! Voilà la Tour Iffel [*sic*]!' And she describes seeing Véra, who had more colour in her cheeks than usual, as she did, too. Gwen looked up the word 'yearning' in her French dictionary, but couldn't find it. She wanted to convey to Véra the strength of her emotion.

There was a check on her ardour, however. Her painting always grounded her, and she could never let melodramatic language falsify her feelings, where art was concerned. Véra had no artistic judgement at all. She thought that painting must be a relaxation for Gwen, and a pleasure. Gwen was

irritated by her obtuseness. She explained to Véra, in a letter written in August 1927:

> I tell you that sometimes my work tires me. It isn't often a pleasure. It has always been tiring and difficult, I do it as I do my housework, because it has to be done . . . and it has the same degree of importance. The only difference is that my painting is more tiring and more difficult and also sometimes gives me little surprises, now that I understand the Technique better. But the pleasure is so rare that it doesn't count. I sometimes enjoy seeing things but that's before thinking about them as drawings or pictures.

She wrote in her notebook, 'Art has to be made, it's no good waiting for it to emerge gradually from within oneself', and she drafted a letter to Véra in which she explained, 'My art was not born, it didn't come out of a mould.'

Gradually she began to recognise that Véra and she had little in common. When Gwen painted a *Madonna and Child* as a gift for her, Véra scoffed at it and said that it was just sentimentalism. Gwen retaliated with anger: 'You seem to think everything is sentimentalism. Did you invent the expression yourself?' When Véra moved away from the neighbourhood, Gwen didn't grieve over her absence.

The image of the Madonna and Child, titled *Madonna and Child in a Landscape*, is different from Gwen's other work in that it is directly influenced by Rouault, whose paintings she

had recently seen and admired for their simplicity and emotional power. Her Madonna and Child are in a dream landscape made up of geometric shapes outlined in black. The clouds have straight edges and are rudimentarily suggested behind the figures – the mother and baby form a simple silhouette, standing on a childishly drawn hill with a double hump like a camel's back. The sharp palm leaves spreading out from the right-hand corner of the painting add to the Middle Eastern mood. It looks like an ancient work of art from Byzantium. This painting, which Gwen made as a gift for Véra, is also reminiscent of the simple outline pictures that her mother taught her to paint when she was a little girl. There is a wistful sense of a lost land of childhood in which the mother and child – Gwen and her mother – were united once, a long time ago.

At the height of her infatuation, when her letters to Véra were boiling over with effusive sentiment, Gwen was making her miraculous watercolour studies of the orphans and nuns in church. They are among the most beautiful works she ever made – jewels of crystal-clear insight that seem to capture the soul of the person in a single instantaneous brushstroke. In one, a little boy, seated next to his stiff, darkly clad guardian, turns around and catches Gwen drawing him. His eyes look at her, riveted and curious. The image must have been made in a flash. She was not disconcerted by his scrutiny; she smiled a little at him to reassure him maybe, but she didn't take her gaze off him for a second, even to look at the marks she was making with her paintbrush.

She made a list in her notebook of the colours she was using in her paintings: Okre Jaune, Okre Brown, Okre Red, Lemon Yellow, Black, Yellow Okre, Chrome Green. Again it was the materials, the substance of painting, that helped to calm her and lead her back to sanity.

The friend who remained closest to her, and whom she never fell in love with, was Ursula Tyrwhitt. Gwen wrote to her, when Ursula mentioned that their old friend from The Slade, Gwen Salmond, wanted to visit her:

It's very lovely here. It's very quiet and peaceful. If I saw GS and others it wouldn't be, because my mind is not strong enough to keep its harmony when any difficulties and obstacles come. But if you came it would not be the same, as we come into each other's solitude or harmony, don't we? We are a part of each other's 'atmosphere'.

On 30 December 1927 Gwen made lists in her notebooks of colours. A new serenity seems to enter her writings at this time. I sense the satisfaction that she feels in working quietly and methodically by herself. She wrote:

Faded dewberry flowers

blacks	flowers	ground
paynes grey	arrange	raw umber
black		

Blackberry flowers

blacks	flowers	ground
vert [de] ch[rome]	yellow ochre	ochre j[aune]
	naples yellow	ochre b[run]
	lem[on] yellow	ochre r[ouge]
	black	

On 29 March 1930 she wrote in her notebook:

Primrose = chromes, verts, bistre, gamboge, blues lacs, mole, capu[t] mortum
Drawing of primrose – brown black (rusty blacks) sep[ia] col[oured]

. . .

Dead leaves. Terres. Sep[ia] Col[oured]
Drawing of dead leaves = Green, black

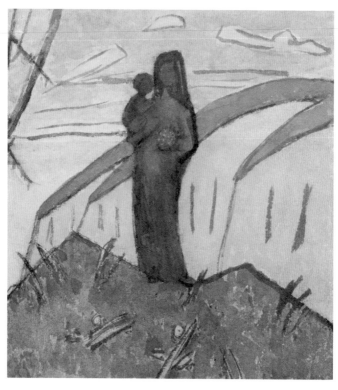

Gwen John, *Madonna and Child in a Landscape*, 1928

Great Russell Street, 28 February 2020

Dearest Gwen,

You wrote in your notebook in August 1916: 'Oh what a world is open to us when our mind is in peace! A world of eternal things. What a world and what sweetness in humble solitary work, what pleasures. Pleasure we miss when we are in société or agitated.'

Thank you with all my heart for your prayers for me today. My painting of the copper beech was torn out of me like a demon being exorcised, and now I feel at peace. This joy I experience is a deeper emotion than any other happiness, and I know that all my loneliness and longing were necessary to bring this new life into the world. I may have done something remarkable. The tree resembles a controlled explosion: rust and red and black and gold. The copper-beech tree is a perennial Ode to Autumn.

And now I must return to my *Willow* painting.

It is later this morning. When I put my painting *Willow Reflected in Water* onto the easel, I realised that it was much closer to being finished than I had thought. I added a halo of gold (using Nickel Titanium Yellow mixed with Old Holland Yellow Light) and I'm

certain that it is there now. It is a gentle, moody, drifting image and I am very pleased with it.

I am filled with such uplifting joy I can't even begin to describe the happiness.

All my love,

Celia

Great Russell Street, 13 March 2020

Dear Gwen,

Neither the *Willow Reflected in Water* nor *Copper Beech, Hampstead Heath* was right, after all. I wish I could have learned from all my years of experience that ecstasy should be distrusted. The joy one experiences, during the act of painting, has no significance. The only emotion indicative of the truth is knowing that a work is completed. I must take a canvas off the easel, finally, and turn its face to the wall, stretcher side out. Then I must move in a business-like way on to the next painting.

My *Willow Reflected in Water* is now titled *Weeping Birch, Hampstead Heath*. It is no longer a tree reflected in water, but the real tree that I see on my walks with my husband on Hampstead Heath. I identified it as a weeping birch, and not a willow, from a book of trees that I have. I have stuck closely to pencil studies I have made of it. It is quietly true now.

My *Copper Beech, Hampstead Heath* was weighted down and suffocated by its own darkness. I have let in air and light through the interstices of its branches and leaves. It is alive now and breathing.

My Father's House happened easily. The image of the house in Bradford has been fixed in my mind for so many years that it was just a question of putting it down on canvas.

I think all three paintings are completed now, and Kate is soon coming to sit for me. I am not certain that *My Father's House* is finished. I need to leave it for a bit, so that when I look at it again I will be able to judge more clearly.

The last painting you did is of a woman looking out of the window. Her face is turned away and hidden by her bonnet, which is a schematic oval. The window could be the back of a canvas with the cross-bar of the stretcher standing in for the window frame. (It's the painting that came into my mind when I was visiting my father's plaque in Bradford Cathedral.) The painting makes no attempt at realist representation. It is made up of squares and cones and surfaces. It is very nearly an abstract.

I would like to simplify and intensify my paintings.

Thank you for all the inspiration you have brought, and continue to bring, me, dearest Gwen.

With a handshake,

Celia

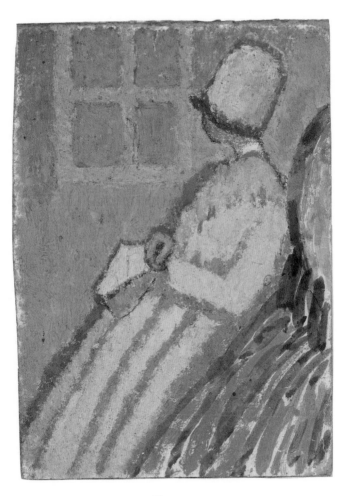

Gwen John, *A Woman in Profile*, c. 1931

Celia Paul, *Weeping Birch, Hampstead Heath*, 2020

Celia Paul, *Copper Beech, Hampstead Heath*, 2020

Great Russell Street, 20 April 2020

Dear Gwen,

Since I last spoke to you, more than five weeks ago now, everything has changed. There has been a global pandemic and everyone has been told to stay at home and only go out if absolutely necessary. I haven't seen a single person, apart from supermarket staff, during all this time, until yesterday when two men, wearing protective gear, arrived at my studio to collect thirteen of my finished paintings so that they can be photographed for an online exhibition.

The paintings included: *Copper Beech, Hampstead Heath*; *Weeping Birch, Hampstead Heath*; *My Plane Tree in Front of the British Museum*. They took away *Overshadowed*, the big self-portrait I talked to you about, where I had first painted in Lucian next to me and then painted him out, so that only his shadow remained; the last *Kate in White* and several more paintings. *My Father's House* hadn't worked, after all, so I painted over it and conjured up the presence of my plane tree outside my window, lit up with gold. And *Self-Portrait in Sunlight*.

Ever since the lockdown the weather has been impossibly fine. Day after day there have been clear blue skies. My plane tree has started to bristle with leaf-buds and the bluetits are

back, courting each other among the branches, as they did last year. During breaks from painting I sit on my balcony, which is no bigger than a small dining table. It is a real sun-trap because it faces south. I drink a cup of tea and look at the spire of St George's, Bloomsbury over the roofs of the offices that come between me and it.

Among the thirteen paintings were two of the room where I sleep – the British Museum peering in through the window, like a voyeur. One is of my room at night: the shadows on the ceiling thrown by the streetlights forming a web above my bed, the cross-bar of the window magnified on the wall next to it, an eerie crucifix. Everything is still. The colours are rust, blackish-blue and gold. In the painting of my room in the morning the gentle light washes in through the window, suggesting hope and peace. There is nothing in the room apart from the bed and the window, and the space that connects the two. The room is a pale-pink shell lit softly by honey-coloured sunlight.

I can't describe to you how different the atmosphere is in my studio. Usually there is the constant throbbing of engines from the traffic outside in the street, the impatient blaring of car horns, the chattering and laughing of the tourists queuing to get into the Museum, huge crowds of visitors photograph-ing each other in the forecourt, street musicians, fire engines. Sometimes the noise has been so deafening that I have been distracted by it while trying to paint, and I think of my mother's counsel, 'one can get above such things', and I have ordered myself to gather quietness within myself.

In these recent weeks there has hardly been a sound, and

the silence has entered my work. There is a deeper feeling of peace in these latest paintings. When I was working on *Self-Portrait, April* I knew that this silence is what I have been famished for. I need to follow this thread of silence, even if London starts to awake again after its illness-induced sleep. Perhaps then I will need to move away in search of quiet.

Two summers ago my oldest sister and I went on holiday together to the cottage among the Preseli Hills in Pembroke-shire where we have been going most summers since my childhood. It belonged to the Bishop of Bristol, who had been a great friend of my father. Outside the cottage is a little brook. I have painted it as a small trickle of water between its mossy banks, and as a rushing torrent swollen and brimming over after a night of torrential rain. The fields of sheep and bracken in front of the cottage stretch all the way down to the Irish Sea. Two headlands enclose the bay. I sleep in an annexe – my sister has the top bedroom in the cottage – as we know we need to have our own space. The annexe has a huge window so that I can look at the sea and the sky. Every morning I woke and thought to myself, 'This is what I want.' On the final day, when the car that my sister was driving to take us back to civi-lisation moved away, up the beloved grassy path to the lane, I looked out of the car window, trying to fix in my memory every detail of the cottage and the surrounding landscape, until she turned a bend and a huge bank of bracken blocked out the view and it was all lost to me. I have been feeling homesick for it ever since.

I have prided myself on my resilience in the face of so much

outer disturbance in my flat in central London, cultivating my inner silence and guarding my space against intrusion. This recent silence, due to the lockdown, has shown me what a strain it has been; I fear that the usual commotion has inhibited me in the past and led to my paintings becoming too tight.

I'm going to go back to Pembrokeshire, as soon as I can, when the lockdown restrictions have eased. I would like to see your own landscape, the landscape of your childhood.

I will write to you from there.

With my love,

Celia

Celia Paul, *My Studio Window, Summer*, 2020

Celia Paul, *Rising Cloud and Bird*, 2020

Celia Paul, *Mountain Stream*, 2014

Preseli Hills, Pembrokeshire, 12–26 September 2020

Dearest Gwen,

Augustus wrote this description, in *Chiaroscuro*, of the area where I'm staying in Pembrokeshire, which you visited regularly when you were a little girl:

> We used to visit the home of our nurse, somewhere in the wilds of Prescelly. The men here were small, dark and bearded. They were woodmen and possibly Euskarians [*Basques*]. Everybody wore pointed clogs with brass toecaps. We sat on our stools with our bowls of *cawl* [*Welsh soup*] and listened, in wonder, to the clatter of the clogs on the stone flags and the unceasing *bavardage* [*gossip*] of our Welsh friends, few of whom knew a word of English.

The cottage where I'm staying is very close to the home of your nurse; it's the same cottage I talked to you about in my last letter, which I've been coming to since I was seven. I am here again with my oldest sister – the sister who was with me before, when we last visited exactly two years ago. Her name is Rosalind Miranda, but we always call her Mandy.

In the main building there is a kitchen and little living room and bathroom on the ground floor, and two upstairs

bedrooms. It was built as a shepherd's cottage (I'm not sure of the date but I know it's very old). The dimensions of the rooms are small and the ceilings low. It is made of brick, which has been whitewashed all over. This is the cottage that we used to crowd into when I was a child: my mother, my father, my four sisters and me, and our two cats.

My sister sleeps in the cottage. This is her space.

The annexe, or 'bwthyn', was built on to the main cottage a few years after my family started to holiday here. Again, my sister kindly agrees to let me use the bwthyn as my space. My bed is screened off, by a curtain, from the spacious, high-ceilinged main room with the vast window at the end, overlooking fields towards the sea.

You wrote to Ursula about Tenby, your home town in Pembrokeshire, in a letter dated 30 July 1908:

> one has not much energy in Tenby, it is very, very, mild. So if you feel as I did in Tenby you cannot work much.
>
> At a place on the sea 4 miles from Tenby the air is very bracing – that is strange, isn't it? But Tenby is shut in by an island etc. (Do you think I'm turning into a guidebook?)

It must have been exciting to escape the confines of the narrow house in Tenby to stay with your nurse's family in the 'wilds of Prescelly'. This is the landscape that surrounds the cottage where I am staying now. It is very dramatic and feels ancient, unchanged and unchanging. You must have stayed

close by. Did you also gaze with awe at the sinister peak of the mountain named Carn Ingli that I can see from a side window of the bwthyn? You must have done, because it is visible for miles around.

When you were a young woman, studying at The Slade, you were in love with your fellow student, Michel Salaman. You wrote to him in the spring of 1899, from Swanage, where you were holidaying with Augustus: 'Yesterday I came to an old wood – I walked on anemones and primroses – primroses mean youth, did you know?'

You wrote something wonderful to Ursula, ten years later, on 15 February 1909, in the same letter where you tell Ursula that she belongs to 'a part of my heart and mind – the same part where my love of art is – which is undisturbed by the events and difficulties of life'. You wrote to her:

I express myself so badly you will not be able to under-stand what I mean! I should like to, however. I think – but I am not sure – if the greatest misfortunes happened to me I could go on living not unhappily because of some ideas, but perhaps that is saying too much.

These words by you, dearest Gwen, are deeply helpful to me. Your self-imposed solitude was not a martyr's instinct, as your brother often implied when he talked about your self-neglect, as he saw it, but a sign of strength. You go on to say, in the same letter: 'I dreamt of primroses last night.'

Your youth, your childhood, was in your thoughts throughout your life. You were sad to lose touch with friends who had mattered to you when you were young. The past meant a lot to you.

When you heard from Michel Salaman again after a very long time, memories of your student years came vividly back to you. He had acquired *The Pilgrim*, a painting you had made in Meudon of your friend Angéline Lhuisset, who had posed for your painting *The Convalescent*. He had written to you to tell you about his purchase, and to tell you that he was now married.

You responded with a letter dated 17 January 1926: 'Do not mind about unwritten letters, future or past. Artists understand things sometimes, don't they, and I shall. But without the letter of last night I shouldn't have been able to. I don't think we change but we disappear sometimes. You disappeared a long time.'

You soon resumed a correspondence. You felt connected to Salaman still, because of his understanding of the choice you made to deprive yourself of ordinary comforts. You wrote to him on 3 June 1926: 'Your letter makes me happy, and gives me the encouragement to go on having my solitude (which sometimes seems a sort of obstinacy).'

All around this cottage where I am staying now there are flowers – stitchwort and tormentil – but no primroses because it's September, not spring.

There is one flower that grows in profusion, and which I know you specially loved; it is the flower that you described to Ursula in the very last letter you wrote to her, in late April

1938, eighteen months before your death. You used to notice it in the hedgerows near your home in Pembrokeshire, and you were delighted to see it also grows in the woodlands around Meudon. It must flourish all year round. You called it 'wild geranium' and wrote that 'The stems are dark crimson, the emerald leaves seem dipped in pale crimson.'

My intention, on coming here, was to make studies of clouds and water. I have recently been working on a series of blue skies and flying birds that I have watched from my studio window in central London. The glorious spring weather lasted throughout the summer and, most days, the skies in London have been a cloudless blue. I thought I could extend the series by working from the more rain-filled clouds of the West Country. But when I got here and looked about me, I realised that what is moving me most, right now, are the grassy overgrown paths.

I know you also loved paths and made watercolour studies of similar grassy lanes, the ones that led in different directions around your studio in Meudon.

The paths that I walk down, and observe, around this cottage make me think of your grassy lanes, and you must have been reminded of Pembrokeshire when you made those studies, living far away in France.

I am struck now by the significance of a path: the one leading to the lonely mountain, the one leading away from the cottage towards the town, the one leading from home, the stream's path to the sea.

I want to make studies of all of these paths and bring them back to London so that I can make paintings from them.

I want to try and write down a few thoughts and impressions for you while I'm here. I am thinking of you a lot, in this setting that is so familiar to you.

But first I must explain why it has taken me five months to write to you again after my last letter.

The coronavirus pandemic is still raging on, and there is no end in sight. I have been working intensely, mainly on my own. Time has seemed to stay in one place, almost like treading water, going nowhere. Each day has bled into the next, so I've been disoriented and have let the days slip by. I'm sorry, Gwen. But you have always been in my mind.

After the strict lockdown measures of April and May, when I didn't see anyone, I then started to meet with my husband, usually in Regent's Park, where we sat on a bench and watched the passers-by. I bought us each a little bottle of wine and a packet of cashew nuts to share. It was almost like sitting in the front row at the theatre, we were so entertained by the activities of the people we watched. I try to walk everywhere, rather than risk catching the infection by taking public transport. It is exciting to know how accessible all the areas that I love are, on foot. (I can't ride a bicycle – I don't know how to stay upright even for a second on a bicycle! I know that you used to love taking long bike rides through the lanes near your home in Tenby. I wish I was more physically adept.) I love walking through Bloomsbury, through Fitzrovia to Regent's

Park and then beyond, over Primrose Hill and on to Hampstead Heath. London seems to get more and more beautiful, to me.

Steven and I had sad news at the beginning of June. The scan showed that the cancer has spread extensively and that the only option the doctors can offer now is palliative chemotherapy. The chemotherapy he started in August made him very ill. As he'd been feeling so well before, he decided to stop the treatment. He's now recovered from the effects and feels well, with no symptoms. His condition seems to echo the strange dislocation that the world is experiencing. Nothing feels real.

So I have come here, to Pembrokeshire, a place that means a lot to you and me, Gwen, to try and regain a sense of how I need to arrange my life, at this critical point. Perhaps this is why I feel I need to focus on paths.

I thought I'd write some thoughts down in my notebook while I'm here, so that you will be reminded of your childhood, and your first home.

14 September 2020

It's two days after our arrival. I'm sitting on a grassy bank beside a pool. The stream that flows on a level with the cottage follows the gentle slope down the hill and has a rest here to collect itself (where the ground flattens briefly), before

plunging down again as the slope steepens towards the sea. My watercolours, paintbrush and plastic cup of water are placed precariously next to me. The tufty grass is very springy and uneven.

The little pool reflects the bracken that encircles it; the pebbles on its muddy bed are clearly visible. The colours are burnt umber and white. The gossamer-beaded light of a cobweb clinging to a gorse bush reminds me of the way the delicate fretwork of your wicker chair catches the light, in your paintings of your room in Paris. The little world of the pool is magical, and contrasts with the real world that surrounds it: blazing gorse flowers (still in bloom) and matted ferns and grasses shaded in chrome green, Prussian Blue and umber.

First thing this morning I tried to focus on the thin clouds and the remains of a jet skein, like a disappearing feather, but I couldn't catch hold of anything in my watercolour and pencil studies. I hoped to indicate diffuseness, smoke, but the rightness only seems to come to me when I focus on substance – even intangible substance, like the bracken's reflection in this pool.

The wind is rattling the long lily leaves, shaped like blades. The lily pods resemble bunches of green bananas. Behind them, the forked lightning of the trunk of a hawthorn tree against the dark leaves and ruby-red berries, strangled and surmounted by an ivy bush.

Beyond the hawthorn are fields leading downwards away, away to the sea. The ferry has set off from Fishguard on its way

to Rosslare in Ireland, and I watch it appearing behind the dolphin-shaped snout of Dinas Head.

The sea is aquamarine and still as glass, despite the persistent biting wind that is blowing the pages of this notebook as I write.

At the top of the hill, on the path this evening, I am suddenly aware of the presence of a huge horned cow, with a lowering look, standing silent, squeezed between the banks of bracken in the narrow lane, surreal and enormous against the fading light in the sky.

I keep being reminded of Goya here; because of the diminutive scale of the dry-stone walls and the dwellings scattered across the widely flung landscape, the vertical forms of the trees, or farm animals when they are silhouetted on a hill, assume a monstrous proportion, just like the gigantic figure in Goya's painting *The Colossus*.

When Mandy and I first arrived, we sensed an absence; the fields in front of the cottage are usually alive with grazing sheep and, in the evenings, we are used to seeing rabbits nibbling the grass, between the sheep. Now everything, on our first evening, was deserted. The emptiness felt sad. It felt like the isolating conditions of the pandemic had followed us here.

But then, the next day, four hesitant sheep appeared and others began to follow their lead. It comforted me a lot to see them.

15 September 2020

It is early morning. Two magpies are busying themselves on the grass. The back of the horned cow appears above the stone wall like a whale rising out of the sea.

I've just been out of the little gate that separates the cottage from the fields. A small stream has been flowing beside the gate ever since the first time I came here, when I was a child. (It's the stream I mentioned to you yesterday.) But now, on this clear, still morning, the stream has run dry: merely rocks and stones.

Before I opened the gate and saw that the stream had dried, I had a sad thought, which I'm unable to remember – I forgot it almost the second it came into my mind – but it has left me with a deposit of sadness.

I have tried to make a watercolour study of the hawthorn tree that I can see from one of the small side windows of the bwthyn. The hawthorn berries cluster like welts on the rheumaticky branches of the stunted tree. My painting is clumsy and not specific enough. The blood-red of the berries appear too exotic, in my study, more like a jacaranda tree in full bloom. I think the hovering sadness is muddying the clear way I can see things when my mind is right. I will stop now and join Mandy for a cup of tea. I can see her sitting in front of the cottage – she has just got up after the night.

*

It is the afternoon now. There was bright sunshine all morning, but now a thick mist has enveloped the whole landscape. The hawthorn tree, which I tried to paint this morning, looks black, its berries dulled. Everything is silent apart from muffled lazy birdsong from an invisible bird. There is the scent of wood-smoke wafting down from the farm further up the mountain. The stillness feels eternal. I think of those beautiful words spoken by Cézanne to his friend Henri Gasquet (Cézanne liked working in veiled light as opposed to direct sunlight): 'Under this fine rain I breathe the virginity of the world. I feel myself coloured by all the nuances of infinity.'

16 September 2020

Mist still screens off the landscape. Certain forms stand out sharply: the nearest trees are coloured dark veridian and black, Payne's Grey, umber; the dry-stone walls are beaded with dew. A daddy-long-legs is pinioned to the window, its legs cobwebbed around it. So much of this haloed light of the shrouding sea-mist of Pembrokeshire persisted in your work and influenced your seeing; your emotional portrayal of forms is remote and cocooned, certain shapes isolated and heightened; the whole composition unified by mist.

I'm disturbed by the sight of the dried-up stream. The overhanging desiccated lip of the under-bed, where the water used to leap down joyfully; I have made studies of this little

life-force in all my recent visits here. But now there is no sign of life. The streambed is a graveyard of old stones and decayed weed.

Mandy is very silent. We are both huddled into ourselves, into our own separate silences. I look into her eyes and I see myself in her. There is a strong physical resemblance between us, as there is between you and your sister Winifred. You use the fluidity of identity in your portraits when you make your sitter resemble yourself, as if she were a sister. I suddenly long to work from strangers whose features are unknown to me.

I speak to Steven every day. I have to climb the hill, above the cottage, to get a signal on my phone. He has recently bought a laptop and he has been writing about philosophical things that I don't understand – 'the transcendental ego', 'the Self and Other'.

Two bluetits are pecking at the moss between the stones of the wall outside my window. They remind me of the birds that inhabit my plane tree. They have beautiful mussel-shell-blue caps and black bandit masks over their eyes above white and lime-green bodies; they look fat and purposeful and contented. They have flown away and a single goldfinch has replaced them. She also feeds from the moss. She is much more shy and uncertain.

I have just done a study of the sea-mist lying over the field with the white stones of the walls, the most described part of

the landscape – each glowing white stone outlined in umber; the trees are ghostly, undefined shapes. I sense your spirit hovering gently over the wistful scene, breathing slowly, briefly revisiting the place you love. A blackbird has flown in a low diagonal across the field.

It is nearly midday now and the landscape is beginning to reveal itself, like a person shaking off sleep.

17 September 2020

The world is laid out like a dream of Paradise in the morning sun; the suggestion of a heat-haze created by the evaporating dew. I've stepped out and there's a fresh chill underneath the warmth. The hawthorns in the fields below the cottage glow like fiery embers against the green and gold of the bracken. Dinas Head nudges gently against a waveless sea.

I have just made studies of the mountain seen from the grassy track at the top of the hill, as the sun was rising.

You painted white stone paths with lines of grass running through the middle. You painted them in Meudon. Here, in your home county, there are similar paths, bordered by bracken, everywhere. These paths feel significant to me. They lead slowly away, always disappearing, cut off by a wall or a hedge. The stream's path leads definitely to the sea. But for man-made paths, the future is mysterious.

These lanes are what I want to concentrate on.

It's just after seven in the morning. I have come back from drawing the path to the mountain. Then I retrace my steps and make a study of the return, the path to the cottage, its single window peeping from under the simple triangular roof: a child's drawing of a house. I have found my 'motif'. I want to make more studies of the path leading towards the dark mountain, and the path back home.

Both paths suggest yearning, but for opposite desires. How do we reconcile these two cravings in ourselves, dearest Gwen?

You found one way to control your longing for home: you painted the simple paths and cottages, the coast and the little girls of Brittany; you were free in France, not imprisoned in the narrow confines of your family home; you were saturated with memories of your lost childhood homeland to which you never returned.

How can I reconcile these opposite yearnings in myself? I want to have the freedom that solitude brings, but I often feel homesick for some unidentified 'home'.

You were born and grew up in one county: Pembrokeshire; this stability of location gave you a sense of security and identity, even if you suffered from claustrophobia at home.

I never had that sense of myself as belonging to any specific place in my childhood. I was born in India, but I knew from the start that I was a stranger there.

There is a third path: the path of the stream to the sea.

I have just remembered that today is the anniversary of your death, eighty-one years ago . . .

I want to talk to you about how, when I returned to India to make studies of the house where I was born, I also visited the beach at Kovalam where we used to stay, in a little house under towering coconut palms, during the holidays. I remember that the waves of the Indian Ocean were terrifying: as huge and unstable as crumbling monuments that could crash down on me and sweep me away. I remember the cool interior of the house and the sloping patch of scrubby earth behind it that served as a garden where, as a four-year-old child, I had found a fragment of black rock that sparkled with silvery bits of a quartz-like glitter; and that I told myself I must never forget it. And on my return, forty years after I had left India with my family, I was still filled with fear. I cowered under my rented parasol, with my legs curled up cautiously in the inky pool of shade, as I watched the vendors dressed in black parading up and down, silhouetted against the dazzling brilliance of the ocean. Occasionally they would approach me with their wares: mangoes, papayas, bananas, pineapples or long lengths of lavishly embroidered cloth. I bought some papaya from a toothless old lady who prepared the fruit carefully for me as I watched, slicing the pink flesh into small cubes, which she placed on a paper plate and handed to me. She told me that I reminded her of her daughter. She said this to reassure me because she sensed that I was timid and uncertain of my

bearings in this strange land, the land of my childhood. She refused absolutely to take any money from me.

19 September 2020

Last night, at around eight, as the sun was setting over Dinas Head, I was on the hill above the cottage talking to my husband on the phone, when a family of horses appeared silently beside me. The father – a huge beast – came lumbering towards me and leaned his massive head over my shoulder so that I looked right into his cavernous nostrils. I knew I mustn't show any trace of nervousness, and he soon moved away to graze on a patch of turf a few yards from me. One of the foals showed an interest in me, too. She gambolled around me, giving me shy and mischievous glances from under her forelocks. The mother and her elder daughter stood aloof.

This morning, when I awoke at about five thirty, it was still dark, but I could see that the horse family had congregated in the field below my window. The foals kept bumping into their mother, who snorted at them without interrupting her feeding.

They looked mysterious in the half-light – the white patches of their fur phosphorescent amid the darker areas, so that it was difficult to make any sense of the forms of their bodies. They vanished with the rising of the sun.

*

I wish I had some 'Rouge Phénicien [*sic*]', the colour that you recommended to Ursula, in the last letter you ever wrote to her. The plant that you called 'wild geranium' is also known as 'cranesbill' because of the beak-like curves of its seedpods; I have just picked a flowered stem from the bank by the still-dry stream. I have done a watercolour study of it in which I have depicted my fingers and thumb clasped around the stalk, with blue sky behind the flower-head; my fingers are Rouge Phénicien, too; in my study, the rhubarb-crimson seems to be travelling through my fingers, up the stem, staining the emerald, to the flower, where it diffuses into a pink the colour of strawberries and cream. I am holding the small blossom high in the air to raise a toast to you, and to the enduring nature of your art.

20 September 2020

You wrote to Ursula on 29 October 1925: '. . . draw and paint from notes and memory. I'm doing such things.'

In your later years you often worked less directly from life. I followed this rule and made simple outlines of the path to the mountain in the morning light, deliberately memorising the scene. It was a simple matter of adding colour on my return. A very effective technique. The mood is different, however. Working from memory infuses a painting with a sense of loss, of nostalgia; the brush-marks are less urgent than if one were working riskily straight from

life: the energy when working from memory is dreamier, more wistful.

Last night I couldn't sleep. I got up and went outside into the clear, cold night. The heavens were spread out above and around me, the stars living presences; I believed what I have read, that we are made of star-dust and that all life and all matter are formed of the same substances. The order and benevolence of the universe welcomed me, on this night.

The experience was too intense for me to even attempt sleep, and I lay awake thinking about the mysteries – the growing sense of empathy between human beings, and between our world and the universe.

This time of the pandemic seems to have sharpened our awareness: I think of someone I love who I am separated from, and I am certain he is thinking of *me*.

I was speaking to a friend before I came away and she admitted that she also felt connected to waves of empathy between herself and others.

I want to try and make a painting of the night sky with its stars. It is something I have thought about doing for a very long time. I would like it to be a big, square painting. I would like it to have a similar silence to an Agnes Martin grid painting, which can never be reproduced by technological means; you have to stand in front of the real painting to sense the silence, like an electric charge between the looker and the image. To make the painting, I will need to find a deeper stillness within myself. I must discipline myself to be still. I am

anxious now and I know that the night sky painting won't work until I am quiet in my soul.

More and more swallows are lining up on the electric wires in front of me as I look out of my window in the bwthyn, over the fields to the sea. The swallows look like musical notes on bars, their bodies single Japanese brush-marks. The sky is pale blue and the sheep are grazing. Mandy has gone to church. I am alone.

As you got older, you became more and more fascinated by the abstract techniques of painting. You wrote, in the draft of a letter to Véra, in 1927, about how you had started using:

> a disc with perhaps 85,000 numbers, by making complicated calculations one can find the colour and complementary tone of any colour or tone. There are very long lists and there are two scales and some quadrants which have to be divided by concentric arcs and there are 10 radii which have to be divided into twenty parts representing twenty tones etc. etc. I can now find the simultaneous contrast, or mixed contrast of any colour or tone.

I just tried to paint a little study of last night's starry sky from memory, but the scene laid out before me of the dreamy blue sea and sky captivated me; and then I looked out of the back window, by my bed behind the curtain, and I saw a sheep

peering over a grassy bank under a sunlit apple tree, and I knew I had to paint *that*; there is so much humour and compassion in the natural world, in 'things' and creatures, and people, which all the colour charts in the world can't begin to address. I don't think I could ever be a completely abstract painter like you nearly became, Gwen.

More swallows have appeared on the wire, directly above my window now, their breasts lit up white, and their backs and tails black in the intense sunlight of the later morning. They are preparing to go to Africa and they are chattering with excitement.

21 September 2020

A blessed day! The sun and the heat; no wind. The tormentils are glowing in the grass, the simplest of flower-forms with their four evenly spaced yellow petals; they are interwoven with the stars of stitchwort. The only sounds are the high whistle of the buzzard and the creaky wheeze of magpies fidgeting in the tree behind me. Mandy is sitting outside the cottage with a big shawl over her head to screen herself from the glare of the sun; she looks as if she's playing a shepherd in a nativity play.

The sheep are at ease with me. They graze fearlessly around my feet as I sit in my deckchair. When I close my eyes I can hear their frenzied munching. One keeps grunting like a pig. Suddenly they all move away, further up the hill.

22 September 2020

Today is a much gentler day altogether: a luminous grey, your own colour, encloses the world. The birds sing falteringly in the trees. I am beginning to think about my return to London, a melancholy feeling like the homesickness that started to seep into every Sunday afternoon when I was at boarding school and had been 'home' for the weekend. I woke sad in the night, thinking of Mandy and me. How I am disturbed by her silence. Is she disapproving of me? I'm sure, really, that she isn't, she's simply absorbed in her own thoughts, as I am in mine.

Watching a fly labouring up and across the glass, for hours repeatedly following the lines of the window frame. The dry-stone walls look like cages today, fencing me in. I understand how you needed to escape; even though you yearned for home, it remained just a yearning; you never returned permanently.

24 September 2020

During the night the rain created a chaotic sound of surging and appeasing. The roof of the bwthyn is made of insulated corrugated iron; as I lay in bed, it felt like I was curled up inside a wildly beaten drum. The storm eased off briefly with the daylight, and I lay listening to the magpies bouncing above me on the roof. When I drew back the curtains there were

three horned cows in the field below me. One was lying flat out on the grass with her head sunk into a puddle in the most depressed fashion.

I went to look at the stream, which was nearly bursting its banks now – a turmoil of conflicting motion, like crowds of people fleeing through a narrow door. Just two days until I'm home. I am longing to be home.

A huge rainstorm has returned, bringing hail. The stones of the path leading to the cottage are decorated with hail, like sugar on cakes. I can see the head of a cow reaching up to the hawthorn bush behind the wall, and I can see its tongue greedily lapping at the berries.

A delicate rainbow makes an arc in the sky over Dinas Head. I am thinking of all the rainbows drawn by children, and stuck in the windows of houses, to offer a sign of hope during the pandemic. It is difficult not to read significance in the miraculous otherworldliness of a rainbow; surely we are not mistaken in reading into it a sign of hope?

The weather has changed again, for the worse. A frightening wind has started to howl.

25 September 2020

It's the morning of my last full day here. In the night there was a tremendous wind, and it's still raging on. At its most powerful, I thought the window would smash, the glass seemed too thin a membrane to withstand the pressure; I lay awake, afraid.

Now, sudden rages of sound, like a caged beast rattling its bars. The sky is astonishing: a blue rent, the colour of lapis lazuli, appears between garishly floodlit clouds; and over the sea the horizon is blackish-purple with amber lights on the waves. A buzzard is circling low over the field in front of me. There is an atmosphere of foreboding.

I think of the ending of *Villette* again, of Lucy Snowe, waiting in trepidation and increasing hopelessness as the storm intensifies outside her window. Her lover, travelling towards her over the ocean, will not return.

I think also of Charlotte Brontë's own life – her infatuation with Monsieur Héger. If Charlotte had been safely married to Reverend Arthur Nicholls, who loved and respected her, at the time of writing her great novels, *Jane Eyre* and *Villette*, if she had had the security of knowing she was loved and had loved in return, could she have written these works?

In the end, soon after marrying Arthur Nicholls, she died while she was pregnant with his child. We will never know what her later works might have been. Perhaps they would have been filled with a new richness and compassion. Like a Rembrandt painting?

26 September 2020

Mandy and I are setting off soon after dawn. An arrow of geese is flying west. Ragged clouds are black with rain, moving

steadily west in the westerly wind. Everything is moving west. Not me! I'm heading east, back to London.

This time, when Mandy drives the car away from the cottage, I am glad to leave. I just give a cursory glance out of the window. I want to go home, to London. I don't think I will come back.

I will write to you on my return, dearest Gwen.

With a handshake,

Celia

Celia Paul, *The Path Home*, 2020

Celia Paul, *The Stream's Path to the Sea*, 2020

Great Russell Street, 1 October 2020

Dearest Gwen,

I returned to London a few days ago. Steve sat for me this morning. I resumed work on a large watercolour of him (it measures 56 x 56 inches) that I had started three years ago. I stopped working on it just before a major operation to remove the cancer that had spread to his bowel. I have done several oil paintings of him since then, but I kept back this watercolour to work on when he was nearing the end. This will be the last painting I do of him.

After the first two sitting sessions I was very surprised to see that, instead of Steve's face, I had painted Lucian's! Lucian has been in my thoughts again. I have been asked to review a recent biography, by William Feaver. A lot of disturbing memories have resurfaced. I need to retrieve Steve from Lucian's influence. I scramble the watercolour marks with white pastel and I can see Steve re-emerging. But I need to address this awakened pain of my memories of Lucian, and I start an oil painting of him and me and Bella, using a photograph of us by Bruce Bernard.

The photograph was taken in 1983, when I was twenty-three, Bella twenty-one and Lucian sixty, the same age I am now. Bruce Bernard took a series of photographs at this time – a lot of them feature the three of us, and in some the painting that Lucian had

just completed stands on the easel behind us; the painting is *Large Interior, WII: After Watteau*.

In the photograph that I'm now using to paint from, Bella sits on the left, I am in the centre, my face tilted towards Lucian, who stares straight ahead at the camera. We are sitting on a low mattress on the studio floor. The paint-splattered wall is behind us. To the left of Bella's head is a dark doorway leading out of the studio into the hall.

I draw out the composition freely in paint. I mark in the interplay of fingers and limbs. I have one hand round Lucian's knee and one hand round Bella's knee. Lucian has one arm round me and the other is reaching forward and nearly touching my hand with his own. Bella has one hand on my shoulder and one hand to her ear, in the act of stroking her black hair from her face.

I start with Bella's face, which comes easily to me. She is wistful and isolated and the dark doorway behind her head resembles a similar dark doorway – the shaded cavity, reached by a snaking path, in the wall of the distant building on the mountainside of *Noli me Tangere* by Titian.

My own head comes easily, too. My blonde hair is draped around me. I look very young. I can clearly see a likeness between myself and my little granddaughter: slightly slanted eyes and a round face.

And then Lucian's face.

I can't paint him. I fix my eyes on the photograph. Surely it's a simple thing to copy his features? But again and again he eludes me. I feel a rising panic. Smoky fumes of anger and hurt

uncoil upwards from my intestines and blur my vision and make my hands unsteady. I can neither put the nose, mouth, eyes, or even his black hair, in the right place, nor read his expression. I can't see him.

I try to step back and distance myself. What does he look like? What is he conveying? He wants to show Bruce Bernard that he loves me. Lucian's head is inclined towards me, as mine is towards him. There is a slightly camp twist to his mouth; the flesh around his lips and cheekbones suggests sensuality, his gaze defiance. He's been caught out and wants to prove he knows, that it was his intention. He is enjoying himself and wants Bruce to be aware of the fact, but he is insecure about his pleasure. Does Lucian look foolish? What would it matter if he did!

He and Bella are dressed in white. I am wearing a brown jumper. The photograph is black-and-white, but I remember the soft tawny jumper that Lucian lent me for the occasion. I could be a Madonna flanked by two angels, like the *Madonna del Parto* by Piero della Francesca; or I could be a teddy bear, which two white-clad children are playing with; or I could be a patient supported by two nurses. The obvious fact is that Lucian and Bella are two of a kind, and I am different.

I often felt outside their intimacy. Sometimes they would whisper to each other and share secrets. Bella always knew about Lucian's other girlfriends. I sometimes felt lonely when the two of them were together. Lucian and Bella supported each other and were proud of each other: it often felt like complicity to me, as an outsider. It comforts me a great deal to

know that you must have suffered a similar isolating hurt with Rodin: he compared you to his beloved sister, Marie, yet you knew that the closeness of blood – in a child or sibling of the opposite sex – overwhelms any other form of love, for a narcissistic man. You tried to emulate Marie's self-effacing piety, but it was a strain for you to subdue your passionate nature. You found your brother's identification with you rivalrous, intrusive, overpowering and upsetting. Your intimacy was threateningly exclusive. You searched for affection elsewhere to try and rid yourself of his possessiveness. You both craved and feared love. Even if no sexual intimacy happened, a boundary had been crossed between your brother and you. You feared that this might happen again if you got too close to anyone.

I have been trying for days now to get Lucian's face right, but all I'm left with is a badly drawn cartoon-character: long nose, slanty eyes, no eyebrows, tufty black hair. I try to distract myself by making a thick impasto of the paint marks on the wall behind the figures. But no, the whole thing is false. I feel sick. I work into the night and early hours trying to get the way his eye is jammed between his eyelids, mad despite his attempt at jauntiness. And then, finally, I give up and paint it all out.

I've just painted the path to the mountain, from one of the studies I made in Pembrokeshire, in its place. I'm pleased with my painting.

Colette was asked what advice she would give someone about how to begin to write. She said something like: Look at what gives you pleasure, and what gives you pain; but look longest at what gives you pain.

I can't face the pain of remembering some of the things that William Feaver writes about in his biography of Lucian Freud. Lucian comes across as brilliantly witty, but so often the brilliance is used as a smokescreen. He was very clever at hiding cruel motives behind a witticism. In his youth he did a self-portrait of himself with a thistle. He is half-hidden, sharp-eyed behind the spikes. He stayed that way. I never knew him, because of the defences that he set up between himself and me. Through trying to do this painting of him just now, I realise how little I ever knew him, and now I never will. This thought makes me very melancholy, as I sit here writing this letter to you, in the flat that Lucian bought me all those years ago. My love for him comes welling up, unexpectedly.

I know what Steve looks like. I understand him and we have always been close. Neither of us has felt the need to put up emotional defences with each other, even though we have each guarded our physical space.

There's a painting in the National Gallery titled *Apollo and Daphne*; it's by Piero del Pollaiuolo. Daphne is in the process of turning into a tree; her lover, Apollo, clings on to her, beseeching her to stay. A suggestion of a smile curves her mouth, and her eyes are focused on something in the far distance. A similar smile hovers around the lips in my watercolour of Steve. Please, please stay with me.

It's autumn now. I started this letter to you at the beginning of October but now it is nearly the end of the month. The virus is

having a second surge and restrictions are back in some parts of England: in the North-West, Wales and here, in London. It is a frightening and uncertain time for everyone. No-one knows when, or how, it will end.

Soon I'm going to work on a painting that I did in 1995. I was thirty-five, the same age as my son is now. It is being brought back to me because the paint surface had started to flake off. A picture restorer has removed the overpaint, but some of the backdrop has been damaged and I need to paint over it. The painting is titled *My Mother and the Mountain*. My mother lies curled up in the foreground, and Trisselwand, the mountain I've talked to you about, is behind her. It will be a significant image for me to return to now. My mother has stayed the same – but I changed the backdrop three times. This time will be the fourth. The cathedral-like mountain, Trisselwand, impressed me when I went to Austria for the first time with Steve, soon after I had started going out with him. A mountain stands for Truth. One can only reach the top by means of circuitous paths that often seem to be leading in the wrong direction; and sometimes one loses one's way. I need to be guided now.

If you don't mind, I'll write to you about this painting in my next letter. Thank you for all you have brought to my life through your art – the stillness and 'collectedness'.

With a handshake,

Celia

Celia Paul, *Looking Back: Bella, Me, Lucian*, 2020

Great Russell Street, 7 November 2020

Dearest Gwen,

I think all the recent events here, on Earth, must have disturbed your sleep.

There has been a new lockdown imposed in England because the coronavirus cases have been mounting; meanwhile the American presidential elections are hanging in the balance. It looks certain that Joe Biden will win, but the mad machinations of President Donald Trump may yet undermine the whole voting process. If Biden wins, I think it might be the first sign that a new beginning is possible. This year has involved so much waiting and uncertainty.

Today I was due to go to Cambridge to spend the day with my grandchildren, but the restrictions say that one shouldn't travel except for work and that one shouldn't mix households. I'm writing this letter to you instead.

There are three paintings in my studio that I have been working on, which all have something to do with endings: the watercolour portrait of Steve; the early painting of my mother and the mountain, which I have recently reworked; and I have returned to painting from the Bruce Bernard photograph of me and Bella and Lucian: I couldn't let it go. I have started a

new canvas but the composition is the same. The William Feaver biography has made me realise that there are things I need to resolve so that I can move on peacefully.

At one point in his biography, *The Lives of Lucian Freud*, in reference to me, William Feaver quotes Anne Dunn, Lucian's lover and the mother of Danny Moynihan, who was at The Slade with me:

> Danny was a student at The Slade and arranged for a students' show at Acquavella in New York. One of them was Celia Paul. Lucian came round, walked straight in, took the work away and that was that . . . Danny was mortified at setting all this up, such a slap in the face. Lucian would get a better gallery for her and he wanted control.

Feaver then asked Lucian for his version of this incident. Lucian replied: 'Danny Moynihan got Celia's paintings from The Slade and she said she wanted them back. He said "Sorry they've gone to America." So I walked round to Redcliffe Road [*where the Moynihans lived*] and took them.'

I just had to step outside onto the balcony and look at the church of St George's, Bloomsbury. It is bright sunlight today. The memory that this anecdote conjures up is very painful and I need to consider my own part in it all.

I remember my dilemma. I had been excited at the thought of exhibiting in America and I had told Lucian about Danny's

plan for an exhibition. Lucian quizzed me about the details, of which I was vague. He sensed my uncertainty. Is this really what you want? he had asked. Immediately I became unsure. Perhaps I would lose his love if I went ahead with this, without his involvement? I thought of what you wrote: 'I paint a good deal but I don't often get a picture done – that requires, for me, a very long time of a quiet mind, and never to think of exhibitions.' Lucian counselled me, on this occasion, that exhibitions can be distracting and that it's important to focus exclusively on one's art, especially when one is young.

You had written to Ursula about your brother's reaction to a joint exhibition that she had proposed for the two of you, and you had said how annoyed Augustus would be if it went ahead without his authority. I have already written to you about this letter. You were cowed by his possessiveness, just as I was by Lucian's. Neither of us values worldly success above love. We need to work peacefully. If there is hostility directed towards us from the men we love, it inhibits us and prevents us from painting freely. We want to avoid incurring rivalrous feelings at all costs. If I had gone ahead with the American exhibition without Lucian's goodwill, his love for me would have turned to resentment. I had witnessed how Lucian reacted to love that had soured. He talked contemptuously of past girlfriends whom he had loved and lost.

What a frail tightrope I had to walk to keep from falling into the abyss of his powerful disapproval. I had to keep this balancing act until the end, even after I had split up with him, in relation to my son. I needed to protect my son. I didn't

think Lucian could turn against Frank, because I knew he loved him, but it remained a dark possibility. I had to make sure I never promoted my art to the extent that Lucian would feel threatened and would abandon my son and me. I failed to keep away his resentment about my art, though. When we were together, at the beginning, he was very supportive; he introduced me to collectors and dealers. But after we had separated, and during the time of Frank's adolescence when Lucian felt bitterness towards me, he told people that I'd lost my talent. He reversed his opinion in the last years of his life when he loved me again, and he praised my art. He attended the private view of my exhibition at Marlborough Fine Art in 2011, the year of his death.

Now I'll describe the painting I've begun again of me, Bella and Lucian. Again, the suggestive dark doorway behind Bella's wistful head. Her figure and Lucian's echo each other, as in the earlier failed painting. I remain a shadowy presence, in my brown jumper, hidden by my long brown-blonde hair, between the lit-up figures of Lucian and Bella, who are both black-haired and dressed in white. But this time Lucian is alive. I've captured him alive. His expression is one of deep hurt. I have wounded him in possessing him. And all my love comes flooding back. I have seen that expression of vulnerability on occasions in real life: sometimes when I was a young woman and upset, he would look at me with terribly concerned distress. It made me feel powerful, and I was reassured by his face that he loved me. The last time I witnessed this expression was

a few days before he died when I visited him on my own, without Frank. He was lying in bed, too ill to speak. I lay down beside him. I said, 'Goodbye' and then I added 'my sweetheart'. He was startled and opened his eyes wide. He then looked at me with real recognition and pain.

I have finished the big watercolour of Steve. It is very delicate. He is there, but only just. He is painted with a sable brush that seems to be dipped in smoke, not paint. The painting feels very fragile, not only because of the ethereally vanishing tones, but also because it's on paper. The paper is mounted onto canvas to give it support. I got a conservator to fix it in place with special glue that won't interact with the paper. I hope it will last. You need to be very protective of works on paper and keep them out of direct light. I want to keep guard over this image. When it is finally collected from my studio I will be bereft.

I have repainted the mountain behind the sleeping figure of my mother.

I'll tell you the story of this painting.

Soon after I returned from Austria with Steve in 1994 I wanted to make a painting of my mother in front of Trisselwand, the mountain that had so impressed me in Altaussee, where we stayed. My mother was my main sitter at that point. She was always in my mind. I needed her presence in my pictures for this reason.

I painted her lying down. She is dressed in sombre green-grey and green-blue. Her head, on the pillow, is in profile and

her eyes are half-closed. I left a white space above and behind her where I intended to place the mountain.

I was due to have an exhibition at Marlborough Fine Art in the spring of 1995. I hadn't yet finished this painting. Since I was very pleased with the figure of my mother, I decided to exhibit it unfinished. I instructed the gallery that I would need the painting returned to me after the exhibition so that I could paint the mountain into the white background.

When the painting was returned to me, I duly painted in the mountain, using sketches and photographs from my trip to Austria the previous summer.

I was satisfied with the painting, but I kept remembering how it had looked in my exhibition with the white blank space behind the figure of my mother. Perhaps it had been better like that? I decided to erase the mountain with white paint, so that it should resemble the painting in its unfinished state.

It was then sold.

A few months ago my friend Ruth [*Guilding*] informed me that she'd just bought it from its owner. She told me that, sadly, the white overpaint had started to flake off. She had arranged for the painting to be taken to a restorer. Would I prefer the white overpaint to be consolidated, or would I prefer it to be scraped off to reveal the mountain? I told her that, since the mountain had been my original intention for the composition, I would like the mountain back. But when the restorer attempted to remove the surface, parts of the white paint were too stuck to the underpaint to remove cleanly. I said that the best thing would be for the restorer to sandpaper the white

surface, and I would repaint the entire mountain. When it was returned to me, the contours of the mountain were just faintly indicated beneath the smooth white overpaint.

I was daunted by the silence and interiority of the image of my sleeping mother, who has been dead for more than five years now, and I suddenly worried that I might not have the courage to repaint the mountain. I needed to still my soul. I needed to think about God and ask for his help.

Early one morning, a few days after the painting's return, I lay in bed and wondered if the time had come.

I went into the studio. I repainted the mountain in one day-long session. I worked blindly, feeling my way.

Had I got it now? I couldn't tell.

With trepidation I resolved to show it to Steve and be guided by his response.

I showed it to Steve. He wept.

When the pandemic is over and it's easier for me to travel, I will visit your grave in Dieppe. I will write a description of my experience. My writing won't be in the form of a letter, or even specifically a communication with you, though of course you will have been the motive for my journey. I will probably need to wait. Everything is unresolved for me right now. I will need to get distance on the events that have shaken the world and overturned my personal life. I would like to write about travelling to Dieppe, when I am ready. I will arrive there by a roundabout route. Perhaps I might make a discovery of some kind, which wouldn't rule out the possibility of joy. I would

like to make studies of all the places that have meant so much to Steve and me: Altaussee, Saint-Malo, Venice, Arezzo, Paris, Florence: all the photographs he took of me on windswept beaches, sunlit steps, tranquil lake shores; when I revisit these scenes, his spirit will be with me and I will feel peaceful. I would like to travel to new places and paint new landscapes. I would like to visit New Mexico, where Agnes Martin lived and painted; and I would like to go to Maine, where Edward Hopper was inspired to paint his landscapes and interiors. I would like to return to Santa Monica. I would like to paint nature, as I did as a young woman before I met Lucian. I would like to paint true and compassionate self-portraits.

They predict that a vaccine will be available at the start of next year and that normal travel should be possible by the summer. At that point Britain will have left the European Union. It is a very distressing outcome of several years of muddled negotiations. So much sadness in these recent years. It is hard to look at the future without fear. I will be alone by then.

I'll write to you soon. It will be my last letter to you, my dearest.

With my love,

Celia

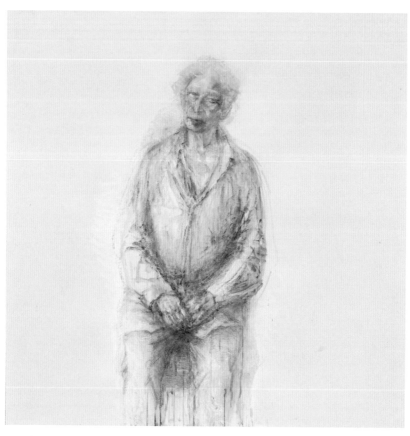

Celia Paul, *Last Painting of Steve*, 2017–21

Celia Paul, *My Mother and the Mountain*, 1994–2020

In her last years Gwen moved again to a different part of Meu-
don, to an abandoned hangar with an adjoining outhouse. It
was even more basic than the one she had been living in. There
was no heating and the roof leaked. She had been distressed by
construction work being carried out in front of her former
studio – apartment blocks that would obscure her view of the
forest. In this new studio she would be very secluded. The two
buildings were made of wood and raised from the ground on
stilts. She approached the overgrown plot of land in which they
were situated by way of a long avenue of linden trees. She
instructed workmen to build a high wall around the studios
and garden, so that she would have absolute privacy. Gwen
didn't do any gardening; weeds grew tall among the acacia
trees. She often slept in the smaller of the two buildings, which
was more like a shed and had no door, even if it was raining. If
it was fine, she slept on the grass in her wild garden. She wanted
to be part of the silence, at one with nature.

She began to neglect herself and was often ill. In a letter
she wrote to Ursula dated 30 August 1936 she says: 'I sleep
here now, in the garden when it's not raining. I sat on the
stone steps to draw a flower and caught an interior chill, a lot
of pain and fever but it is gone now.' And in the last letter she

wrote to her beloved friend Ursula, Gwen tells her that she 'can't walk well just now . . . so painful to stand and walk'.

She didn't, however, confess to Ursula the seriousness of her condition. The only person she confided in was her older brother, Thornton. She told him that it must be a secret – she didn't want anyone to know. He agreed to her wishes and understood that she didn't want any intrusion, and that she certainly didn't want to be taken to hospital. Gwen suffered terrible pain in her stomach and bowels.

The secrecy surrounding her final illness is similar to the secrecy surrounding her mother's, in the house near the sea in Haverfordwest. Gwen felt very close to her.

In the last eighteen months of her life she stopped painting. She wanted to go home. She had often longed for death, but she made the quiet decision that it was time now. Her life was completed.

I think of her on her final journey. She made her way to Dieppe because she felt compelled to have one last sight of the sea. She knew she was dying and she longed for the sea of her childhood on the Pembrokeshire coast.

As soon as she got to Dieppe she collapsed. She died in the Hospice de Dieppe on 18 September 1939, at the age of sixty-three.

Towards the end she wrote in her notebook, 'Don't think (as before) to work for years ahead & the number possible – you work for the moment . . .' And she wrote, 'You make your life let it be consciously, with fearlessness.'

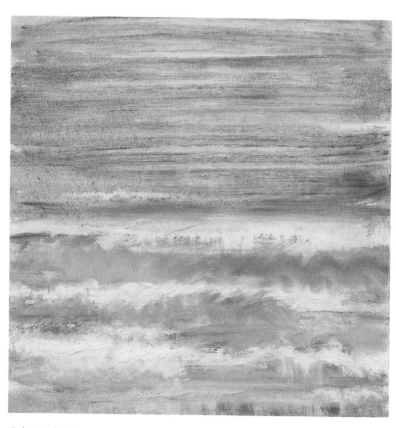

Celia Paul, *Dieppe*, 2021

Great Russell Street, 11 November 2020

Now, finally, I want to ask your advice, dearest Gwen.

I think about how I want to live and paint truthfully. I think of the words that the great writer John McGahern wrote: 'the best of life is life lived quietly, where nothing happens but our calm journey through the day, where change is imperceptible and the precious life is everything'. I think about Paul Cézanne's words: 'is Art really a priesthood that requires the pure in heart, who completely surrender themselves to it?' I think about how to reconcile living and valuing life while at the same time renouncing it, and how it might be possible for me to tame and curb my longing, anxiety and loneliness by knowing when a painting is done or a person has left, knowing how to move on purposefully, without resignation, but with peace.

Goodbye, dearest Gwen. Think of me and help me by your quiet presence to be peaceful at the last.

The final words recorded in the book of your letters and notebooks are from a draft letter to Ursula Tyrwhitt in which you list the oil paints that mean most to you:

Rouge Phénicien is the colour of what we call wild geranium. The stems are dark crimson, the emerald leaves

seem dipped in pale crimson just now, the rest of the
leaves are somewhat 4 Anglais. Earlier in the summer the
leaves are emerald green all over . . .

Rose Erythrine . . . is a very beautiful and brilliant Rose . . .
Laque Géranium – fugace [*fugitive*]
Rouge rubis . . .
Laque de Smyrne
Claire (light)
Ordinaire (le Franc)
Moyen [*medium*]
Foncé [*dark*]
À peu près the colour of the roses in tufts now in flower.
4 Anglais is the green on the tubs in bands by your hotel . . .
Ocre jaune demi brûlé is useful to me . . .
Cinabre vert is the green ball holding the snowdrop petals . . .
Vermilion français is warmer than V[ermilion] écarlate . . . Poppies.

It is my sixty-first birthday today.
With a handshake,
Celia

Celia Paul, *January Sky*, 2021

Notes

Many of Gwen John's papers are in the National Library of Wales, Department of Manuscripts and Records, Aberystwyth. The letters and notebooks I have quoted can also be found in Ceridwen Lloyd-Morgan (ed.), *Gwen John: Letters and Notebooks* (London, 2004).

2 **'it may not be always . . .':** GJ to Jeanne Robert Foster, 6 December 1922, National Library of Wales (NLW) MS 23850D, ff.5–7

2 **'As to me . . .':** GJ to Ursula Tyrwhitt, 4 February 1910, NLW MS 2148D, ff.38–40

6 **'implacable nature . . .'** Augustus John, *Chiaroscuro* (London, 1954), p.17

9 **'No doubt all these words . . .':** GJ to Ursula Tyrwhitt, 15 July 1927, NLW MS 21468D, f.159

10 **'feeling the old compulsion':** Augustus John, *Chiaroscuro*, p.196

32 **'I bathe in . . .':** GJ to Michel Salaman, spring 1899, NLW MS 14930C, ff.20–1

32 **'Your paper is crooked . . .':** quoted in Malcolm Yorke, *Matthew Smith: His Life and Reputation* (London, 1997), p.37

33 **'abounded in talented . . .':** Augustus John, *Chiaroscuro*, p.30

34 **'Why I hate . . .':** quoted in Yorke, *Matthew Smith*, p.36

37 **'If to "return to life" . . .':** Augustus John, *Chiaroscuro*, p.194

49 **your idol, Véra:** see Sue Roe, *Gwen John: A Life* (London, 2001), p.253

52 **'Turn gently towards . . .':** 30 August 1922, NLW MS 22293C, f.106

60 **'We hire our room . . .':** GJ to Ursula Tyrwhitt, late 1903, NLW MS 21468D, ff.7–8

63 **'I do nothing . . .':** GJ to Ursula Tyrwhitt, early 1904, NLW MS 21468D, ff.11

63 **'She was extremely queer . . .'** Dorelia quoted in Michael Holroyd, *Augustus John: The New Biography* (London, 1996), p.149

63 **'I am getting on':** Ibid., p.149

71 **'the musician gathers . . .':** Augustus John, *Chiaroscuro*, p.59

85 **'Well, my own work . . .':** Vincent to Theo van Gogh, 23 July 1890, *The Complete Letters of Vincent van Gogh*, translated by J. van Gogh-Bonger (London and New York, 1956), vol. 3, p.298

102 **'I think them rather good . . .':** Holroyd, *Augustus John*, p.49

104 **'Gus offered to arrange . . .':** GJ to Ursula Tyrwhitt, 6 June 1925, NLW MS 21468D, ff.140–2

114 **'Thanks for your criticism . . .':** GJ to Ursula Tyrwhitt, 15 October 1911, NLW MS 21468D, ff.63–4. (At the end of the nineteenth century, the word 'artistic' started to be used as a criticism implying that a painting was contrived: Impressionism stated that one should work directly from Nature. Lucian Freud, much later, was still using the word 'artistic' when he spoke to me about certain paintings he disliked because they were self-consciously skilful and preconceived.)

117 **'no women have . . .':** Rodin to Albert Ludovici, quoted in Ruth Butler, *Rodin: The Shape of Genius* (New Haven, CT, 1993), p.395

119 'It is like the sun . . .': Rodin, *Les Cathédrales de France* (Paris, 1914), quoted in Roe, *Gwen John*, p.54

120 'Cher Monsieur . . .': Musée Rodin archives, n.d., quoted in Roe, *Gwen John*, p.51

121 'I am at Rodin's . . .': GJ to Ursula Tyrwhitt, 1904–5, NLW MS 21468D, ff.15–16

124 'quelquechose': Musée Rodin archives, Le matin de mardi, quoted in Roe, *Gwen John*, p.76

124 'Look at those slim legs . . .': quoted in Butler, *Rodin*, p.437

124 'is no longer . . .': quoted in Butler, *Rodin*, p.440–1

124 'Do you know . . .': Musée Rodin archives, jeudi soir, quoted in Roe, *Gwen John*, p.59

125 'Oh mon Maître . . .': Musée Rodin archives, vendredi matin, quoted in Roe, *Gwen John*, p.59

129 'Last evening I walked . . .': GJ to Ursula Tyrwhitt, 18 November 1911, NLW MS 21468D, f.66

131 'I am better alone . . .': NLW MS 22281B, f.10

133 'sex, sex . . . bodies': Butler, *Rodin*, p.437, quoted in Roe, *Gwen John*, p.55

143 'Dear Ursula . . .': GJ to Ursula Tyrwhitt, 22 November 1917, NLW MS 21468D, f.110

151 'The French papers . . .': GJ to Ursula Tyrwhitt, 27 September 1914, NLW MS 21468D, ff.80–1

152 'There is a feeling . . .': GJ to Ursula Tyrwhitt, 19 May 1918, NLW MS 21468D, ff.118–19

153 'It is strange . . .': GJ to Ursula Tyrwhitt, 29 March 1918, NLW MS 21468D, ff.115–16

159 **'Gwen John's apparent timidity . . .'**: Augustus John, *Chiaro-scuro*, p.195

163 **Jeanne was a poet . . . :** For this section I have drawn on Sue Roe's *Gwen John*, especially pp.191–210. The sources are mainly from the National Library of Wales, the New York Public Library and the New York Foster-Murphy papers, as well as the Tate archives.

171 **Her *Woman in Profile*:** Cecily Langdale, *Gwen John: with a Catalogue Raisonné of the Paintings and a Selection of the Drawings* (New Haven, CT, 1987), p.102

171 **'I have sat for Gwen John . . .'**: Jeanne Robert Foster to John Quinn, quoted in Roe, *Gwen John*, p.218

173 **'My mind is very slow . . .'**: GJ to Jeanne Robert Foster, 6 December 1922, NLW MS 23850D, ff.5–7

174 **'I don't think . . .'**: GJ to John Quinn, 9 May 1922, Ceridwen Lloyd-Morgan (ed.), *Gwen John: Letters and Notebooks* (London, 2004), p.127

174 **'Is it really true . . .'**: quoted in Roe, *Gwen John*, p. 234

201 **'Take your time . . .'**: Ibid., p.125–6

202 **'Of spirit so still . . .'**: William Shakespeare, *Othello*, Act 1, Scene 3

202 **'It is a high-wrought flood'**: Ibid., Act 2, Scene 1

202 **'Like to the Pontic Sea . . .'**: Ibid., Act 3, Scene 3

202 **'She was false as water'**: Ibid., Act 5, Scene 2

204 **'*The poor soul* . . .'**: Ibid., Act 4, Scene 3

209 **'I said to my soul, be still . . .'**: T.S. Eliot, 'East Coker', *Four Quartets* (London, 1940)

224 **'dark night of the soul'**: St John of the Cross, *Dark Night of the Soul*

233 **'I am ridiculous . . .'**: Holroyd, *Augustus John*, p.49

233 **'I suffered a long time . . .'**: Holroyd, *Augustus John*, p.28

234 **'they dared not . . .'**: Ibid., p.48

239 **'In my Father's . . .'**: John 14:2

244 **'Eily sent me . . .'**: GJ to Ursula Tyrwhitt, 12 July 1908, NLW MS 21468D, ff.23–4

248 **'I think if we are to do . . .'**: GJ to Ursula Tyrwhitt, summer 1910, NLW MS 21468D, ff.46–7

250 **'it is so exquisite . . .'**: GJ to Ursula Tyrwhitt, 24 January 1925, NLW MS 21468D, ff.133–4

257 **'At the moment . . .'**: GJ to Véra Oumançoff, September 1927, NLW MS 22301B, f.23

260 **'It's very lovely here . . .'**: GJ to Ursula Tyrwhitt, 15 July 1927, NLW MS 21468D, f.159

287 **'Under this fine rain . . .'**: Michael Doran (ed.), *Conversations with Cézanne*, trans. by Julie Lawrence Cochran (Berkeley, Los Angeles and London, 2001), p.114

311 **'Danny was a student . . .'**: William Feaver, *The Lives of Lucian Freud: Fame, 1968–2011* (London, 2020), p.126

312 **'I paint a good deal . . .'**: Holroyd, *Augustus John*, p.95

323 **'the precious life'**: John McGahern, *All Will Be Well: A Memoir* (London, 2005)

323 **'is Art really . . .'**: Cézanne to Ambroise Vollard, 1 January 1903, Alex Danchev (ed.), *The Letters of Paul Cézanne* (London and New York, 2013), p.325

List of Illustrations

Acknowledgements

I have written about Gwen John's life where it intersects, or conflicts, with mine. I have deliberately left out details of her story, as I have left out details of my own. This book is not a biography of Gwen John; it is an encounter. I am indebted to Sue Roe for her admirable biography *Gwen John: A Life*, especially for the detailed information about Gwen's relationships with Rodin, Jeanne Robert Foster and Véra Oumançoff. I have used material from the beautifully illustrated biography with catalogue raisonée *Gwen John* by Cecily Langdale; as well as *Gwen John: Letters and Notebooks*, edited by Ceridwen Lloyd-Morgan. I have also referred to Michael Holroyd's biography *Augustus John*; Augustus John's memoir, *Chiaroscuro*; as well as *Rodin: The Shape of Genius* by Ruth Butler. I would recommend these books to anyone interested in reading a comprehensive assessment of Gwen John's life. Some of the information comes from hearsay: Zoe Hicks passed on several intimate facts about Gwen John's life to Lucian Freud, who then shared them with me. As can be seen in the extracts from her letters and notebooks, Gwen John was a wonderful writer. The Musée Rodin archives possess a number of her writings, including the letters to 'Miss Julie': a fantasy persona, encouraged by Rodin to try to help her channel and control her obsessive thoughts about him. I have not used this material in the

context of this book, but I would recommend that her writing becomes more widely recognised. Her art – her paintings and drawings – urgently need to be given more attention.

I have left out details of my own life and I have adapted certain facts. There are many absent presences in the book – several of the most significant being that I was accompanied on two of the trips to America by members of staff from the Victoria Miro Gallery: Rachel Taylor looked after me with great kindness throughout my time in Los Angeles. Rachel found the beautiful hotel in Santa Monica; organised the trips to museums, and all the transport; and introduced me to her friends and family living in Los Angeles, who made me feel welcome. Isabelle Young accompanied me to Yale and looked after me there: it was a pleasure to be with her. Robert Holzberger from the Victoria Miro Gallery organised the wonderful hotels, the flights and transport for the visits. My deep gratitude goes to the great generosity and sensitivity of Victoria Miro, who, knowing how homesick I always am when I go abroad, arranged for her valued members of staff to accompany me. Before joining her gallery, I had never been to America. It was through her that I first went to New York, and subsequently to Yale and Los Angeles. All three places have been revelations to me; my stay in Los Angeles was one of the most inspiring times in my life: this book would not have been written without it, or without Victoria's help and encouragement. All three of my trips to America were occasioned by exhibitions curated by Hilton Als. I am profoundly grateful for his support and for his unique vision.

I owe a deep debt of gratitude to Sarah Chalfant for her

wisdom, guidance, inspiration and friendship. Without her friendship I wouldn't have become a writer. Similarly, I am indebted to Alba Ziegler-Bailey for her intuitive understanding of my writing and for her unfailing support. I'd like to thank all the staff at the Wylie Agency.

I am deeply grateful to Bea Hemming, my editor at Jonathan Cape. The subtle way she guides and shapes my writing never feels intrusive. She has given me confidence through her instinctive understanding of my intention. I feel very fortunate indeed to be working with her again on this second book.

The pandemic has prevented me from travelling to New York to meet my editor, Susan Barba, at New York Review Books. Even though we haven't actually met, I know she has a real knowledge of my intention and purpose. I feel very thankful to be working with her, albeit remotely. I am very grateful to Nicholas During for all his dedicated support. And thanks to Jeff Posternak at the Wylie Agency, New York.

I would like to thank all the staff at the Victoria Miro Gallery. My special thanks go to Hannah van den Wijngaard, Kathy Stephenson, Erin Manns, Valeska Gerson, Bea Bradley, Clare Coombes.

I would like to thank Roger Thorp at Thames & Hudson for giving me a copy of *Gwen John: Letters and Notebooks*, which he produced while at Tate Publishing.

I am grateful to Jake Auerbach for providing the occasion to revisit the Brontë Parsonage and my former home in Bradford for his documentary film *Celia Paul: private view*.

Rivkah Gevinson, Isabelle Young, Rachel Taylor and I explored

the Getty Villa together. It was Rivkah's twenty-ninth birthday. She and I wept in front of the classical sculpture titled *Elderly Woman*. I'd like to thank her for this, for listening to me as we walked round and round the herb garden at the Getty Villa and for our continuing friendship.

I would like to thank Siemon Scamell-Katz, Rachel Cusk and their great friend Andrew Winer for an inspiring encounter at the Getty Museum.

Thanks to Frankie Rossi, of Marlborough Fine Art, for her generous support over many years.

I am grateful to Ruth Guilding for enabling me to re-visit and re-work my painting *My Mother and the Mountain* in her and Andrew Wilson's collection.

To my sisters – Rosalind Paul, Lucy Archer, Jane Williams, Kate Paul – for all the loving kindness. I would particularly like to thank Rosalind Paul for her help with the French translations in this book.

To my dearest Frank Paul – thank you for all the love and for sharing the joy of your family with me: your wife, Masha Cleminson, and your children, Eve, Lawrie and Daphna Cleminson (Daphna Grace Irene, born 28 July 2021).

On 22 March 2021 my husband, Steven Kupfer, went into a hospice in Hampstead. He was in Keats Ward. When he died just after midnight on 29 March, the owls were hooting in the trees of the hospice garden, which was situated not far from Keats House and Hampstead Heath. Words cannot describe how I feel. I have been painting him in his rowing boat on the lake in Austria: a prayer of gratitude for his life which he shared with me.

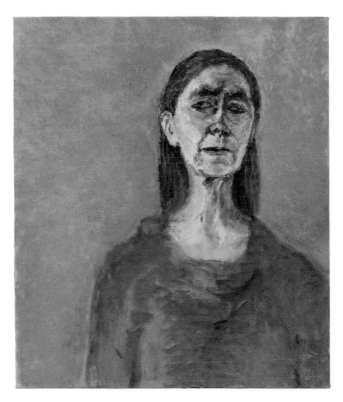

Celia Paul, *Self-Portrait, April 2021*

Tarkovsky, Mirror.